Pride&Joy

Pride&Joy
Taking the Streets of New York City

Jurek Wajdowicz

THE NEW PRESS

© 2016 by Jurek Wajdowicz
Preface © 2016 by Jon Stryker
Introduction © 2016 by Kate Clinton
All rights reserved.
No part of this book may be reproduced, in any form, without written permission from the publisher.

Requests for permission to reproduce selections from this book should be mailed to:
Permissions Department, The New Press, 120 Wall Street, 31st floor, New York, NY 10005.

Published in the United States by The New Press, New York, 2016
Distributed by Perseus Distribution

ISBN 978-1-62097-185-7 (pbk)
ISBN 978-1-62097-206-9 (e-book)
CIP data available

The New Press publishes books that promote and enrich public discussion and understanding of the
issues vital to our democracy and to a more equitable world. These books are made possible by the
enthusiasm of our readers; the support of a committed group of donors, large and small; the col-
laboration of our many partners in the independent media and the not-for-profit sector; booksellers,
who often hand-sell New Press books; librarians; and above all by our authors.

www.thenewpress.com

Book design and composition © 2016 by Emerson, Wajdowicz Studios (EWS)
This book was set in Helvetica Inserat, Helvetica Neue, Franklin Gothic and News Gothic

Printed in the United States of America

Preface
JON STRYKER

The photographs in this book and others in this series are part of a larger collective body
of commissioned work by some of the world's most gifted contemporary photojournalists.
The project was born out of conversations that I had with Jurek Wajdowicz. He is an
accomplished art photographer and frequent collaborator of mine, and I am a lover
of and collector of photography. I owe a great debt to Jurek and his design partner,
Lisa LaRochelle, in bringing this book series to life.

Both Jurek and I have been extremely active in social justice causes—I as an activist
and philanthropist and he as a creative collaborator with some of the household names
in social change. Together we set out with an ambitious goal to explore and illuminate
the most intimate and personal dimensions of self, still too often treated as taboo: gen-
der identity and expression, and sexual orientation. These books continue to reveal the
amazing multiplicity in these core aspects of our being, played out against a vast array
of distinct and varied cultures and customs from around the world.

Photography is a powerful medium for communication that can transform our under-
standing and awareness of the world we live in. We believe the photographs in this series
will forever alter our perceptions of the arbitrary boundaries that we draw between others
and ourselves and, at the same time, delight us with the broad spectrum of possibility for
how we live our lives and love one another.

I am particularly happy seeing Jurek's *Pride & Joy* come to life. For this book he is
not only the artistic director, but also the photographer. He, and the other photographers
in this ongoing series, are more than craftsmen: They are communicators, translators,
and facilitators of the kind of exchange that we hope will eventually allow all the world's
people to live in greater harmony. ∎

Jon Stryker, philanthropist, architect, and photography devotee, is the founder and board president of the Arcus Foundation,
a global foundation promoting respect for diversity among peoples and in nature.

Introduction
KATE CLINTON

Stepping off the curb into the New York City Pride Parade has the exhilarating, familiar rush of "Here we go!"

All the decisions behind that day's first step:

The outfit, the layering, the shoes, the snacks, the hydration, the ID, the SPF, the phone calls, the texts, the plans to meet, the affinity group, the banner, the slogans, the glitter, the makeup, the precision dance-step practice, the post-parade plans.

All the politics of the parade:

The organizing, the meetings, the fund-raising, the infighting, the committees, the subcommittees, the sub-sub-subcommittees, the ordering of the rainbow-balloon arch and port-o-johns, navigating the labyrinthine city departments, the noise ordinances, the parade security, the registration, the volunteer lawyers, the corporate sponsors, the politicians, the reviewing stand, the selection of grand marshals, the marshaling of volunteers, the cleanup.

All the history of the parade:

The Stonewall riots, the Homophile Society, the parade on the first anniversary of the riots, the first years of visibility, the growing numbers, the numbers disputed by the media, the party, the disco beat, the AIDS protests, the moment of silence, the chants, the signage, the protesters, the spectators, the sirens, the Big Apple Marching Band, PFLAG, the Center kids, the leather contingent, Lavender Light Gospel Choir, the LGBT veterans, the veteran LGBT elders,

SAGE, TransPride, International Pride, LGBT employee groups, the Imperial Court, the Supreme Court decisions, the fireworks, the dance on the pier, the next day's mandatory brunch recap.

All of these somehow crystallize into one glorious, joyous, outrageous, sexy, sweaty, present moment—as small and beautiful as a glittered nipple and as large and beautiful as the rainbow flag rippling down the canyon of Fifth Avenue.

The decision to come out of the closet is a very private moment. Each lesbian, gay, bisexual, and transgender person faces it. No confetti, no thumping bass, no cheering people. Those who have come out know the subtle shift forward, the first step out of the closet, then the wild, liberating, headlong rush of "Here we go!"

The Pride Parade celebrates and inspires that moment and that movement every year.

Stepping off the curb, off the sidelines, into a community.

Here we go!:

Rumors of a parade of those who have come out, news stories, and police reports, spur others to join the masses.

Marchers with bags on their heads now posting sweaty selfies.

Chanting, chatting, waving, smiling.

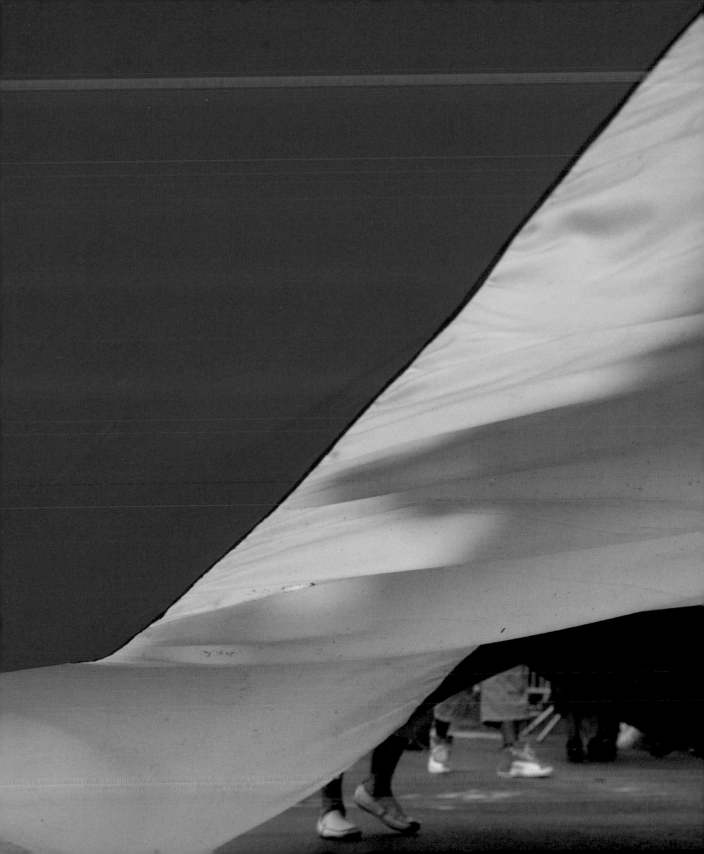

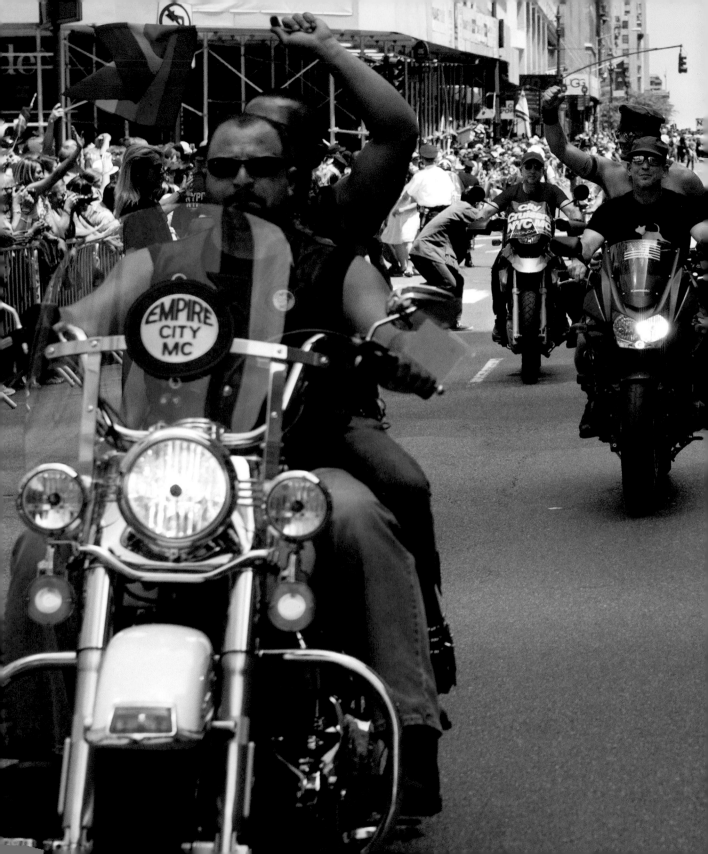

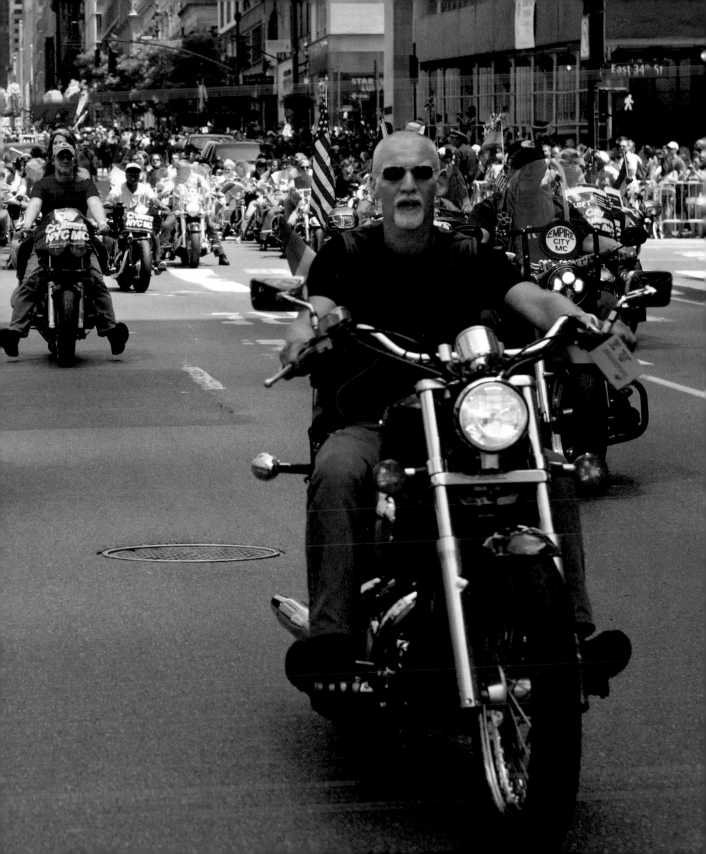

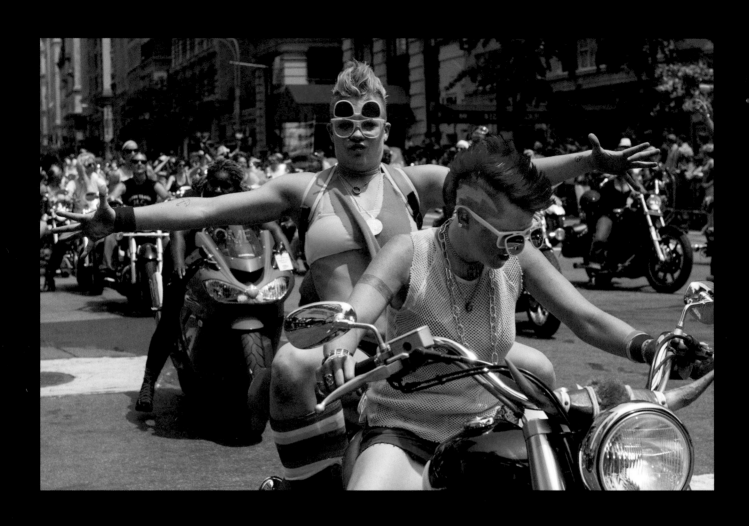

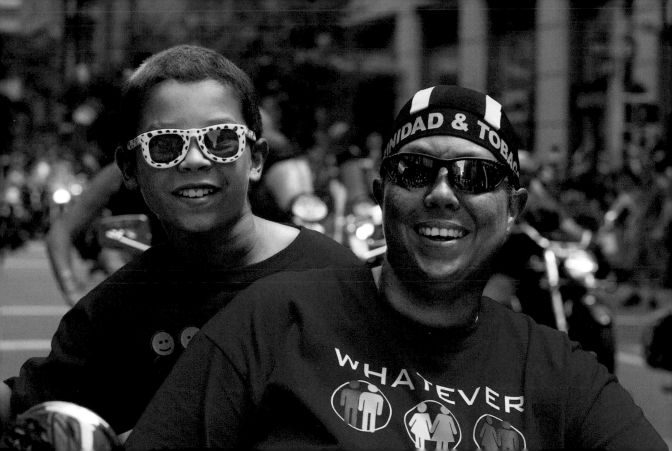

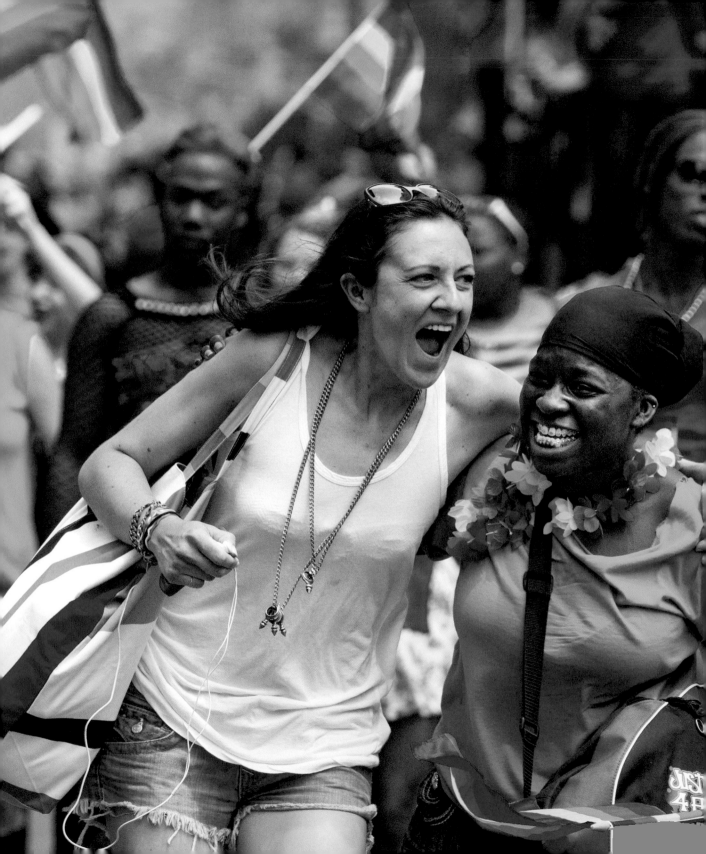

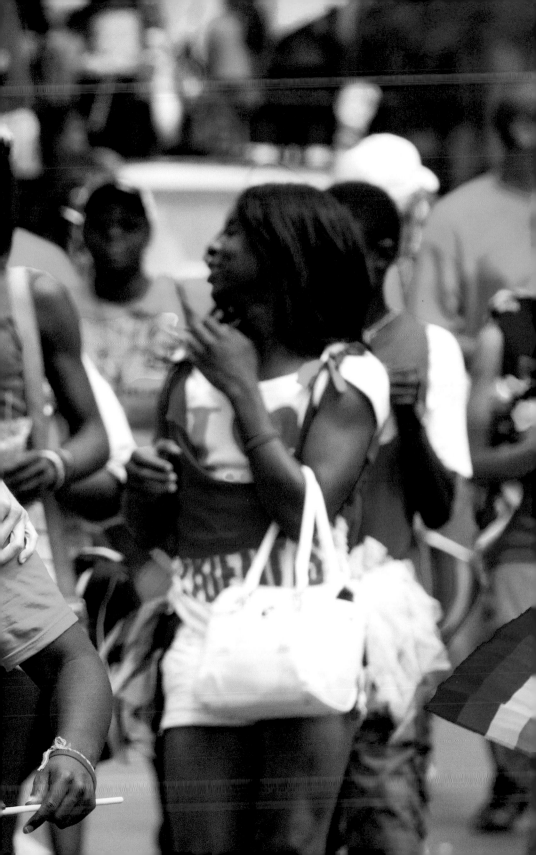

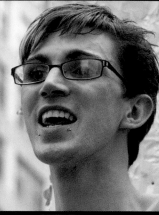
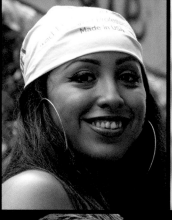
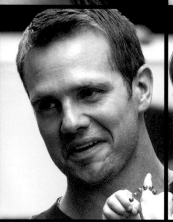
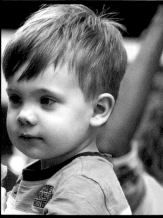
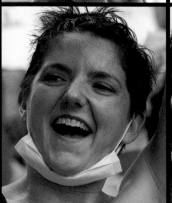
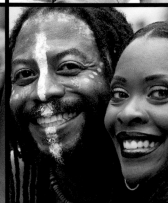

After two marriages to men, I fell in love with Byllye in 1989, but did not start to come out of the closet for six more years. Our first Pride Parade came almost by mistake. We happened to be in San Francisco to attend a meeting, and took some additional time to visit family members.

We were visiting my brother when I realized that the Pride Celebration was happening the next day. The day of the parade, my brother drove us in, but he chose not to attend (he has not only attended several Pride Parades since, but also helped officiate at our wedding). The crowd for the parade was HUGE—so big that I almost forgot to worry whether someone from work might recognize me and tattoo a big L on my forehead. The parade was amazing: bright, colorful, and loud. People were in various states of dress and undress, drag queens and kings, walking, riding bikes, and in cars. There were people in uniform, local EMTs, firefighters, and police, as well as members of the armed services. There was music, with those in marching bands carrying, beside their instruments, banners of celebration and pride. Everyone seemed so happy and very proud.

Just when I thought that I had seen everything and needed a little time to take it in, around the corner came a phalanx of what seemed like one million women riding motorcycles! The loud and proud Dykes on Bikes overjoyed and energized me. Those women were the highlight of the Pride Parade for me. I felt all-powerful and fully able. —**NGINA LYTHCOTT AND BYLLYE AVERY**

My first time at the NYC Pride March was in 1981. I had just moved to the city after graduating from college. It was really transformative for me, at age twenty, to be in that huge crowd of gay people. In everyday life, my queerness, or at least my outness, had become an issue. Looking for a job, walking down the street, being with my family, there was always some degree of tension and friction because of my difference. But here among the marchers there was no difference. —**ALISON BECHDEL**

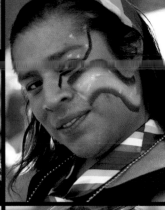
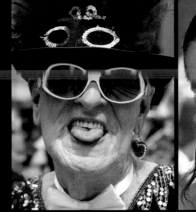

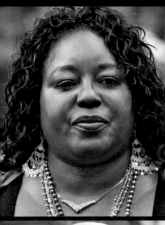
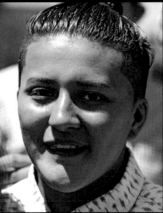
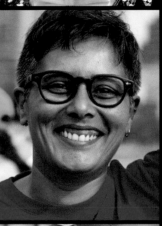
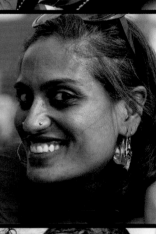

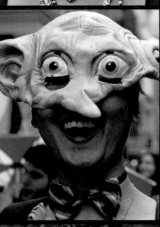
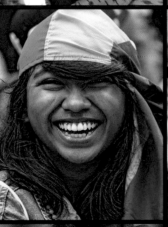
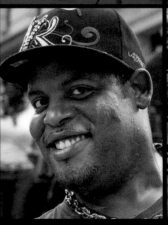
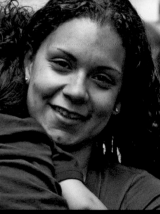

I lived through the worst of the AIDS deaths. The one minute of silence has always been an important mainstay to me. I take the time to remember the names and faces of so many people and imagine what the march would look like if they were alive.

—**JANET WEINBERG**

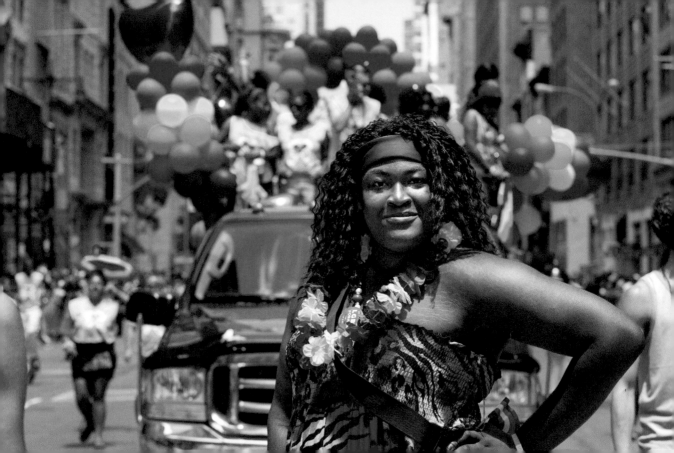

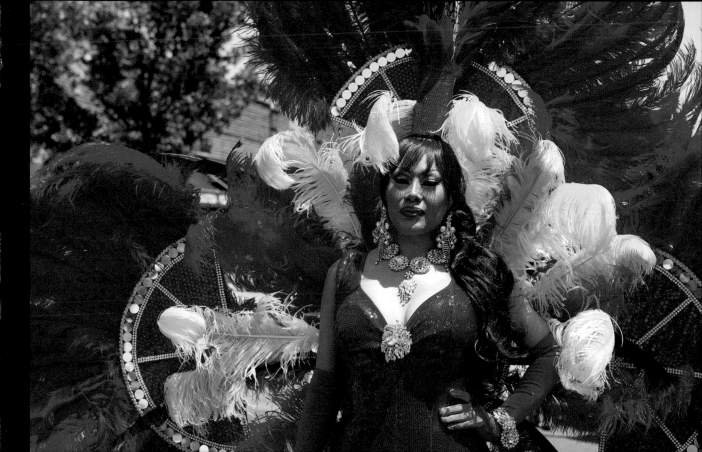

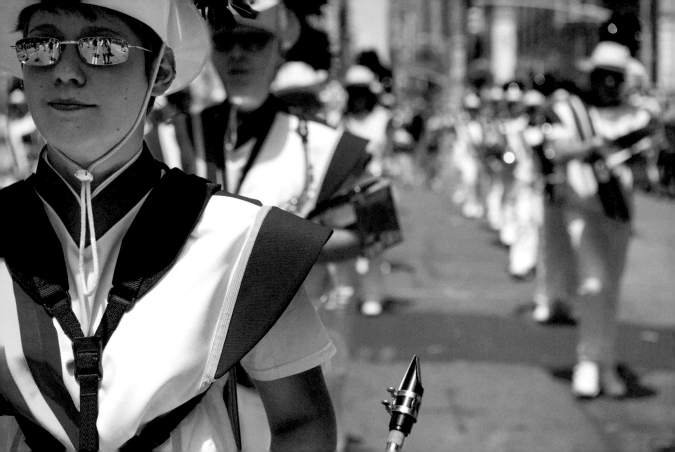

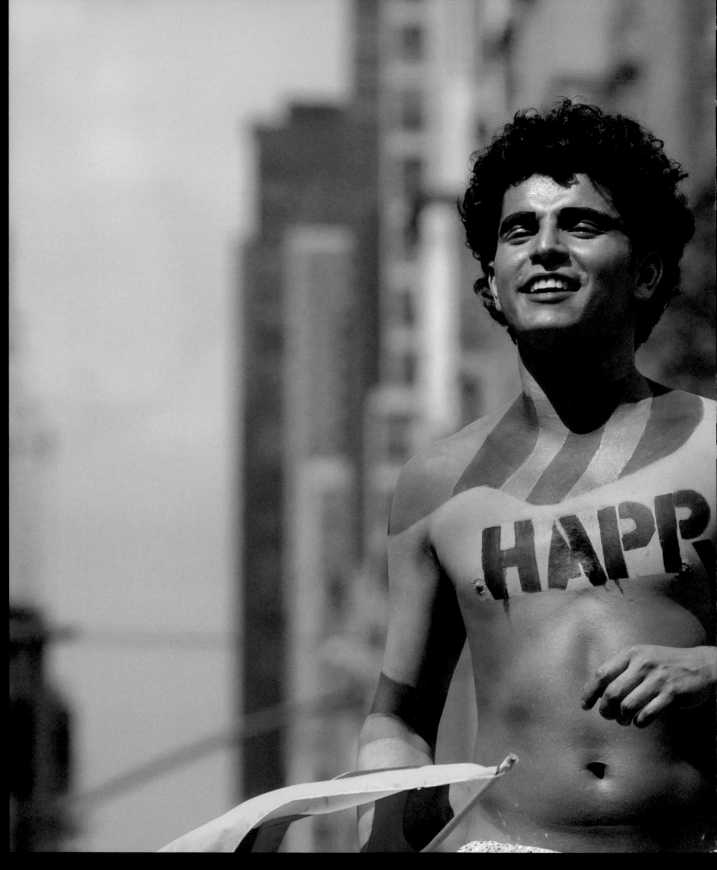

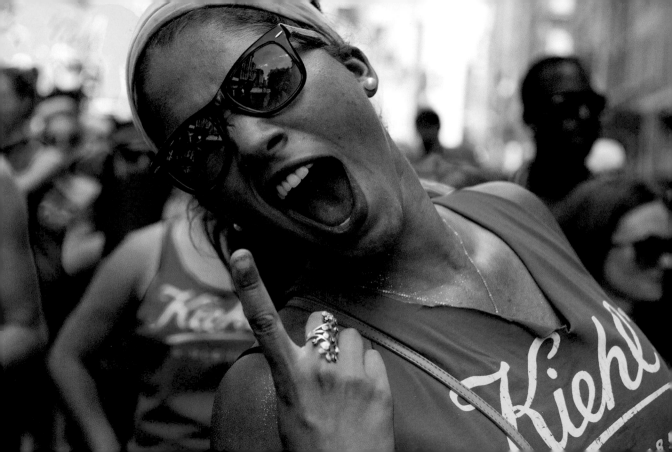

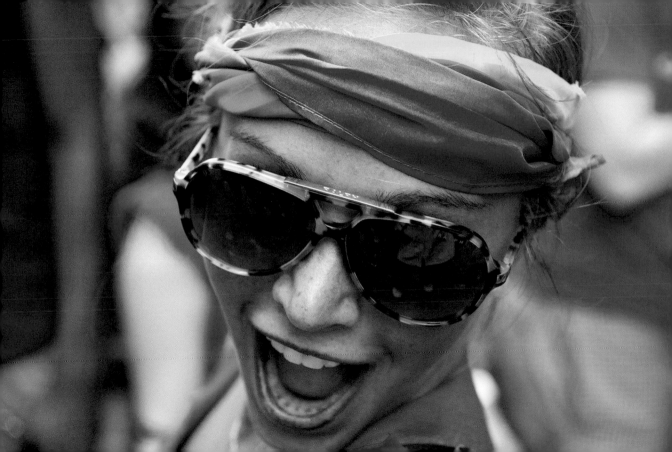

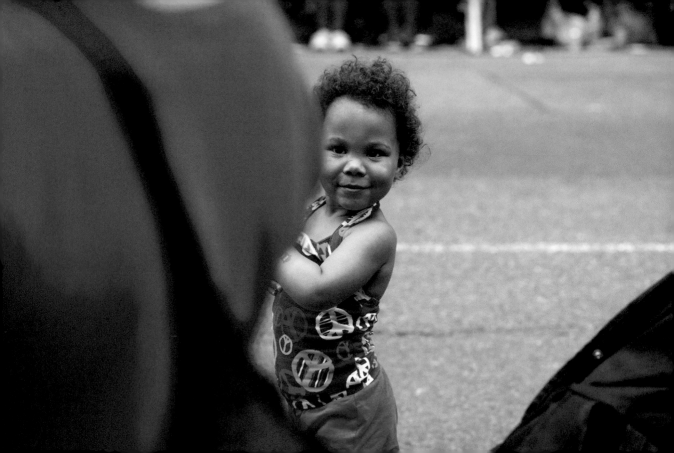

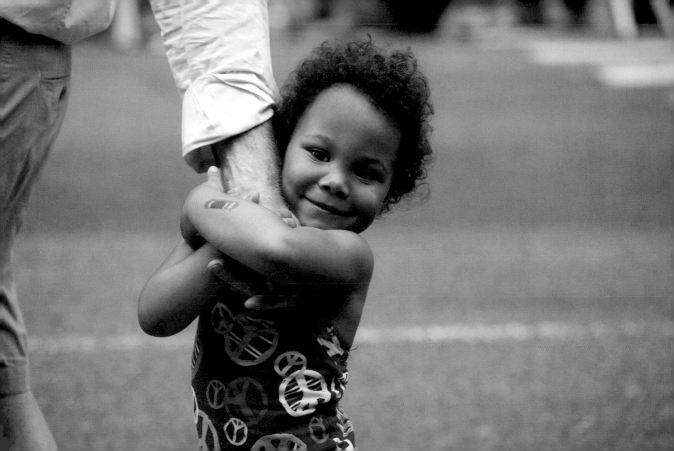

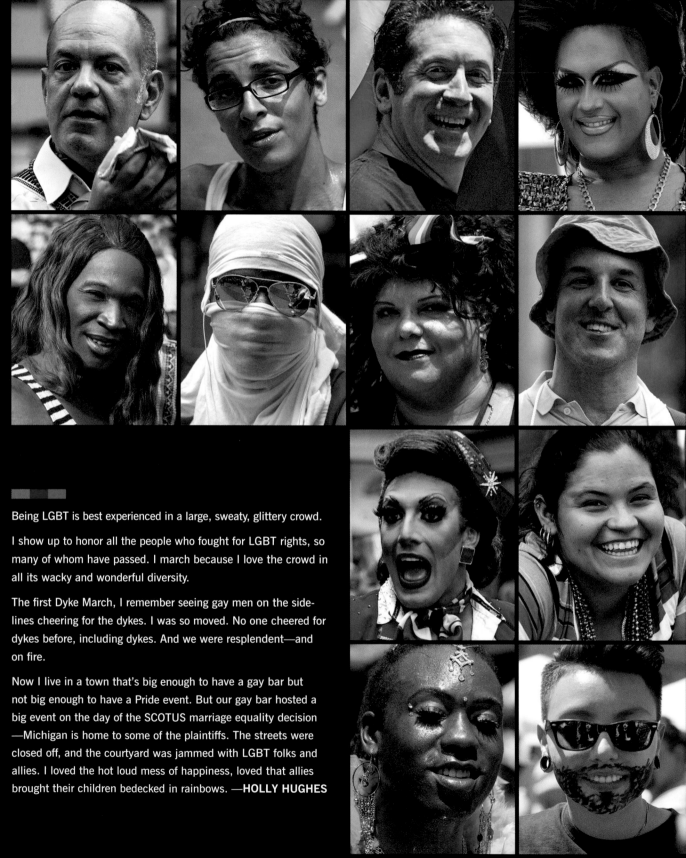

Being LGBT is best experienced in a large, sweaty, glittery crowd.

I show up to honor all the people who fought for LGBT rights, so many of whom have passed. I march because I love the crowd in all its wacky and wonderful diversity.

The first Dyke March, I remember seeing gay men on the sidelines cheering for the dykes. I was so moved. No one cheered for dykes before, including dykes. And we were resplendent—and on fire.

Now I live in a town that's big enough to have a gay bar but not big enough to have a Pride event. But our gay bar hosted a big event on the day of the SCOTUS marriage equality decision —Michigan is home to some of the plaintiffs. The streets were closed off, and the courtyard was jammed with LGBT folks and allies. I loved the hot loud mess of happiness, loved that allies brought their children bedecked in rainbows. —HOLLY HUGHES

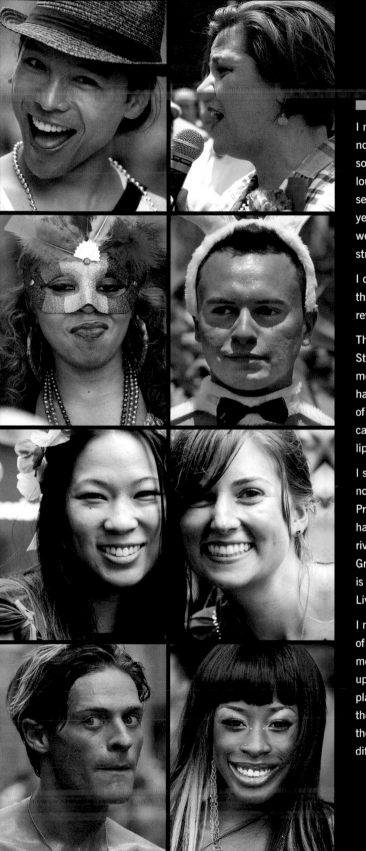

I missed NYC Pride this year. I've missed it many years; and now you ask, I think it's also true that I miss it. I soured on Pride some years ago, when the monster floats became so large and loud and the people's banners so few and scrawny. Commerce seemed to have edged out community. And then there was the year that LGBT service people led the parade the very same weekend an Iraqi artist I knew lost her life in a U.S. bombing strike on Baghdad.

I didn't feel pride that year. I felt confused. The liberation Pride that had excited me was losing out to piece-of-the-pie Pride—a revolution I found hard to dance to.

The Prides I relished were rowdy, riotous affairs, where we booed St. Pat's and held on tight to our "Avengers" flags. In London one memorable year, coal miners on strike joined the queers (as we had joined them on their picket lines), and I caught a glimpse of a grand queer festival of love and fight, seductive enough to catch fear off guard and smudge out our borders like so many lipsticked lips after kissing.

I started skipping Pride. I coupled up. I got distracted. But now, now that you ask, it'd be hard to tally up the gifts I got from Pride. Pride is present in the freedom I feel holding my lover's hand anywhere; in the image I have of a massive rainbow river of lives flowing down Fifth Avenue. Turn west, toward Greenwich Village, and I swear, the air between the buildings is salty with the sweat and heat of a million moved-on bodies. Lives lost and found.

I marched for women who needed no one to march, or do much of anything, for them. They did for themselves. I marched to meet and mourn and resurrect the parts of myself I keep cooped up or quiet. I marched to practice stepping off my safe, private place on the pavement and into the mad helter-skelter crush in the street. I marched to be reminded that there is joy there, in the mix of singular, special people in a common crowd, dancing differently together. —**LAURA FLANDERS**

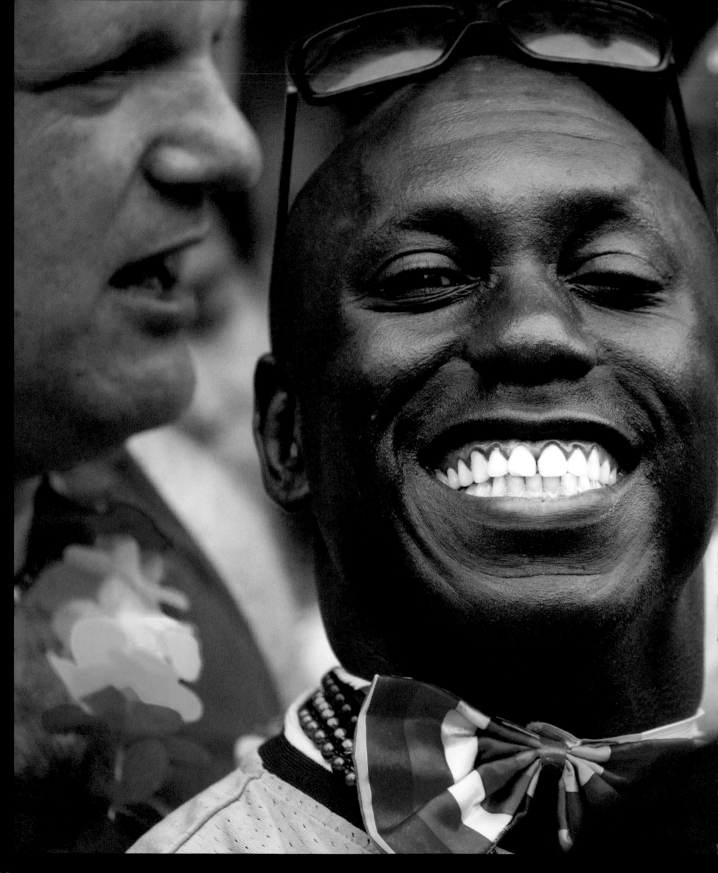

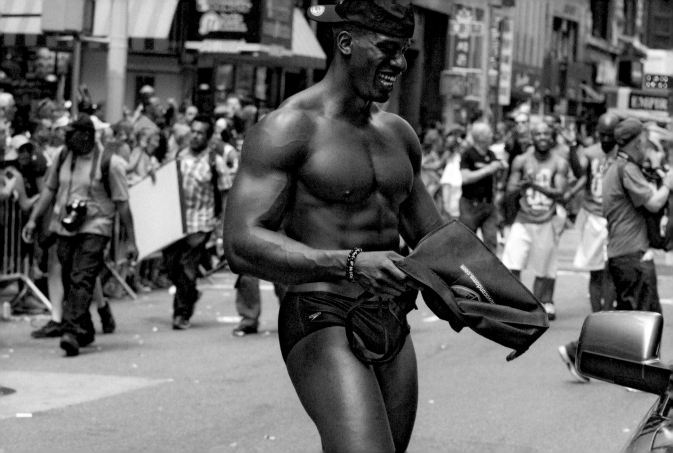

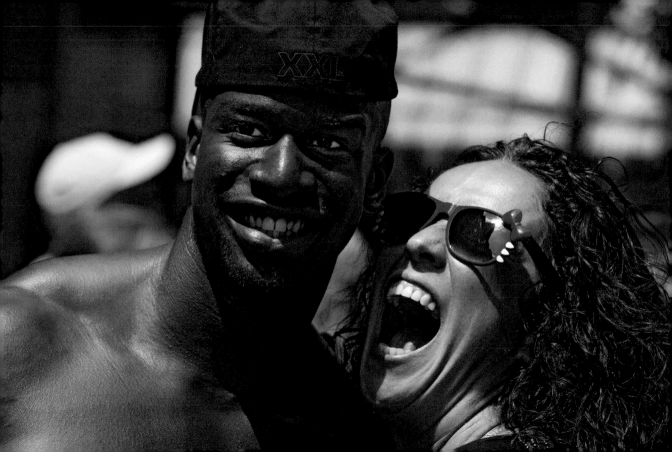

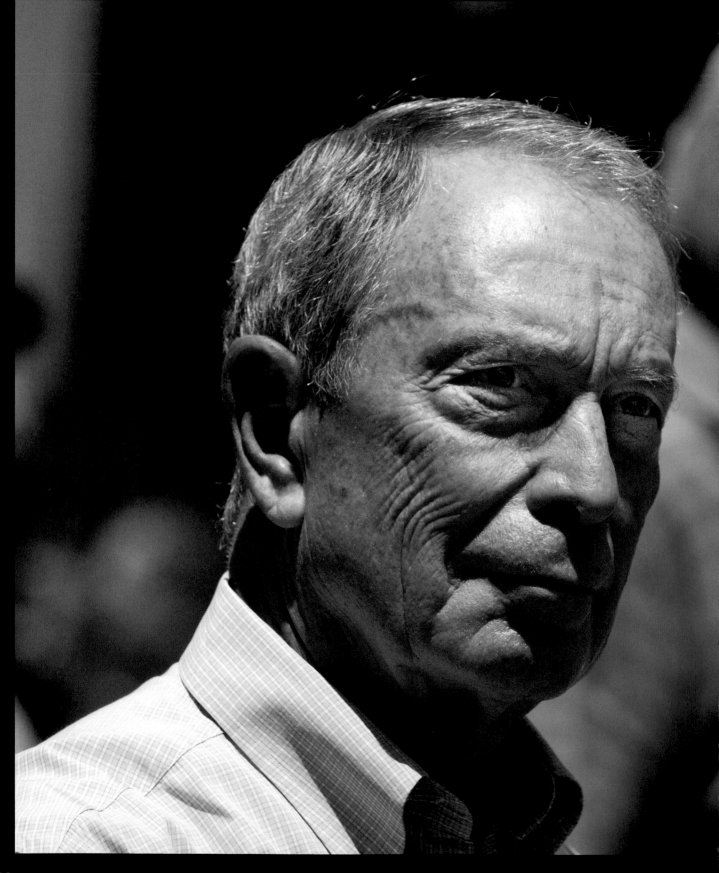

Marriage equality has made our city more open, inclusive, and free—and it has also helped to create jobs and support our economy. . . . New York has always been a great place to get married, and since the passage of the Marriage Equality Act, we're welcoming more and more couples, their families, and friends from around the country and the world.

—FORMER MAYOR MICHAEL BLOOMBERG

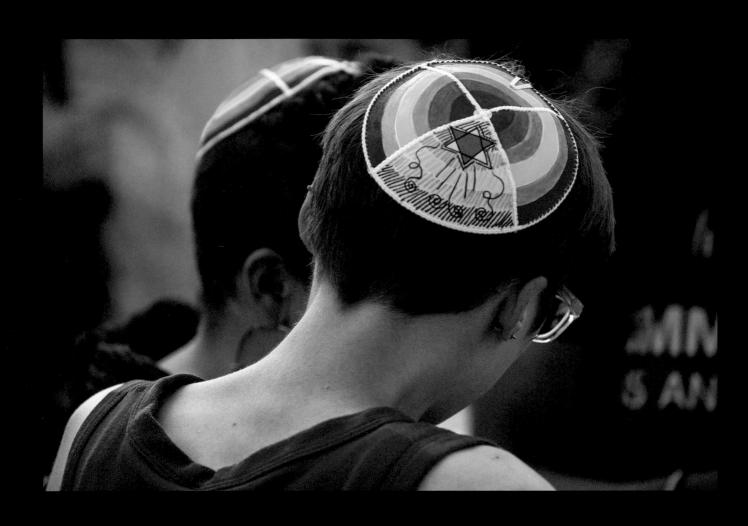

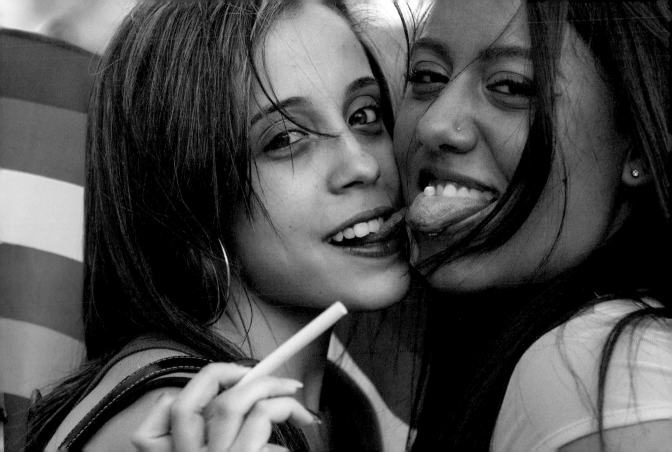

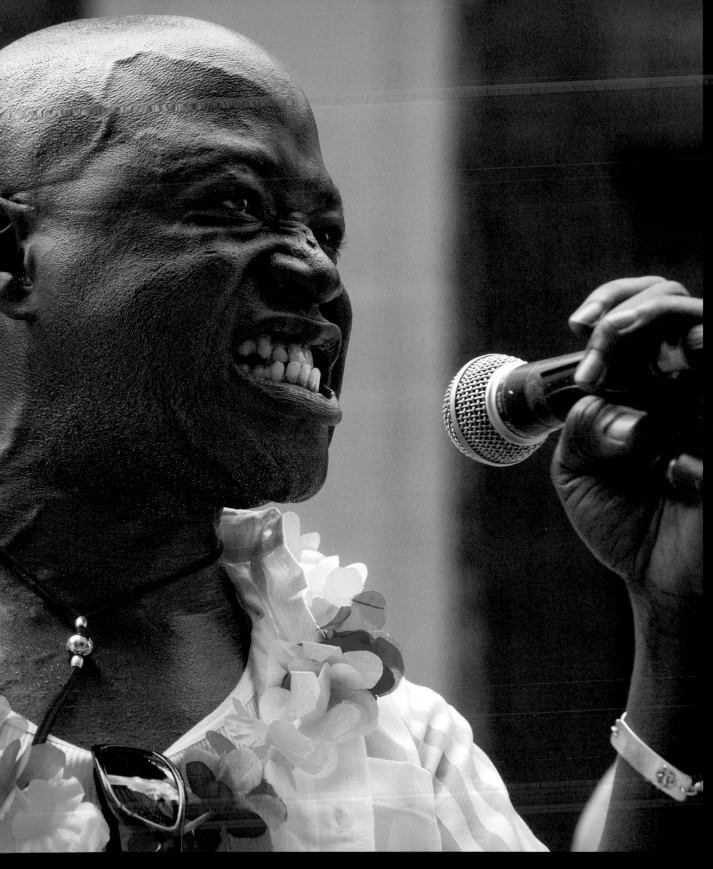

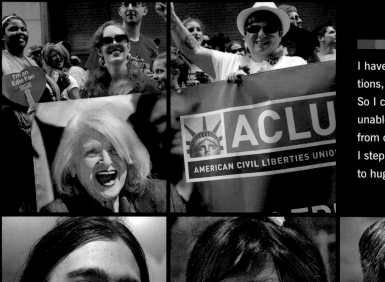

I have a huge love for the gay community in all its manifestations, so I love to be with them. It's getting more difficult for me. So I compromised for the first time this year. I had been ill and unable to walk in the heat, and I joyously accepted an invitation from our emcees, whose stand is next to the judge's stand. I stepped down from time to time for marchers who came up to hug me. —**EDITH WINDSOR**

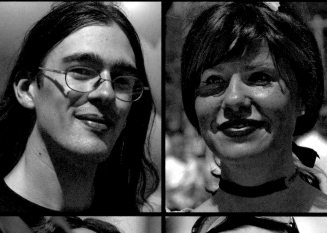

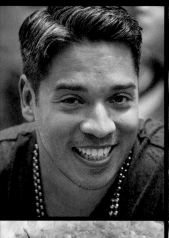

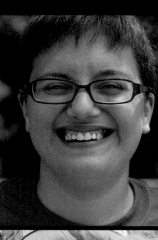

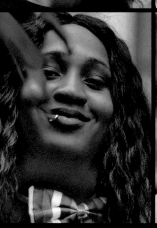

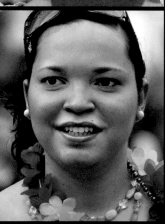

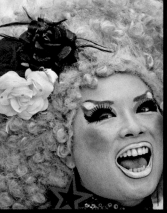

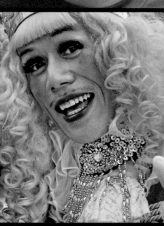

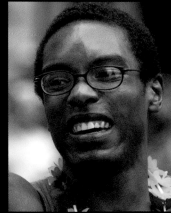

The first time I marched was with ACT UP in 1988. I marched again and again with the group in the next few years. For me it was one way to bring attention to the AIDS epidemic in the media. But more importantly, it was a way to activate, challenge, and demand action from those within the LGBT community who were either in denial or complacent. The march, for many of us who were AIDS activists at the time, was seen as too much celebration and not enough expression of anger at the government and media for willful negligence. Being part of it, marching in our own contingent, was opportunity to remind people that our enemies were doing all they could to keep us from attaining our rights—including allowing us to die. —**MICHELANGELO SIGNORILE**

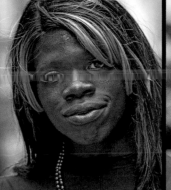

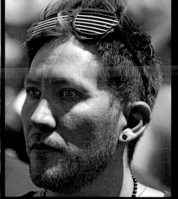

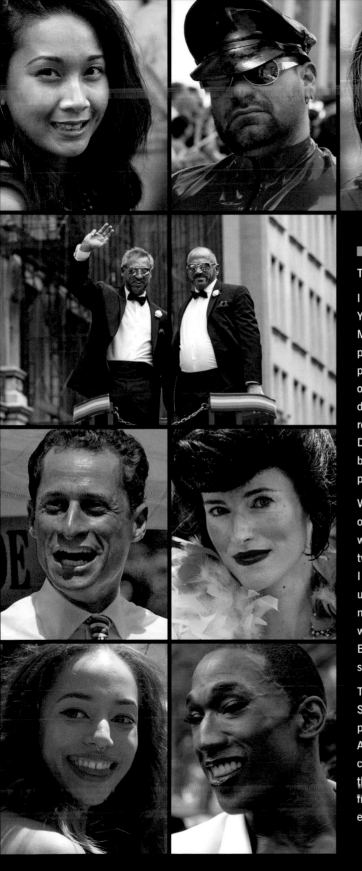

The First Caribbean Pride March

I was there when Caribbean Pride first marched in the New York City Pride Parade in 1998. Anyone who has seen a Pride March in North America or Europe knows that most groups project music. We arranged for a truck and a DJ who regularly played during Brooklyn's West Indian Day Parade. About thirty of us gathered very early in the morning to put our homemade decorations on the truck—we had almost every flag from the region, and a few signs. We gave explicit instructions to the DJ to include some Haitian *kompa* and Spanish salsa music in between soca, dancehall, and reggae—and told him he couldn't play any homophobic songs.

We also had a banner and a large rainbow flag on a pole. Early on, I commandeered the flag. In Trinidadian carnival, the "flag woman" traditionally leads the carnival band, dancing and twirling. I don't know how many people got the reference, but I had a blast! We were a bit nervous starting out, but many of us were friends, and it was hot, and there was great music, notwithstanding the DJ. (Either he ignored us or didn't know what we meant; after he started to play the infamous "Boom Bye-Bye," we had to station someone next to him to vet the songs.) So we danced and laughed our way through Manhattan.

That hot day there were three reactions to our little group. Some people smiled and waved, especially if Bob Marley was playing. Some stared confused at our colorful bodies and clothes. And some Caribbean people screamed in joyful recognition and climbed over the barricades to join us. By the time we reached the end of the march, we were several hundred strong, with new friends waving the flag, holding the banner, and dancing with each other and us. —**ROSAMOND S. KING**

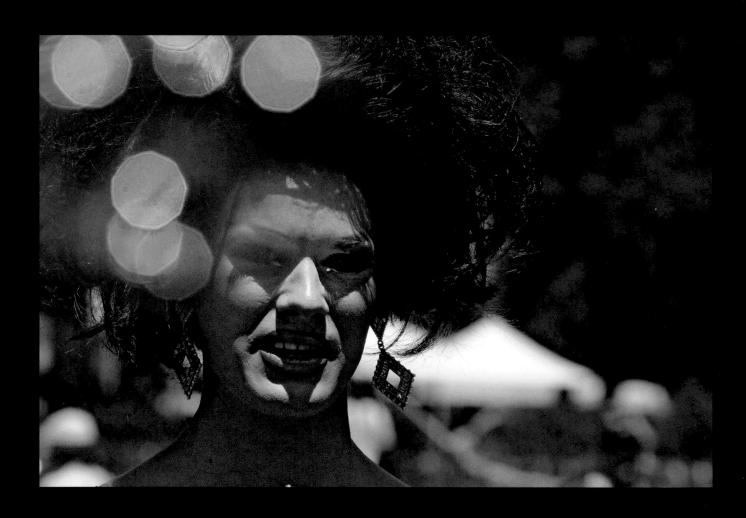

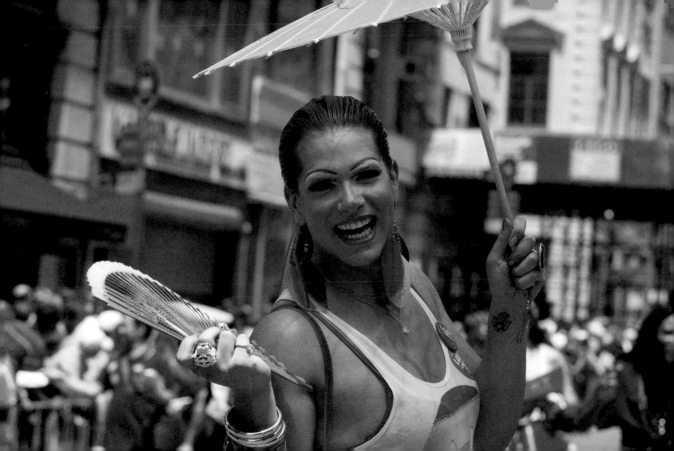

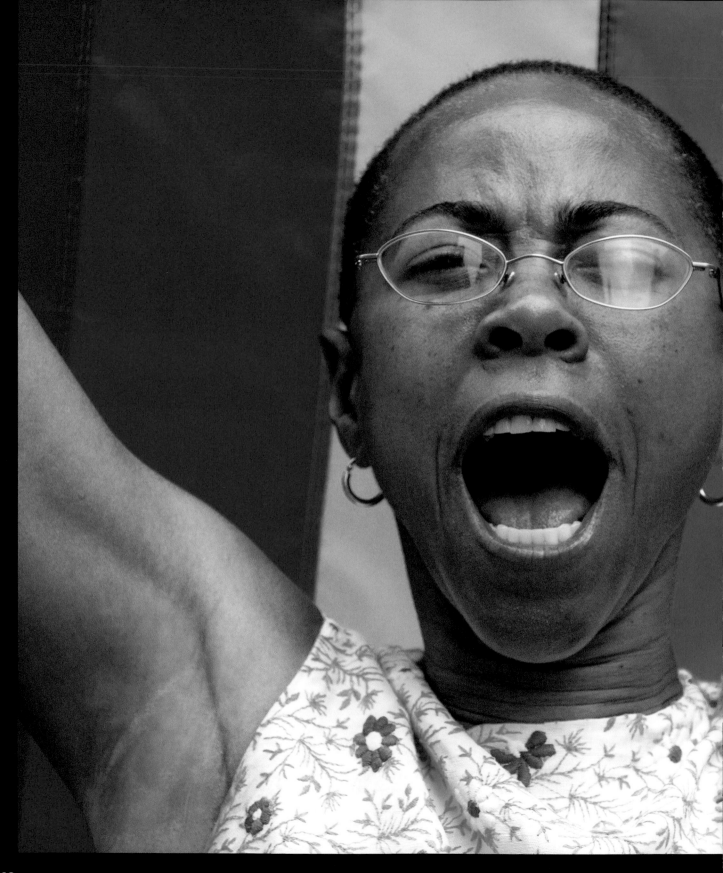

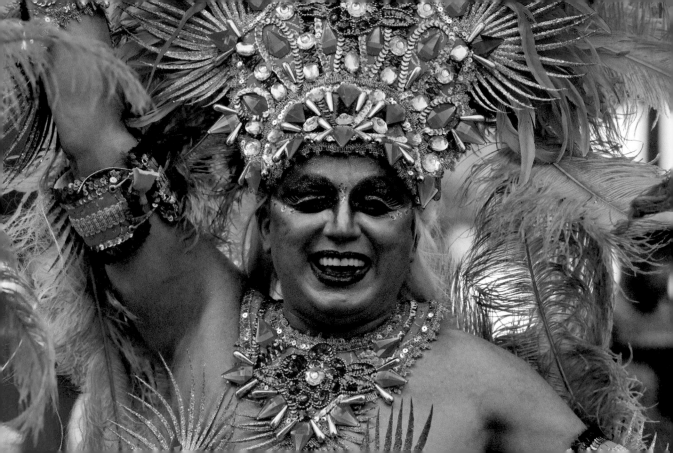

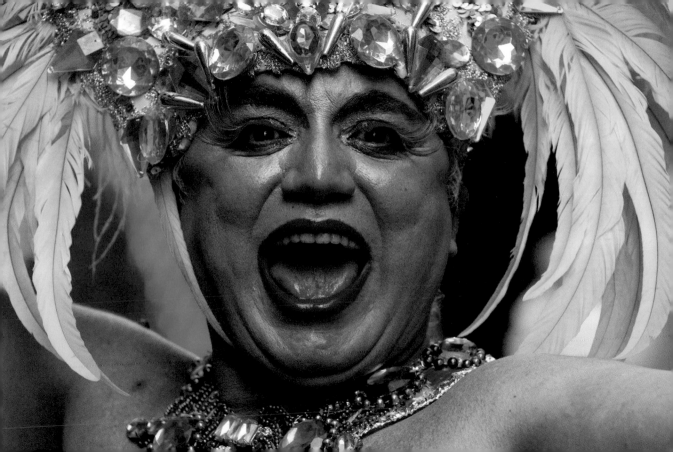

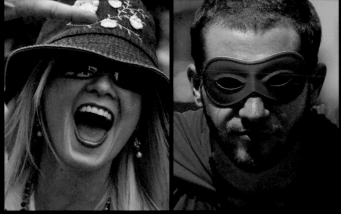

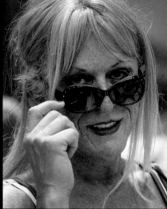

Four decades ago I attended my first Pride Parade in Los Angeles. There was a grand total of five thousand of us marching down Hollywood Boulevard, chatting away. We thought the crowd was huge and we couldn't believe so many of us turned out. These early marches were less celebratory and more like protests demanding equal rights.

There were several memorable Pride Marches for me, and they usually involved parades that took place after huge events in our history. The energy of the marchers after Anita Bryant surfaced in her anti-LGBT initiatives was incredible and so was the one the very next year when we were fighting Proposition Six (the Briggs Initiative). The size of the marches had suddenly doubled.

Marching in these parades was initially a scary experience, since I was terrified that someone I knew would see me. However, I figured I might as well be terrified in the streets instead of alone in my apartment. The parades gave me an extraordinary sense of belonging and introduced me to my new tribe and family.

My best Christopher Street West moment was when I was grand marshal in West Hollywood after the parade moved there. It was the final moment of no more hiding for me. Out and proud for all to see—and by that time the parade had grown to over four hundred thousand. —**DAVID MIXNER**

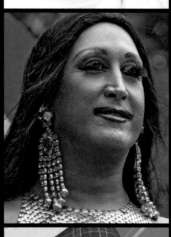

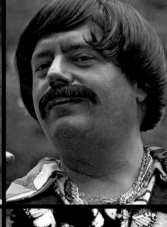

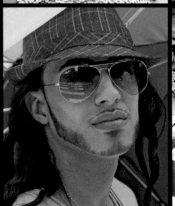

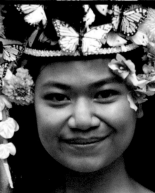

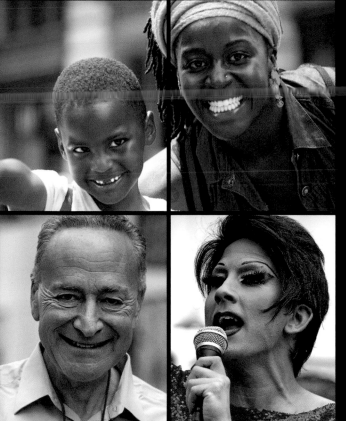
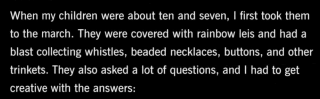

When my children were about ten and seven, I first took them to the march. They were covered with rainbow leis and had a blast collecting whistles, beaded necklaces, buttons, and other trinkets. They also asked a lot of questions, and I had to get creative with the answers:

"Those are lesbians who like to ride motorcycles, but we don't generally use the term 'dyke.'"

"Not 'real' bears. Some men like other men with a lot of facial and body hair."

"No, the mayor is not gay, but he is supportive."

"Catholics are not usually supportive of LGBT issues, but Dignity is a group of LGBT Catholics."

"People use condoms to prevent getting diseases and keep from getting pregnant. Put that down; you don't need it yet."

"Yes, they are very tall. It's better to say 'transgender' than 'man-lady.'"

"That's a club where men go to meet each other. I think the guys generally wear more clothes than that, but it's hot out here and they are dancing very hard."

"Wave at our bank teller. I think it's a sign that LGBT issues have gained wider acceptance, but I'm not really into the whole corporate thing." —**LINDA VILLAROSA**

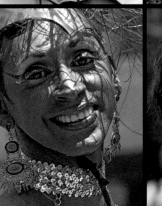
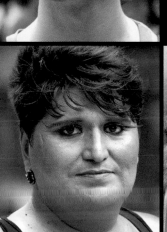
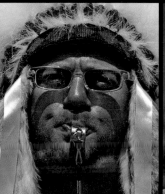
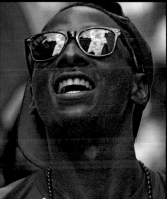

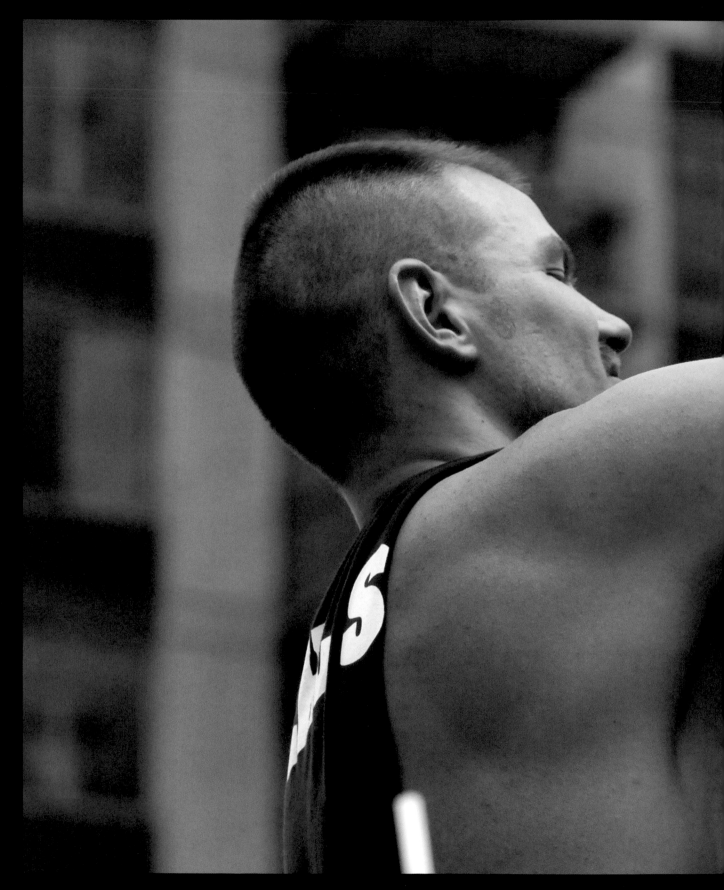

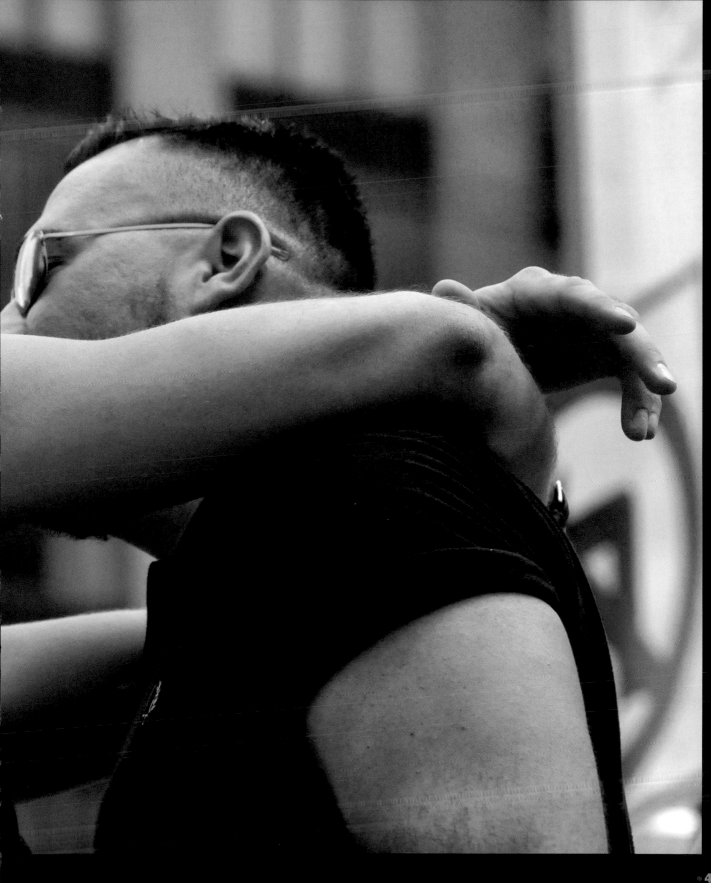

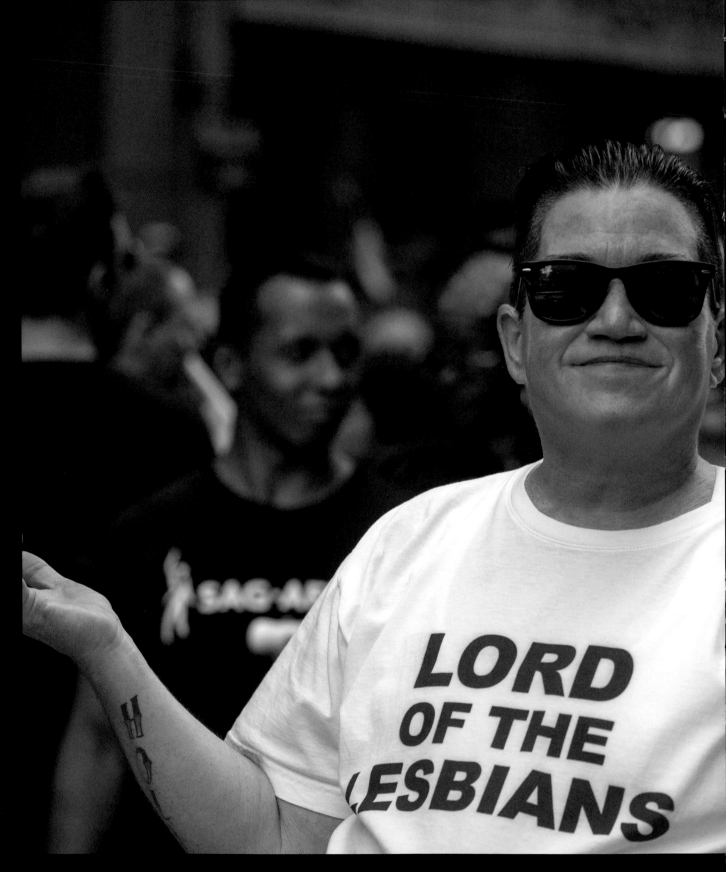

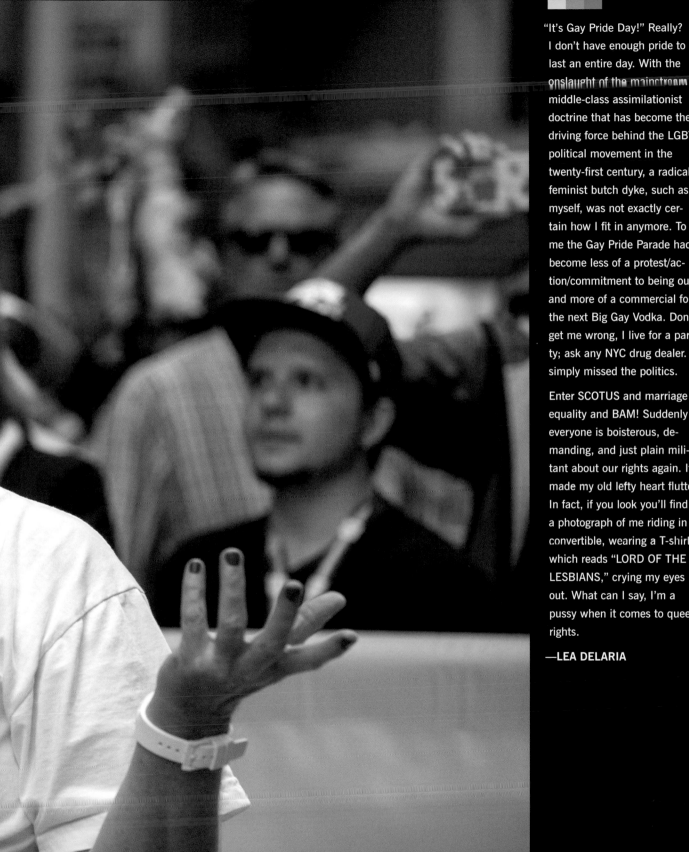

"It's Gay Pride Day!" Really? I don't have enough pride to last an entire day. With the onslaught of the mainstream middle-class assimilationist doctrine that has become the driving force behind the LGBT political movement in the twenty-first century, a radical feminist butch dyke, such as myself, was not exactly certain how I fit in anymore. To me the Gay Pride Parade had become less of a protest/action/commitment to being out, and more of a commercial for the next Big Gay Vodka. Don't get me wrong, I live for a party; ask any NYC drug dealer. I simply missed the politics.

Enter SCOTUS and marriage equality and BAM! Suddenly everyone is boisterous, demanding, and just plain militant about our rights again. It made my old lefty heart flutter. In fact, if you look you'll find a photograph of me riding in a convertible, wearing a T-shirt which reads "LORD OF THE LESBIANS," crying my eyes out. What can I say, I'm a pussy when it comes to queer rights.

—LEA DELARIA

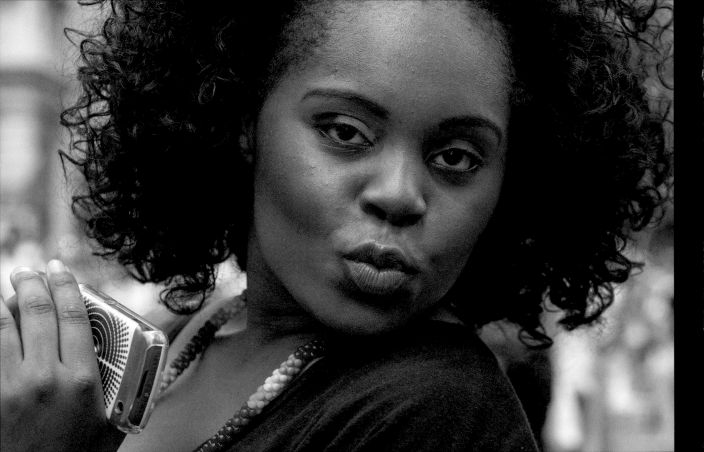

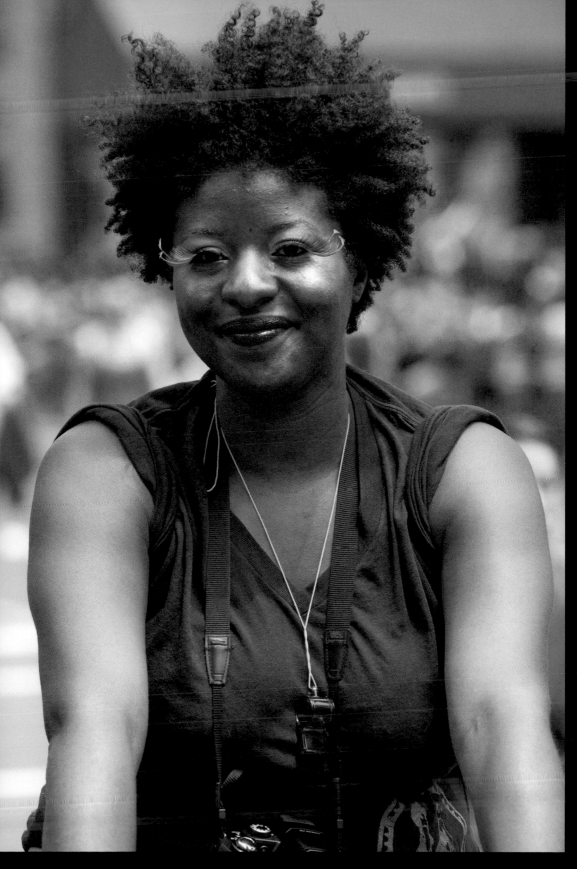

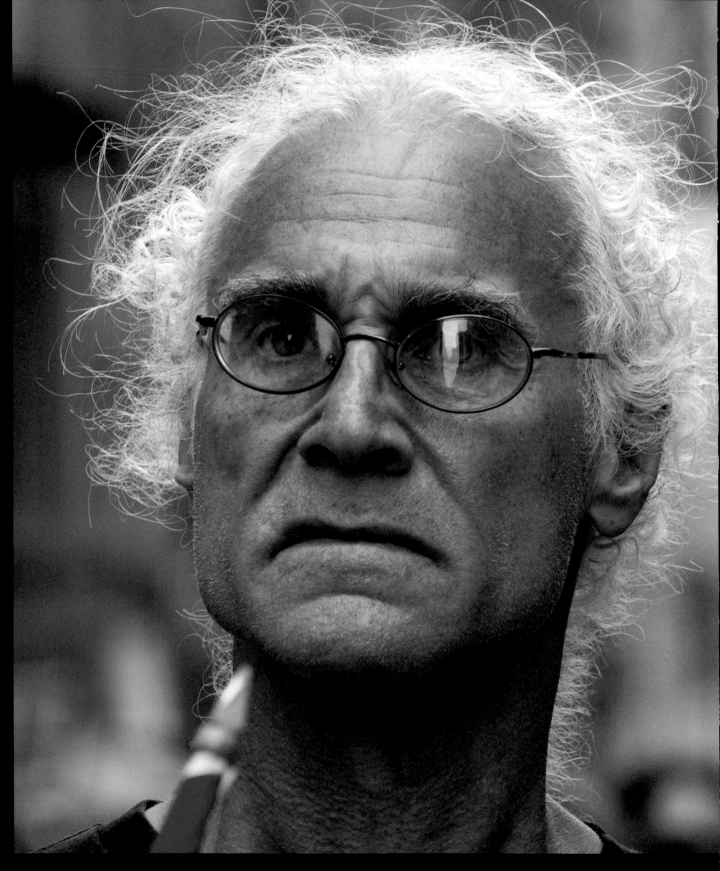

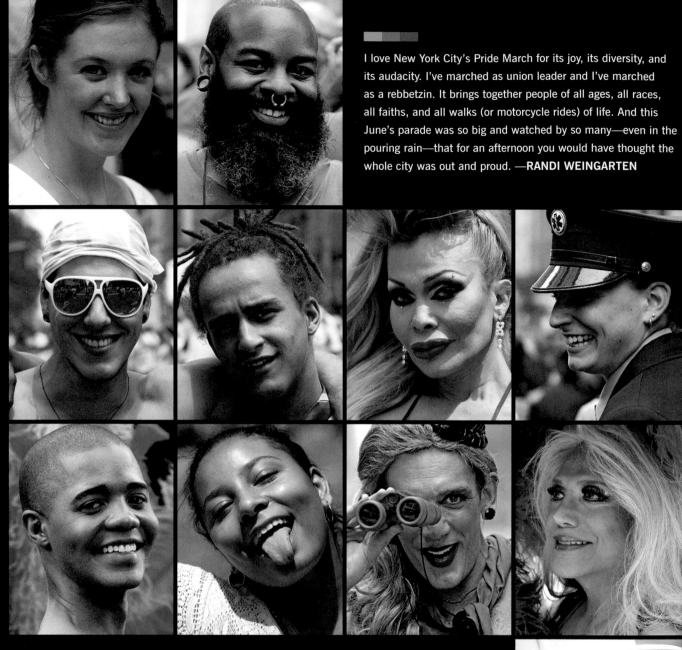

I love New York City's Pride March for its joy, its diversity, and its audacity. I've marched as union leader and I've marched as a rebbetzin. It brings together people of all ages, all races, all faiths, and all walks (or motorcycle rides) of life. And this June's parade was so big and watched by so many—even in the pouring rain—that for an afternoon you would have thought the whole city was out and proud. —**RANDI WEINGARTEN**

Telling your parents you were gay in 1981 also meant telling them you would never marry, never have children, and never be a Marine. Roughly three decades later—a good chunk of a life, but a small window of time for the kind of social change LGBT activists were demanding—my husband Terry and I were honored to be grand marshals at the New York LGBTQ Pride March. The invitation was in recognition of the It Gets Better Project, which we launched, but hundreds of thousands of LGBT people around the world helped to create. When Terry and I rode up Fifth Avenue in that car in June 2011, surrounded by tens of thousands of out-and-proud queers of all ages, races, genders, ambitions, and aspirations, we were doing it for the struggling queer kids out there. We were there to say that not only would it get better—so long as we were willing to work and fight for it—it would also get WAY more fun. —**DAN SAVAGE**

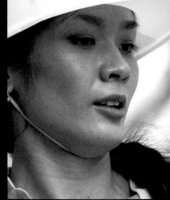

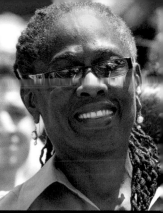

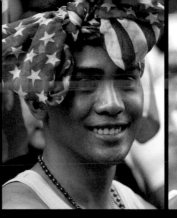

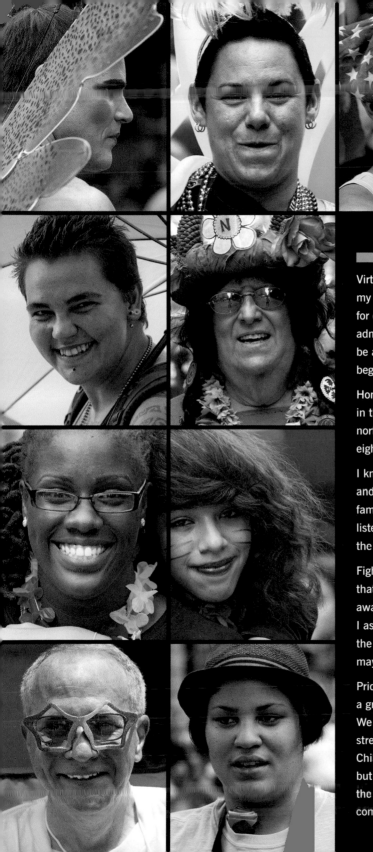

Virtual Pride 1974: New York City Pride was a key event in my coming out story. In 1973, I headed to upstate New York for college. During the course of my freshman year, I would admit that I'd fallen in love with my female best friend, would be awakened politically by the feminist movement, and would begin to tell a few friends that I was a lesbian.

Home for the summer in June 1974, I was the dutiful daughter in the car with my parents on the way to visit relatives who lived north of the city. It was the same day as the Pride March. I was eighteen years old.

I knew the march was happening but I wasn't out to my parents and couldn't imagine how I'd be able to get out of this little family visit. So I brought a transistor radio and earphones and listened to live coverage of the Pride March in the backseat of the car.

Fighting for Pride 1981: I was a newly minted attorney the year that the mayor of Boston decided to reroute the Pride March away from its historic origins in the Beacon Hill neighborhood. I assisted the more experienced attorneys who went into court the Friday before Pride and obtained an injunction against the mayor's actions. The parade was restored to its traditional route.

Pride with Babies 1987: We had no idea how we'd be received: a group of lesbian moms pushing our infant children in strollers. We waited in the heat for the march to kick off, and down the street we went behind a banner that said "Lesbians Choosing Children Network." It might seem like business as usual today, but back then it was something pretty new. The cheers from the crowd on both sides of the street were deafening. Our community approved. It was a big relief. —CINDY RIZZO

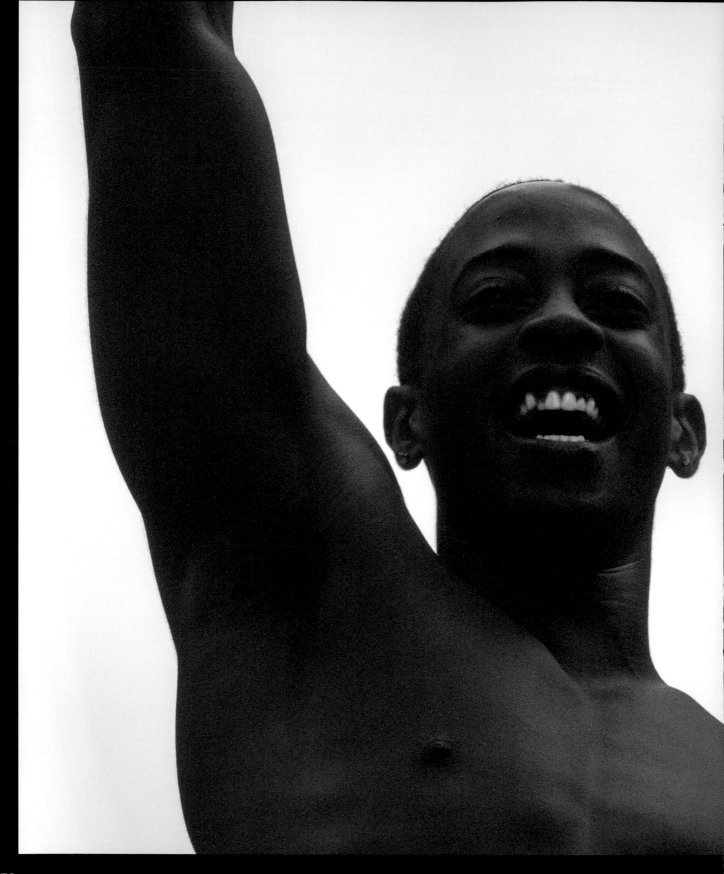

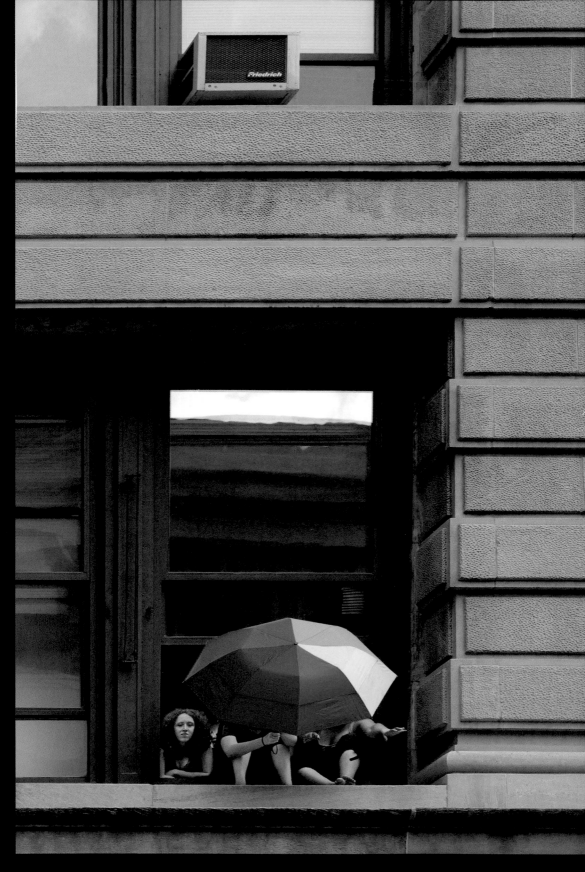

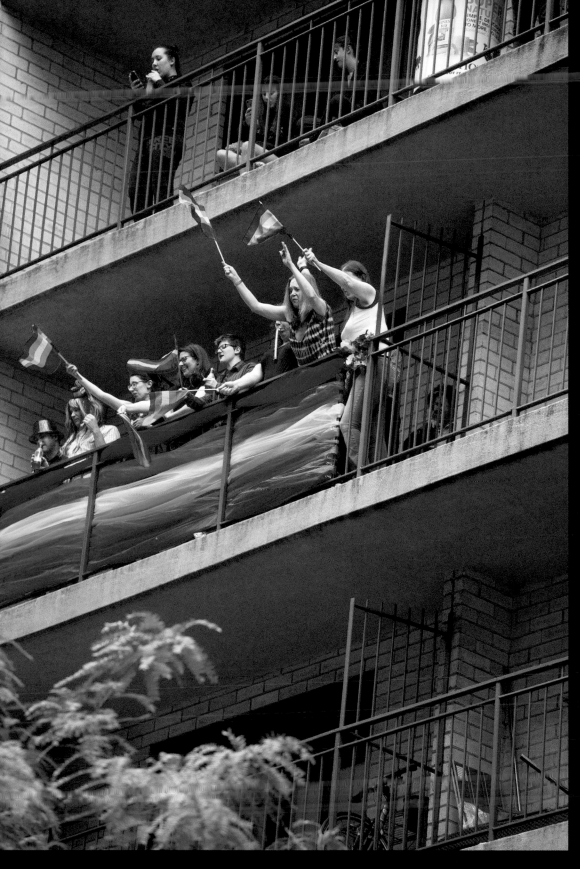

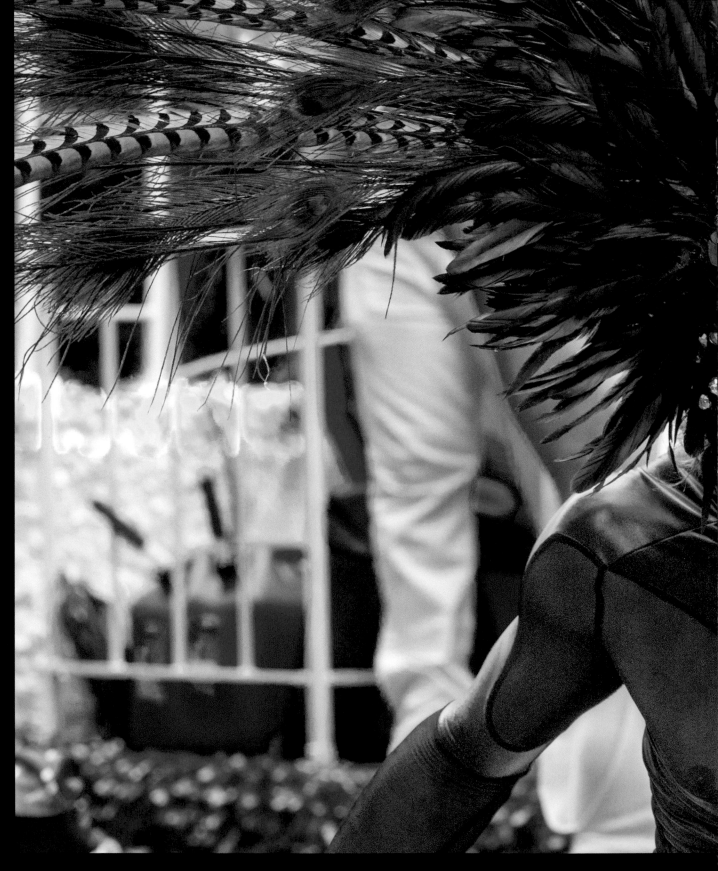

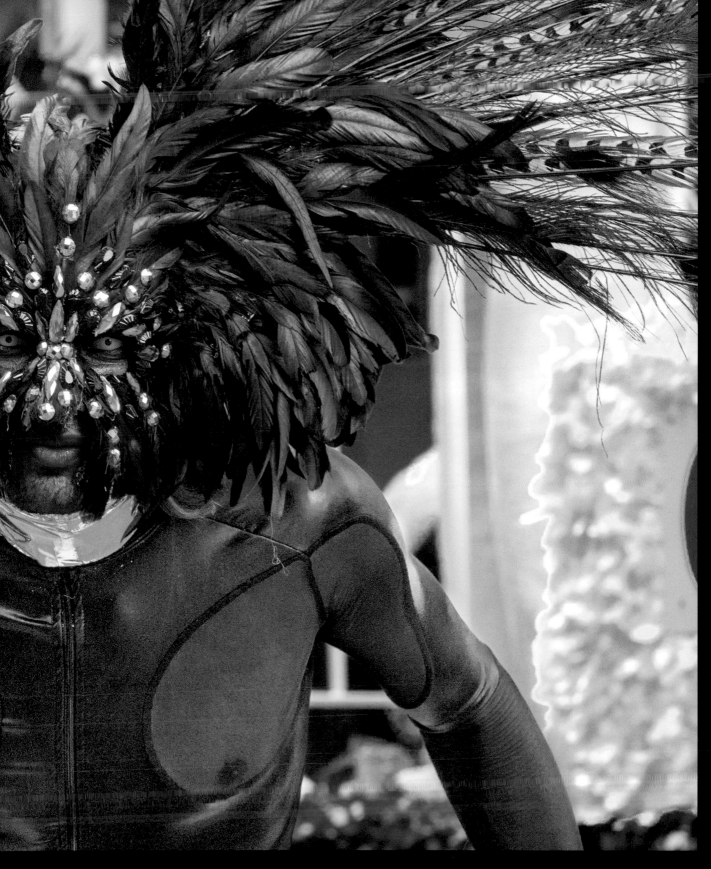

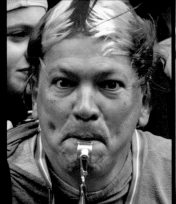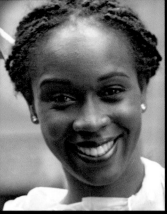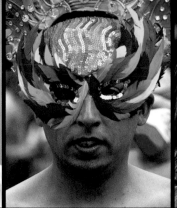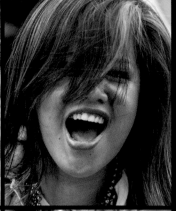

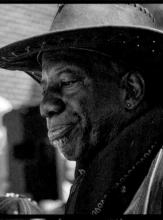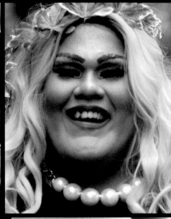

I first marched, in 1973, as an act of political assertion. We were marching in defiance of the pressures to remain invisible, of the fears we all carried with us about coming out into the open. That first march was so exhilarating that I knew I would keep doing it. I kept marching for the sense of collective power and pride that the march provided. In more recent years, my marching has been in Chicago, where I've lived since 1999. Now I march because of the thrill of having hundreds of thousands of onlookers cheering and applauding me and all the other marchers! Trust me, that wasn't the case in the early and mid-1970s.

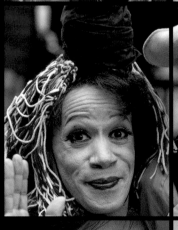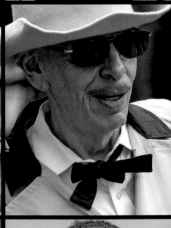

In 1973, the year of my first march, the route went from Columbus Circle, down Broadway, and then south on Seventh Avenue to the Village. In those days, there were no crowds of onlookers waiting for the march. I loved seeing the shock on the faces of the pedestrians in the theater district as they saw thousands of screaming homosexuals shouting "Come Out! Come Out!" and "Gay Pride, Gay Power!" It was unforgettable. It made me wish we could do it every day.

My last NYC Pride March was 1983. Two days later, I left New York, where I was born, raised, educated, and lived for my first thirty-five years, in order to take a college teaching job as an "out" gay historian, something very unusual in 1983. The Pride March, and the going-away party afterward that Jonathan Ned Katz hosted for me in his Greenwich Village home, were the best farewells I could have ever imagined. —**JOHN D'EMILIO**

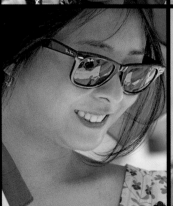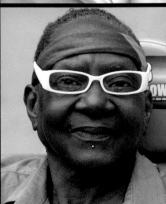

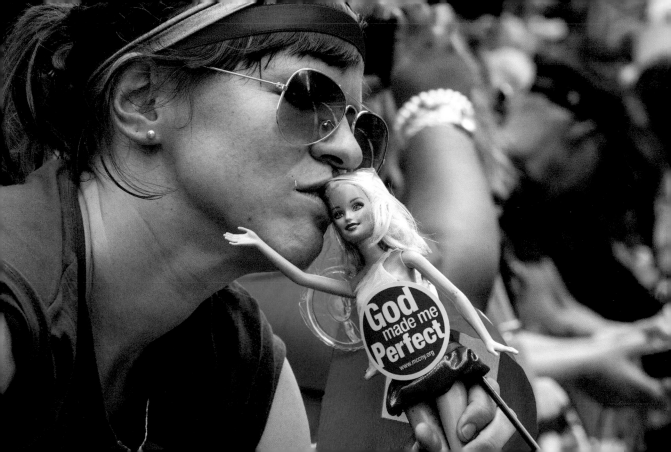

The Pride Parade channels a unique exhilaration that's fundamental to LGBTQ identity and can only be expressed in the streets where gay liberation started. We bring our queer energy into synagogue services year round. On Pride we feel fabulous and blessed without announcing what page we're on in the prayer book. —**RABBI SHARON KLEINBAUM**

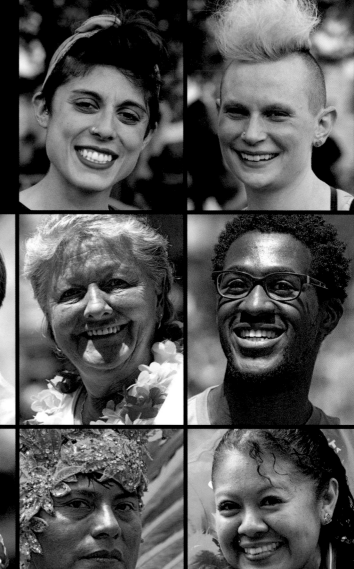

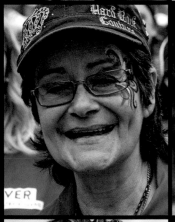

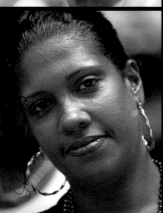

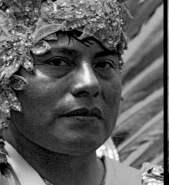

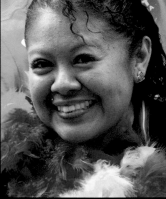

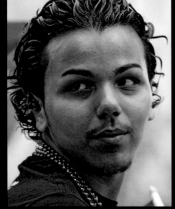

I remember my first march, I think it was 1976 or '77. I was still in college and pretty isolated. I took the train into New York from Long Island and the subway to Sheridan Square. In those days the march began on Christopher Street and we walked up Fifth Avenue to the rally in Central Park.

I didn't know anyone and just jumped in. For a long time I marched with a group all dressed in black who I think turned out to be the Gay Anarchists. It was sunny and hot. I was a little freaked out by it all, but in a good way.

We got to Central Park and I ran into a couple of lesbians from school and watched the rally. Then Lou Reed and Patti Smith came out. He sang "Walk on the Wild Side" and she sang "Gloria." Things really began to change for me around then. I'll never forget that day. —**RICHARD D. BURNS**

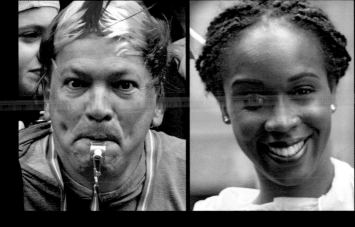

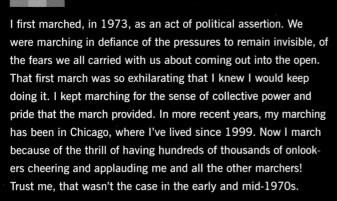

I first marched, in 1973, as an act of political assertion. We were marching in defiance of the pressures to remain invisible, of the fears we all carried with us about coming out into the open. That first march was so exhilarating that I knew I would keep doing it. I kept marching for the sense of collective power and pride that the march provided. In more recent years, my marching has been in Chicago, where I've lived since 1999. Now I march because of the thrill of having hundreds of thousands of onlookers cheering and applauding me and all the other marchers! Trust me, that wasn't the case in the early and mid-1970s.

In 1973, the year of my first march, the route went from Columbus Circle, down Broadway, and then south on Seventh Avenue to the Village. In those days, there were no crowds of onlookers waiting for the march. I loved seeing the shock on the faces of the pedestrians in the theater district as they saw thousands of screaming homosexuals shouting "Come Out! Come Out!" and "Gay Pride, Gay Power!" It was unforgettable. It made me wish we could do it every day.

My last NYC Pride March was 1983. Two days later, I left New York, where I was born, raised, educated, and lived for my first thirty-five years, in order to take a college teaching job as an "out" gay historian, something very unusual in 1983. The Pride March, and the going-away party afterward that Jonathan Ned Katz hosted for me in his Greenwich Village home, were the best farewells I could have ever imagined. —JOHN D'EMILIO

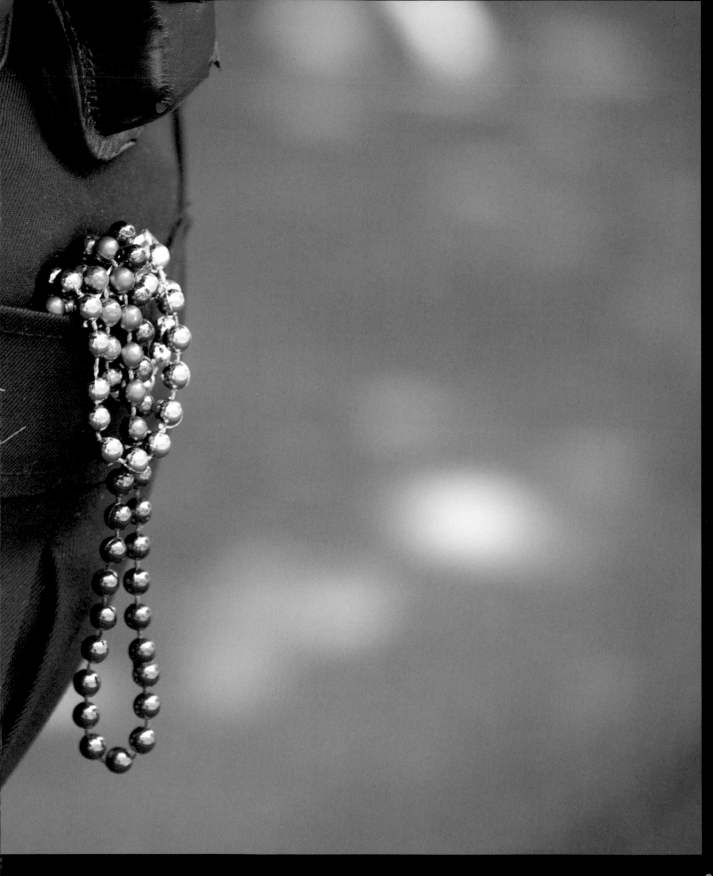

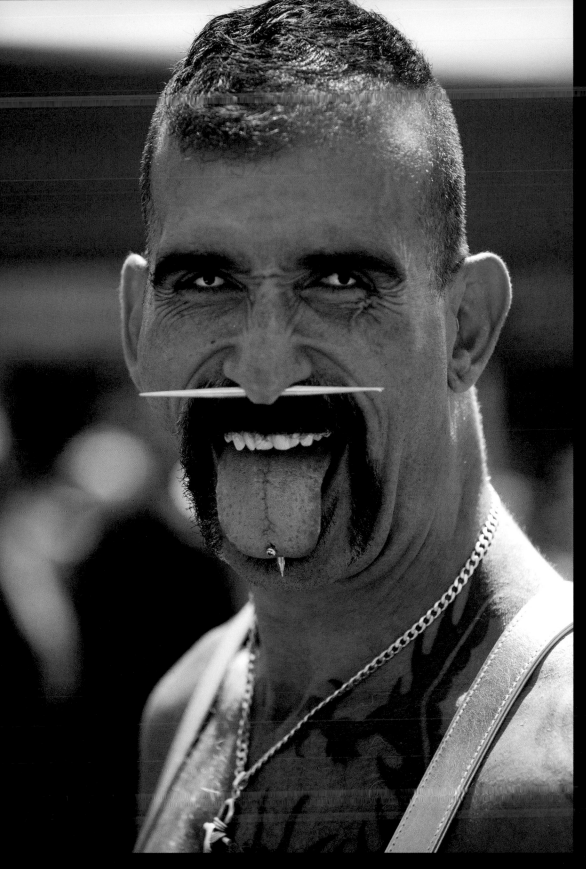

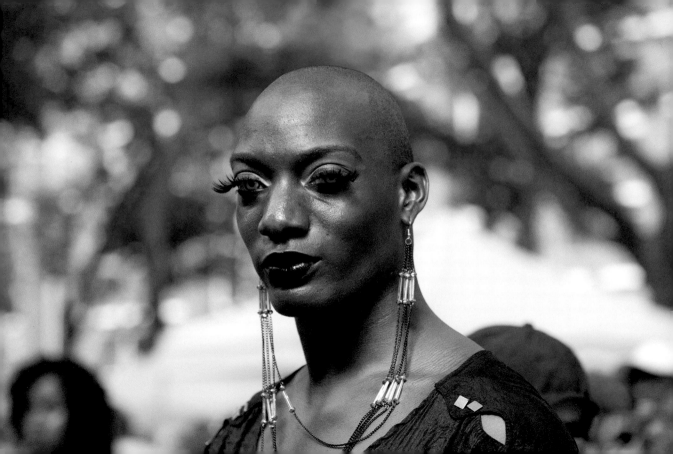

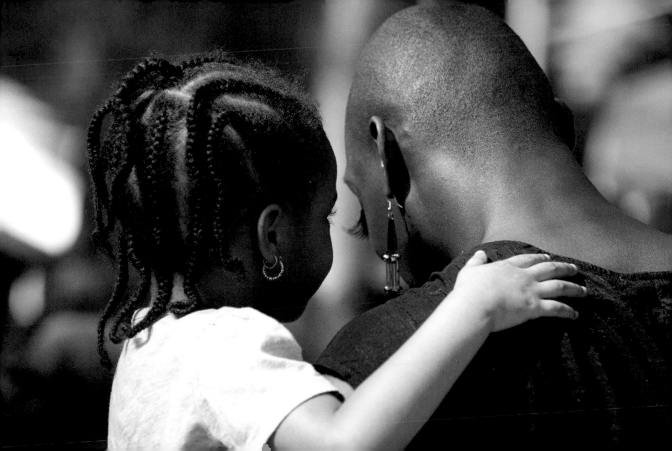

Pride 2015 felt like all the meanings of Pride smashed together. I was marching with people who had not yet been born the last time I'd thought of Pride as political. My thirteen-year-old daughter danced in front of the Russian-speaking contingent the entire way; a year and a half earlier, we had had to leave Russia in a hurry after the government there started talking about removing kids from queer families. Activists from Moscow and Kyiv marched side by side at the front of the group, making New York Pride one of the few places in the world where Russians and Ukrainians could engage in activism —or celebration—together. A month earlier, Moscow Pride had, as usual, ended in arrests for its would-be participants. One of them, twenty-five-year-old journalist Yelena Kostyuchenko, was now marching in New York, wearing a little black dress with feathers and reveling in the luxury of not having to don combat wear. Next to her was thirty-one-year-old Taras Karasichuk, one of the organizers of Kyiv Pride, which had been attacked by right-wing thugs, injuring a dozen participants and as many police. I had been with Karasichuk in Kyiv, but now I felt self-conscious about the frivolous and blatantly commercial ways of New York Pride. "I think people deserve a celebration every once in a while," he said. "If, say, Zara called me next year and asked me to wear one of their dresses to Moscow Pride," Kostyuchenko added, "I think that would be a real step forward."

—MASHA GESSEN

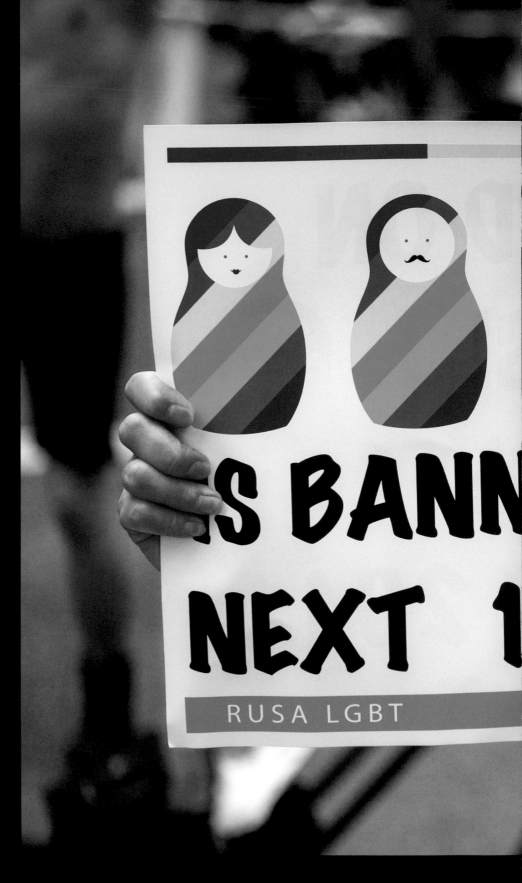

MOSCOW
GAY PRIDE
ED FOR THE
00 YEARS!

rusalgbt.com

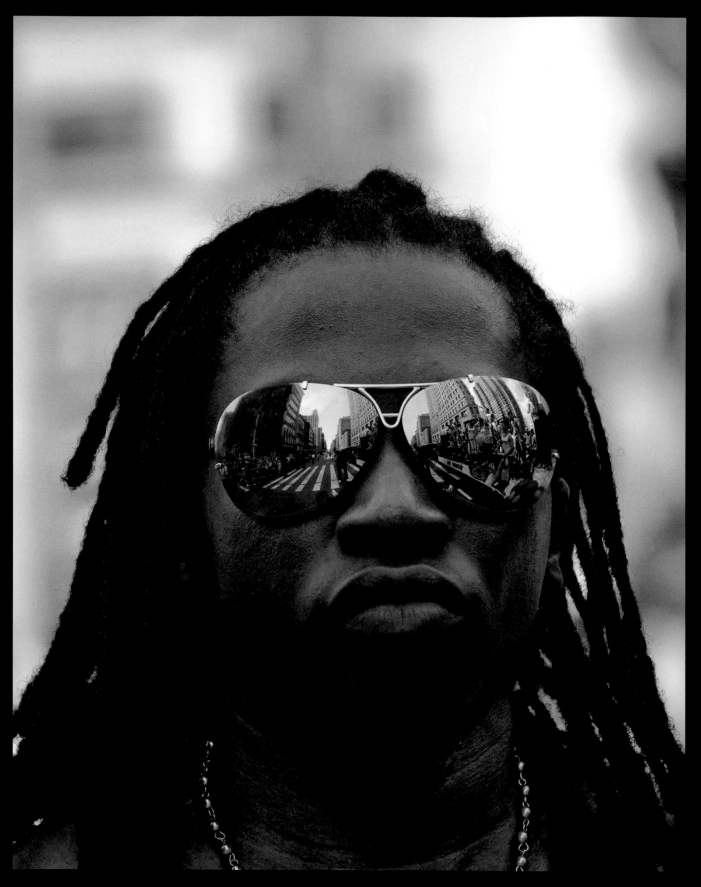

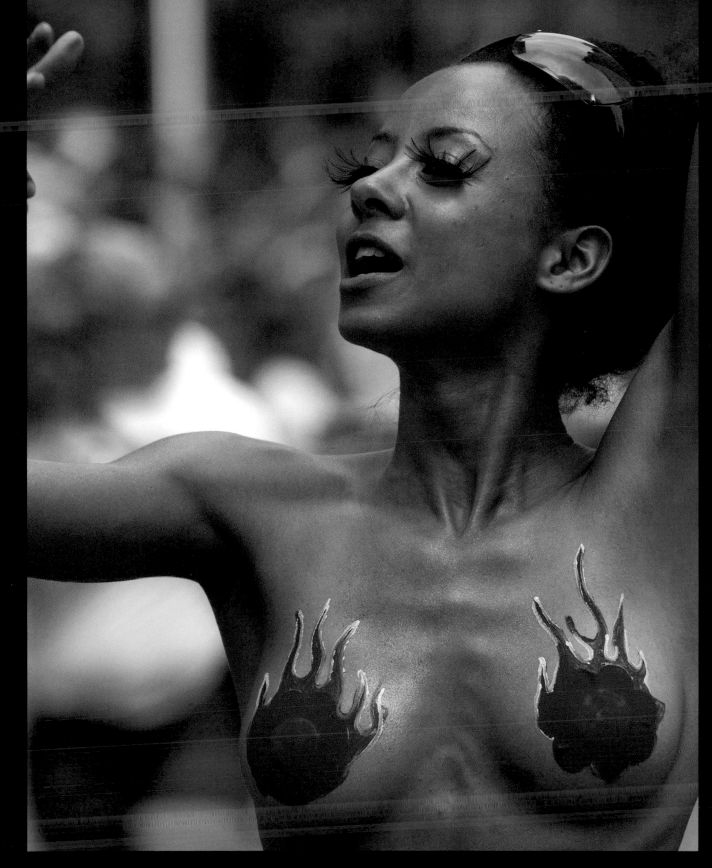

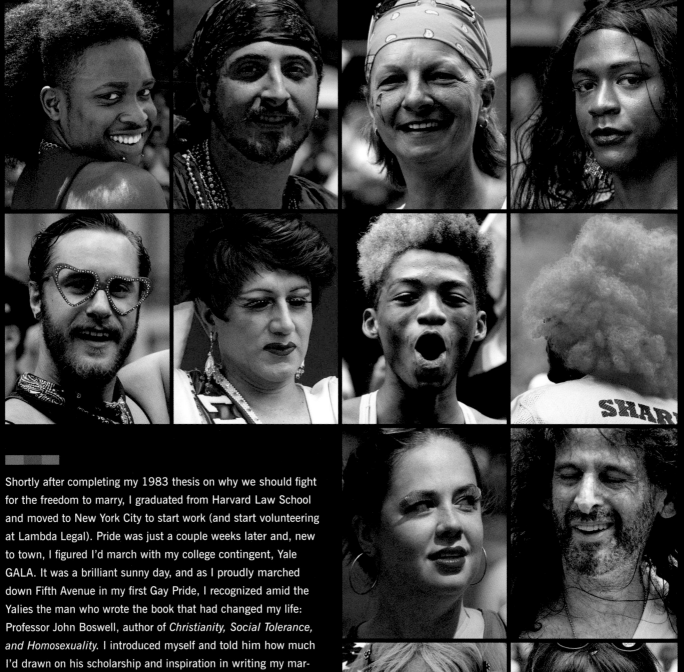

Shortly after completing my 1983 thesis on why we should fight for the freedom to marry, I graduated from Harvard Law School and moved to New York City to start work (and start volunteering at Lambda Legal). Pride was just a couple weeks later and, new to town, I figured I'd march with my college contingent, Yale GALA. It was a brilliant sunny day, and as I proudly marched down Fifth Avenue in my first Gay Pride, I recognized amid the Yalies the man who wrote the book that had changed my life: Professor John Boswell, author of *Christianity, Social Tolerance, and Homosexuality.* I introduced myself and told him how much I'd drawn on his scholarship and inspiration in writing my marriage paper. He was as excited as I was, and we plunged into a discussion of his research into same-sex marriages throughout history and my vision of a campaign to claim the vocabulary of marriage and thereby change non-gay people's understanding of who we are along with our place in society and the law. We talked all the way down the route, cheered by more gay people than I'd ever seen, and I felt radiant and part of a movement; in those dark days of discrimination and death, I saw the sunshine and what became my life's path opening before me.

—EVAN WOLFSON

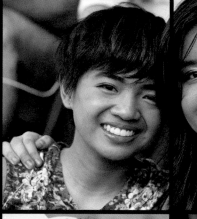

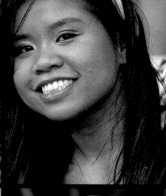

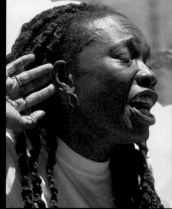

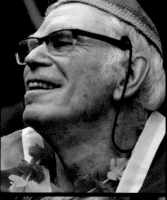

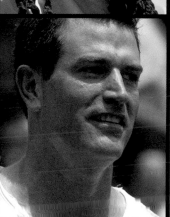

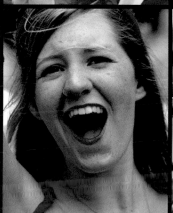

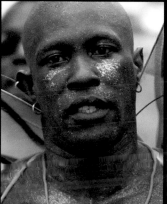

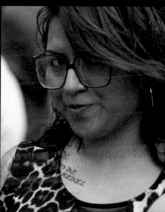

I march to be seen and heard, especially by the people in the crowd who may not be able to be fully out. I want them to see the march, from wherever they may be, and know that they are not alone. I march to stand with my community, to smile, to support one another, and to celebrate all of our beautiful and vibrant differences.

For the last six years, I have marched with the LGBT Community Center in New York City. Marching with an LGBT center is the very best way to do it. Everyone is welcome, and you march with youth, elders, couples, families, trans folk, leather folk, etc. I personally march for justice—justice for all in our community, especially those who are still marginalized, stigmatized, and brutalized. The fight for full LGBT equality is not over.

I love witnessing people's first marches. We usually have a large contingent of LGBT immigrants, many of whom are publicly identifying as LGBT and marching for the very first time. To see the look on their faces when they are cheered on by what seems like all of New York City is simply priceless. To see a young person strut their stuff down Fifth Avenue, out for the very first time, marching with their peers, is joyful beyond imagination. Last year two friends of mine marched with their newly adopted baby, and it was their first public appearance as a family. They thought they could never have kids, and they wanted him to experience the embrace of the LGBT community from his very first days.

—GLENNDA TESTONE

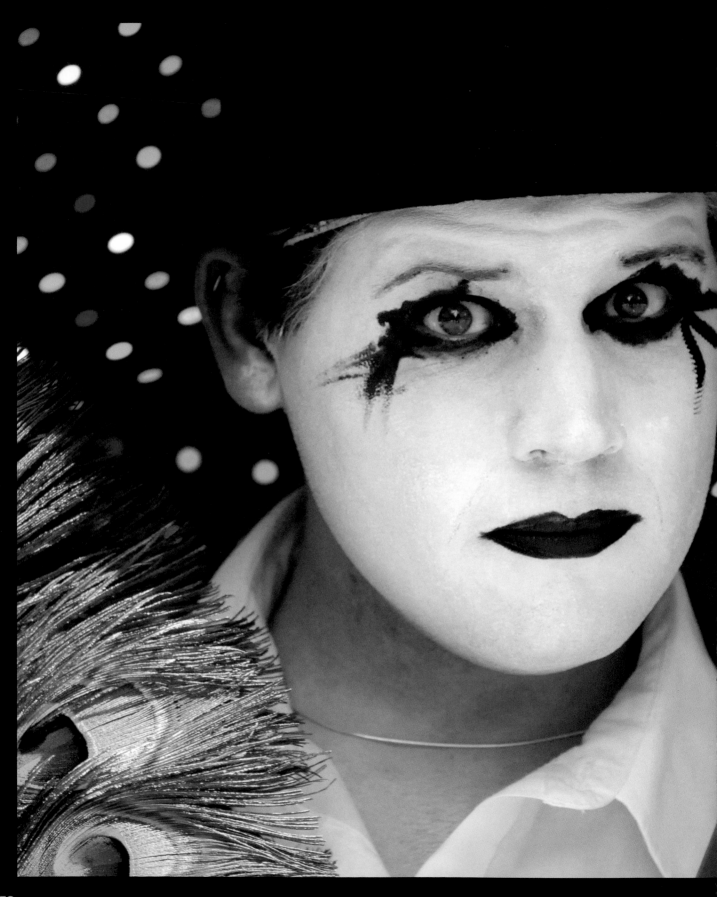

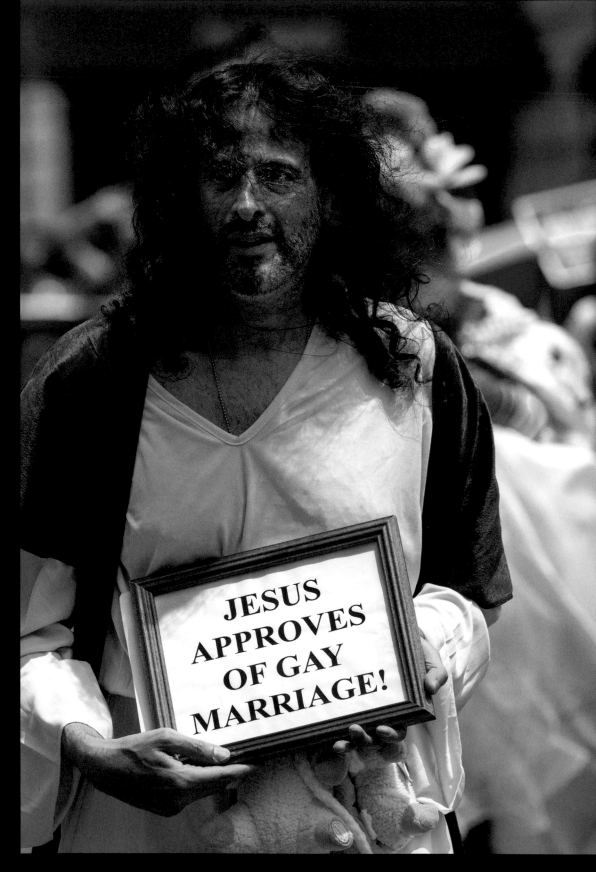

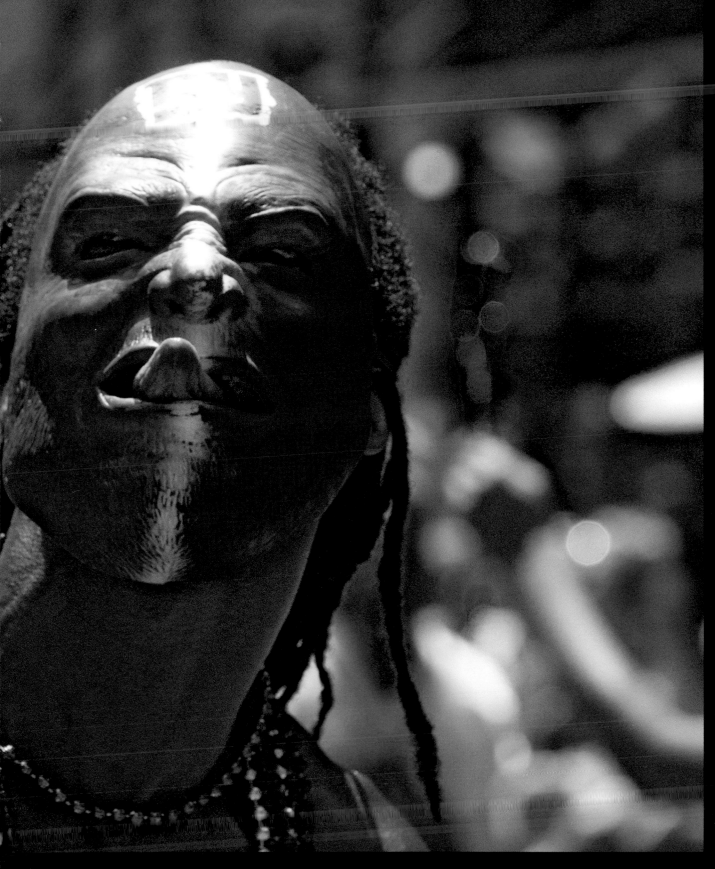

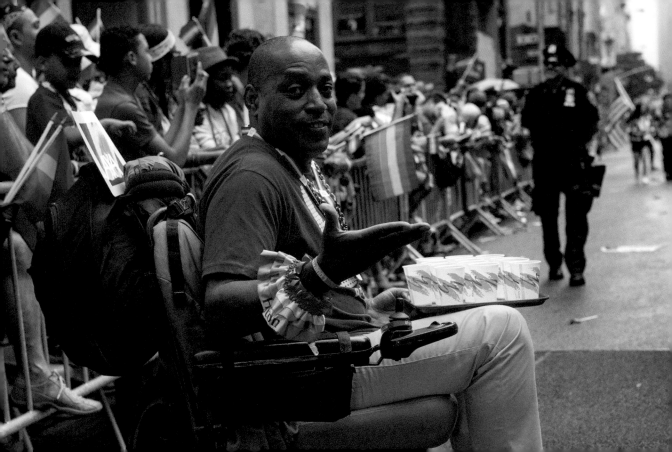

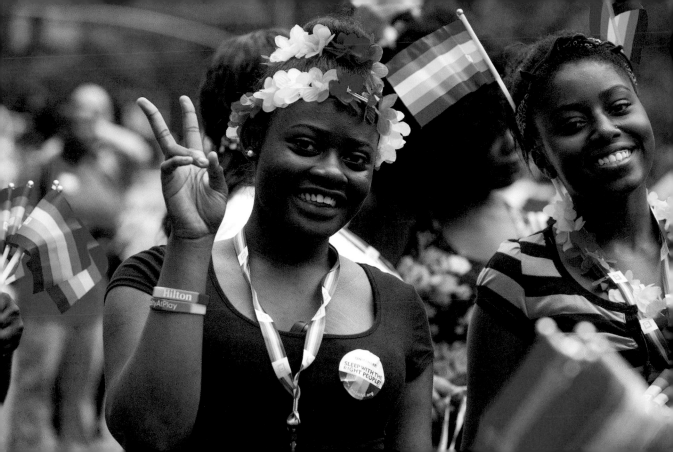

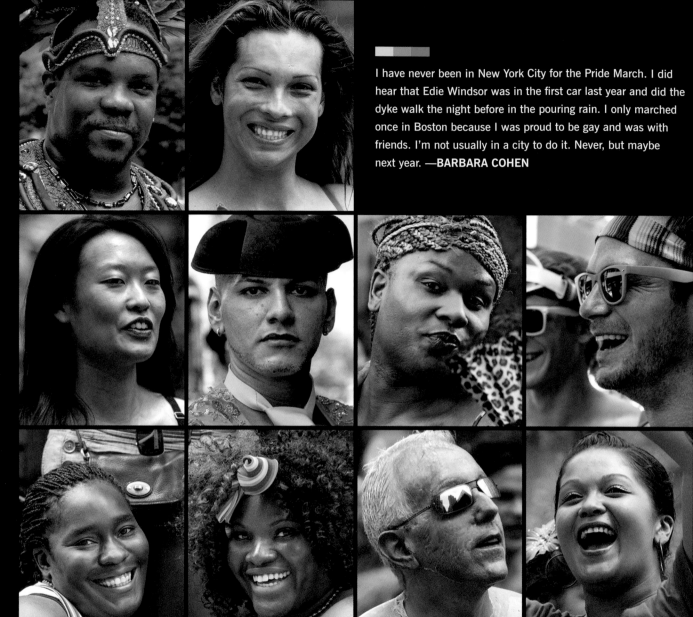

I have never been in New York City for the Pride March. I did hear that Edie Windsor was in the first car last year and did the dyke walk the night before in the pouring rain. I only marched once in Boston because I was proud to be gay and was with friends. I'm not usually in a city to do it. Never, but maybe next year. —BARBARA COHEN

In the early days of the LGBT movement the annual Pride March was just that: a march! Not a parade, not an occasion for corporate advertising, and not only a celebration of our community but also a recommitment to our struggles. The New York City march used to begin in the West Village and march uptown, ending in Central Park. But at some point, some of the queer businesspeople downtown (and maybe some non-queer folks as well) realized that if the march ended up in their neighborhood they could probably make a lot of money from this annual event. And so the annual march—where we proudly and with great joy affirmed our values and raised our diverse voices in our unified demand for justice—started to change. I will always cherish the memories of those early, vibrant, bold, and creative marches. —LESLIE CAGAN

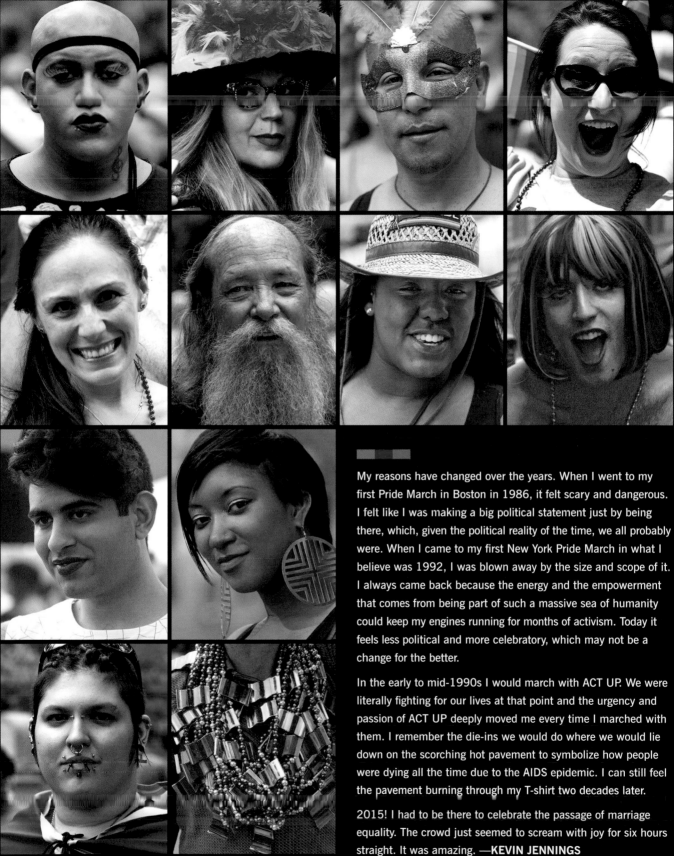

My reasons have changed over the years. When I went to my first Pride March in Boston in 1986, it felt scary and dangerous. I felt like I was making a big political statement just by being there, which, given the political reality of the time, we all probably were. When I came to my first New York Pride March in what I believe was 1992, I was blown away by the size and scope of it. I always came back because the energy and the empowerment that comes from being part of such a massive sea of humanity could keep my engines running for months of activism. Today it feels less political and more celebratory, which may not be a change for the better.

In the early to mid-1990s I would march with ACT UP. We were literally fighting for our lives at that point and the urgency and passion of ACT UP deeply moved me every time I marched with them. I remember the die-ins we would do where we would lie down on the scorching hot pavement to symbolize how people were dying all the time due to the AIDS epidemic. I can still feel the pavement burning through my T-shirt two decades later.

2015! I had to be there to celebrate the passage of marriage equality. The crowd just seemed to scream with joy for six hours straight. It was amazing. —**KEVIN JENNINGS**

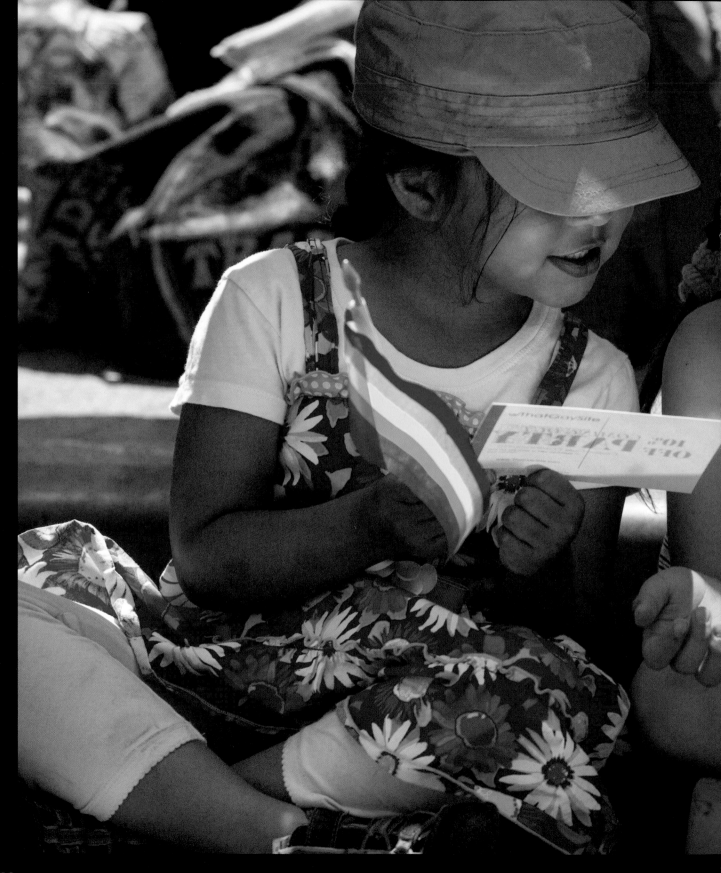

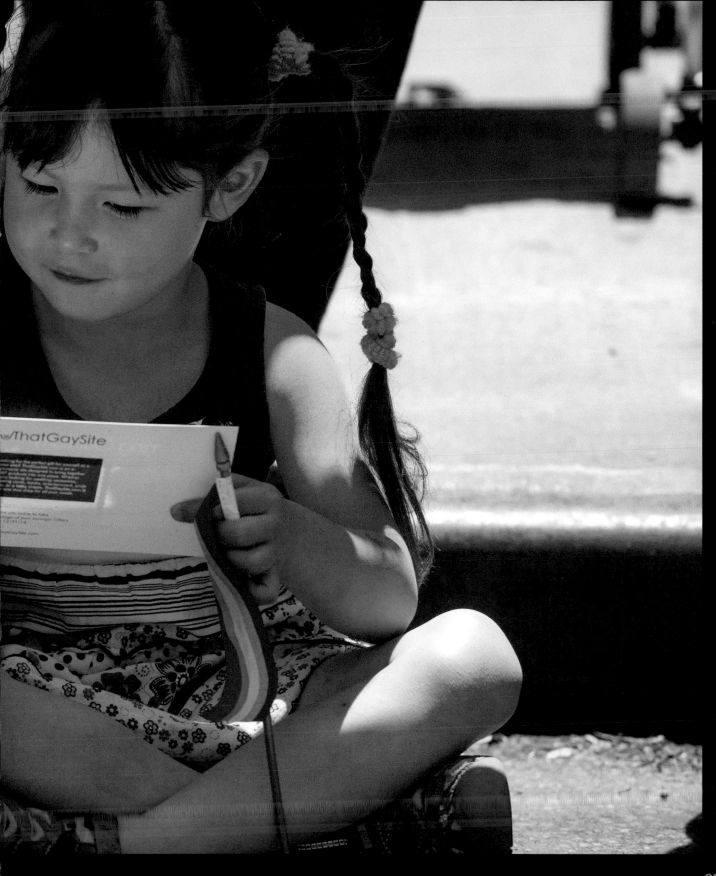

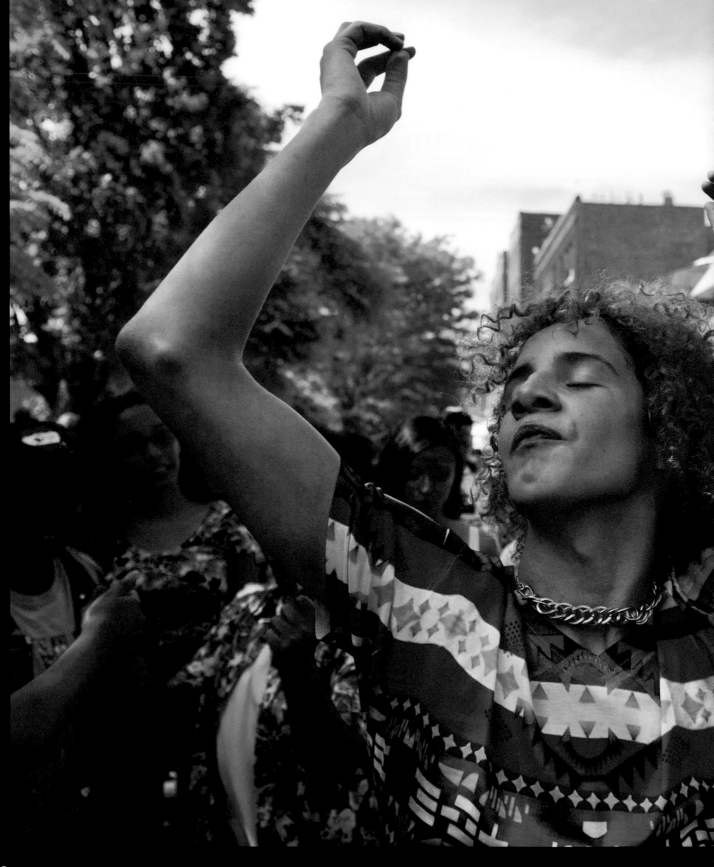

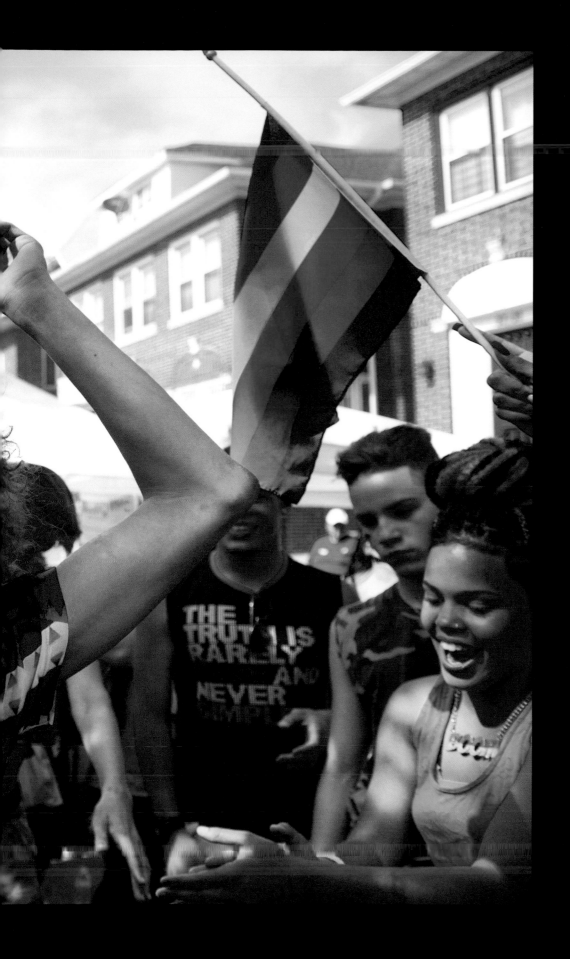

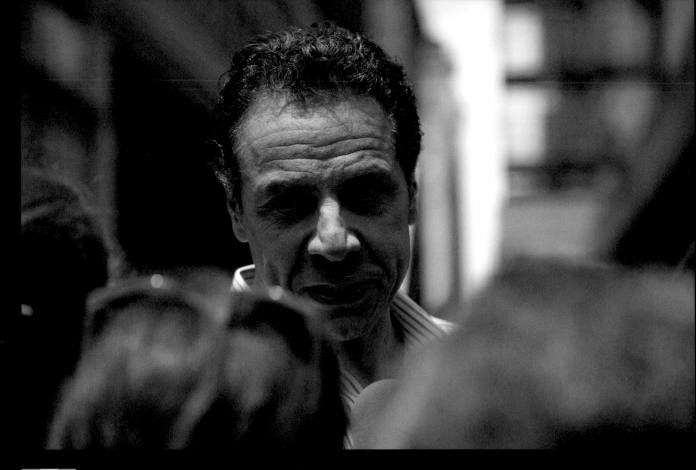

New York has always been a beacon for the country on LGBT rights. We started the movement at Stonewall, we led the way with marriage equality, and now we are continuing to show the nation the path forward. We will not tolerate discrimination or harassment against transgender people anywhere in the state of New York—period.

—GOVERNOR ANDREW CUOMO

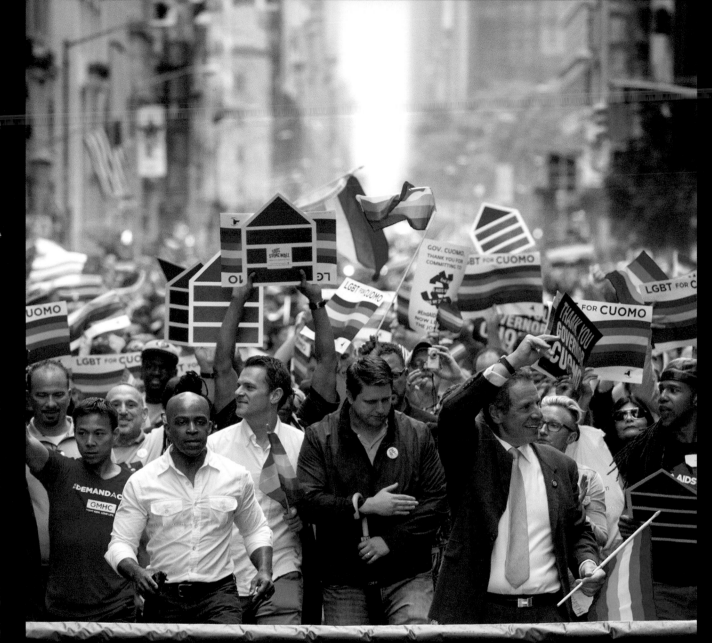

NEW YORK
LED THE WAY

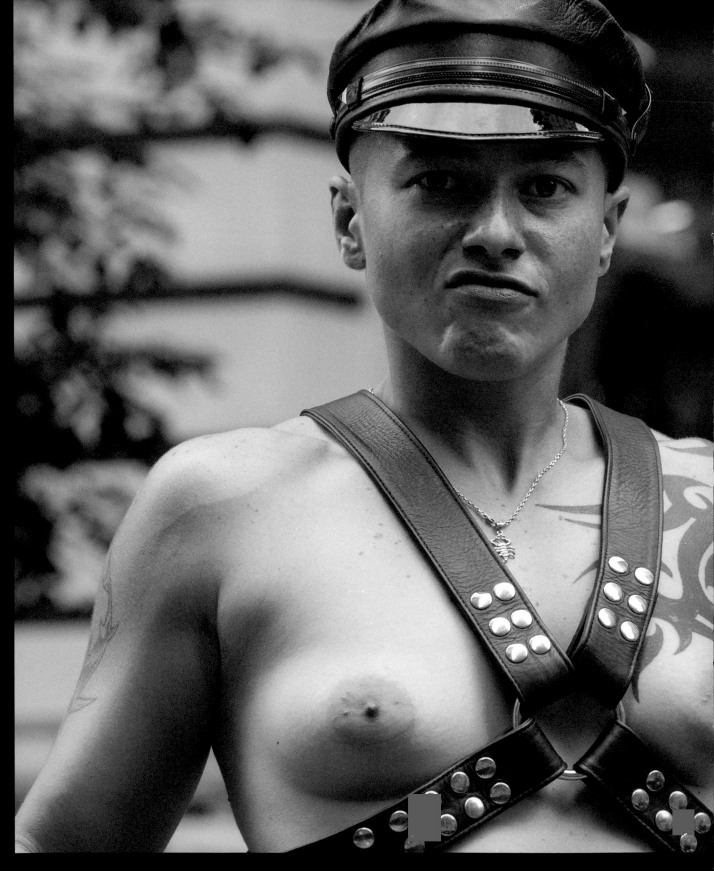

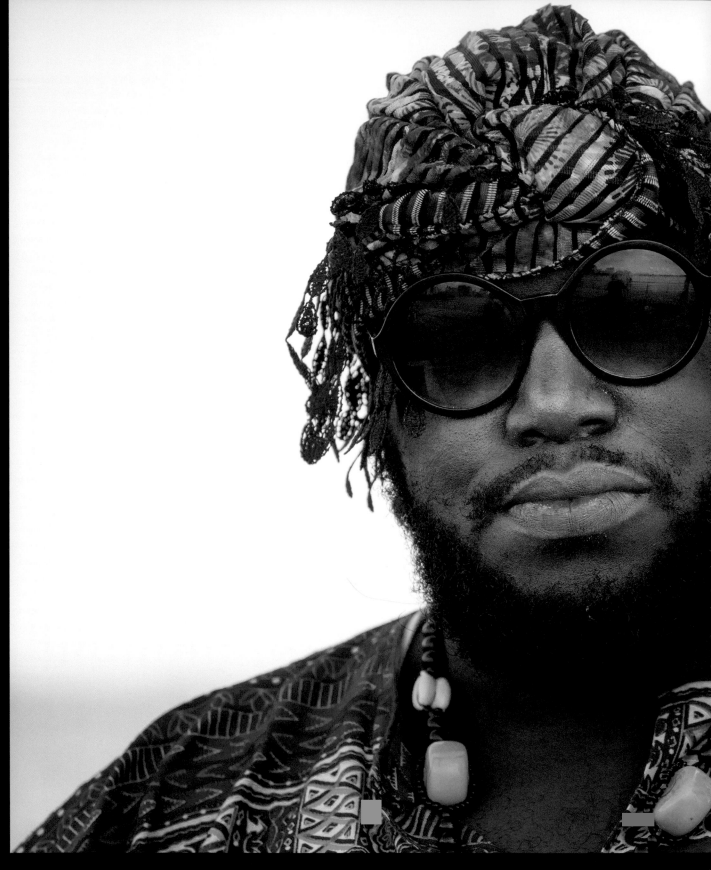

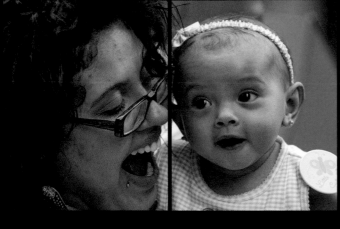
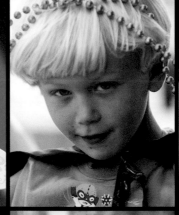
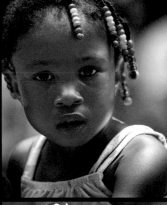

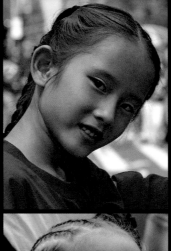
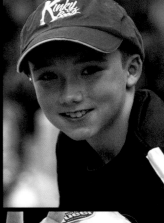

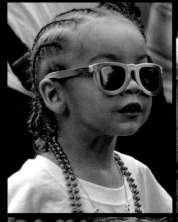
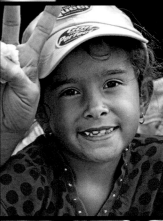

One of my march memories is the time my children's Nonna, my mother, marched with me. ("Nonna marched? No way!") Promising her she didn't have to go topless on the Clit Club float, I asked which contingent she wanted to spend our day with. She already knew. "I'd like to march with PFLAG [Parents and Friends of Lesbians and Gays]." Honestly, I didn't know she had ever heard of PFLAG. I remember thinking that was cool. She had done some research. She had found support for herself. She had found a way to support me.

I did wear a shirt, my black "Silence=Death" ACT UP tank top, sleeves cut off like my jean shorts. And high tops. My mother had on a solid, light-blue T-shirt and comfortable pants. Sensible shoes. It can be a long walk in hot sun. She didn't wear a hat. I don't think she expected to stay. She didn't hold a sign, just her purse, and my hand. We gathered on the designated side street and as our turn came up to weave ourselves onto Fifth Avenue, people on the sides started to clap, cheer, and wave. They yelled, "Thank you" and "We love you." Funny but they were not talking to me. They were expressing their gratitude to my mother for not shunning me, for not marginalizing them, for saying that lesbian lives matter.

Our image—a white mother walking with her white, twenty-two-year-old, tall, brash, short-haired, in-your-face daughter who loved to have sex with other girls—the image of the two of us, walking slowly down the street, holding hands, was so radical in that moment that people cried. I cried back.

—CATHERINE GUND

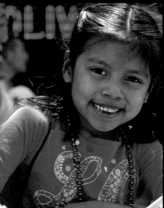
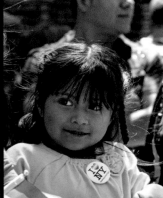

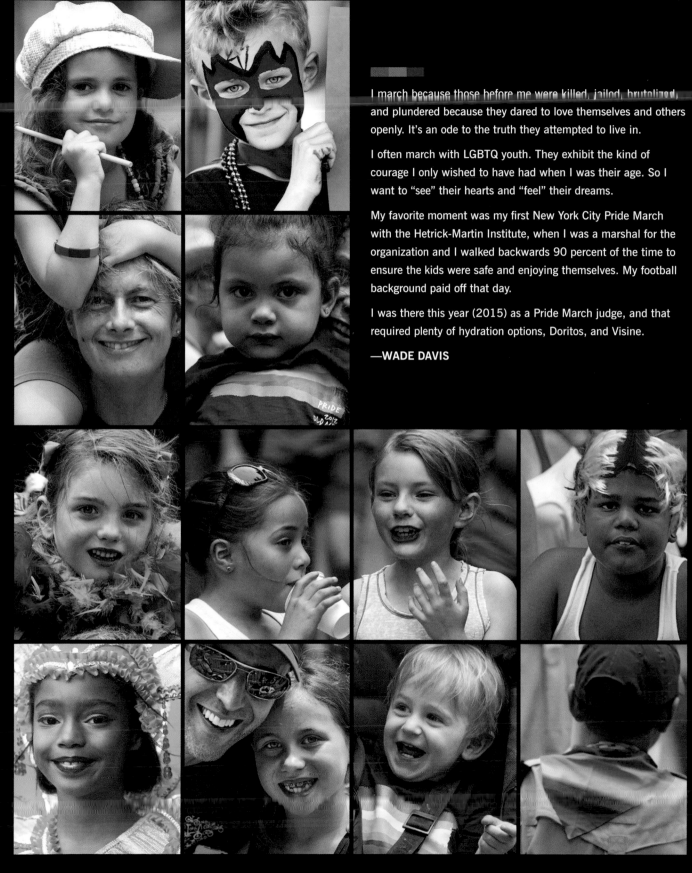

I march because those before me were killed, jailed, brutalized, and plundered because they dared to love themselves and others openly. It's an ode to the truth they attempted to live in.

I often march with LGBTQ youth. They exhibit the kind of courage I only wished to have had when I was their age. So I want to "see" their hearts and "feel" their dreams.

My favorite moment was my first New York City Pride March with the Hetrick-Martin Institute, when I was a marshal for the organization and I walked backwards 90 percent of the time to ensure the kids were safe and enjoying themselves. My football background paid off that day.

I was there this year (2015) as a Pride March judge, and that required plenty of hydration options, Doritos, and Visine.

—WADE DAVIS

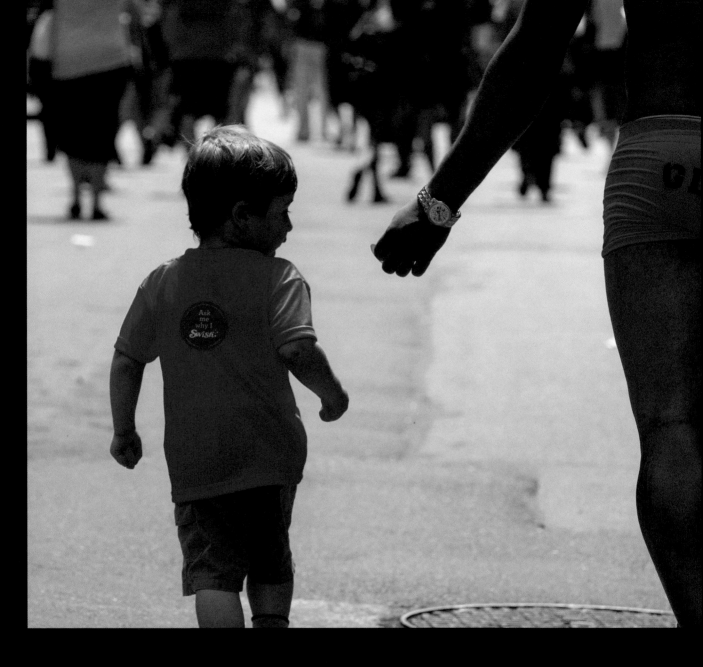

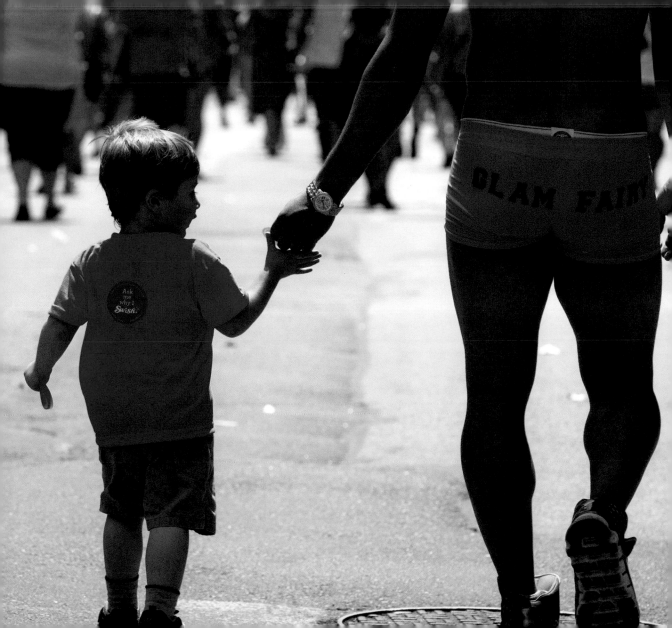

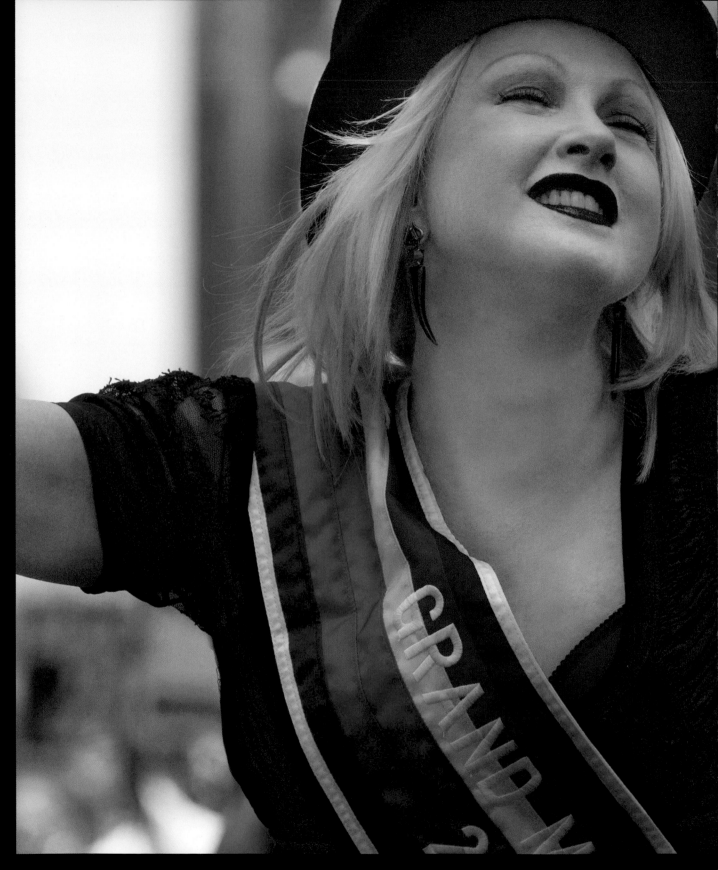

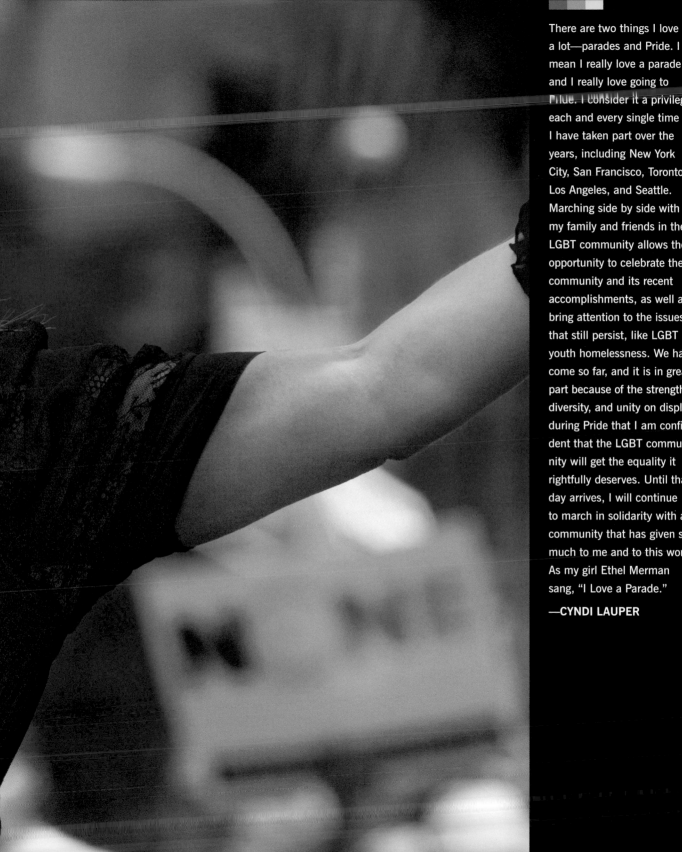

There are two things I love a lot—parades and Pride. I mean I really love a parade and I really love going to Pride. I consider it a privilege each and every single time I have taken part over the years, including New York City, San Francisco, Toronto, Los Angeles, and Seattle. Marching side by side with my family and friends in the LGBT community allows the opportunity to celebrate the community and its recent accomplishments, as well as bring attention to the issues that still persist, like LGBT youth homelessness. We have come so far, and it is in great part because of the strength, diversity, and unity on display during Pride that I am confident that the LGBT community will get the equality it rightfully deserves. Until that day arrives, I will continue to march in solidarity with a community that has given so much to me and to this world. As my girl Ethel Merman sang, "I Love a Parade."

—CYNDI LAUPER

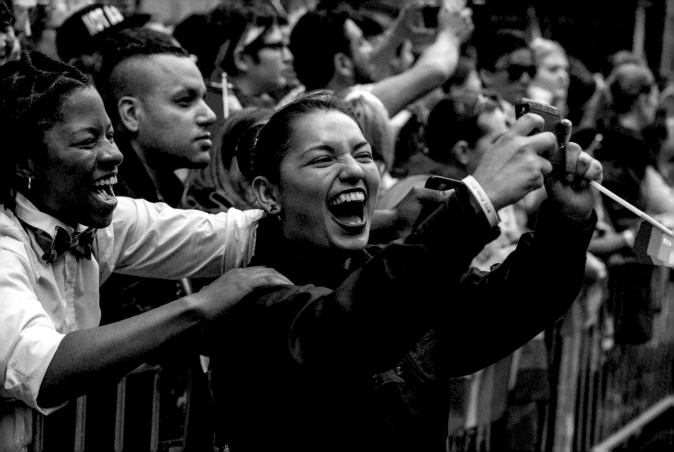

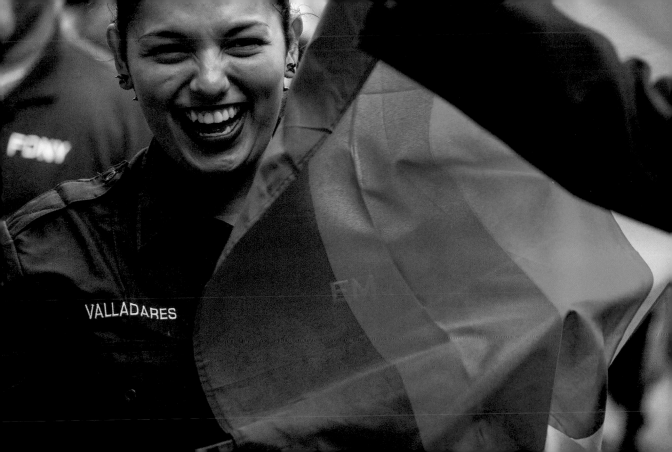

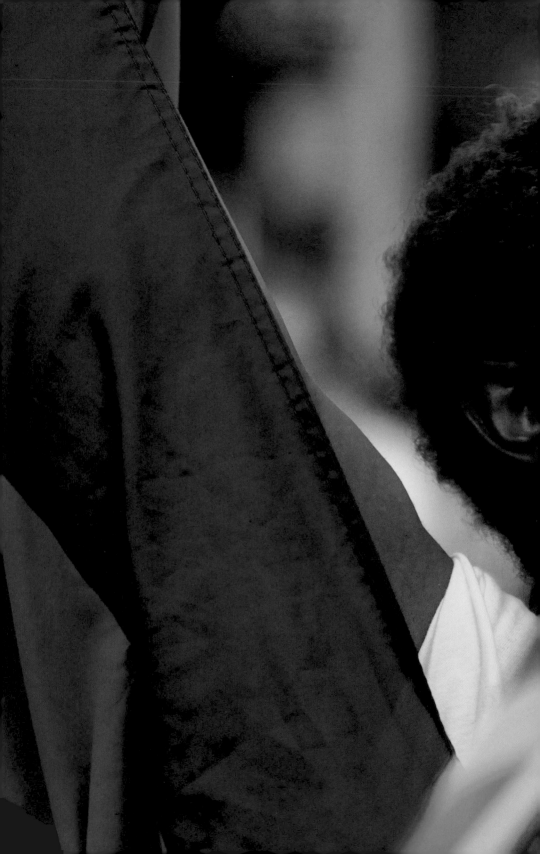

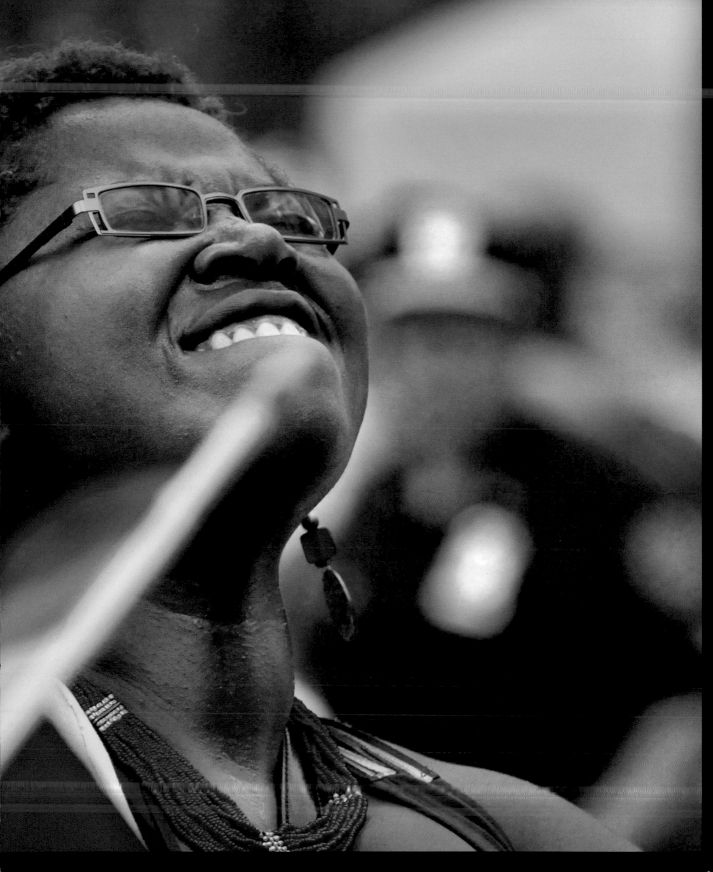

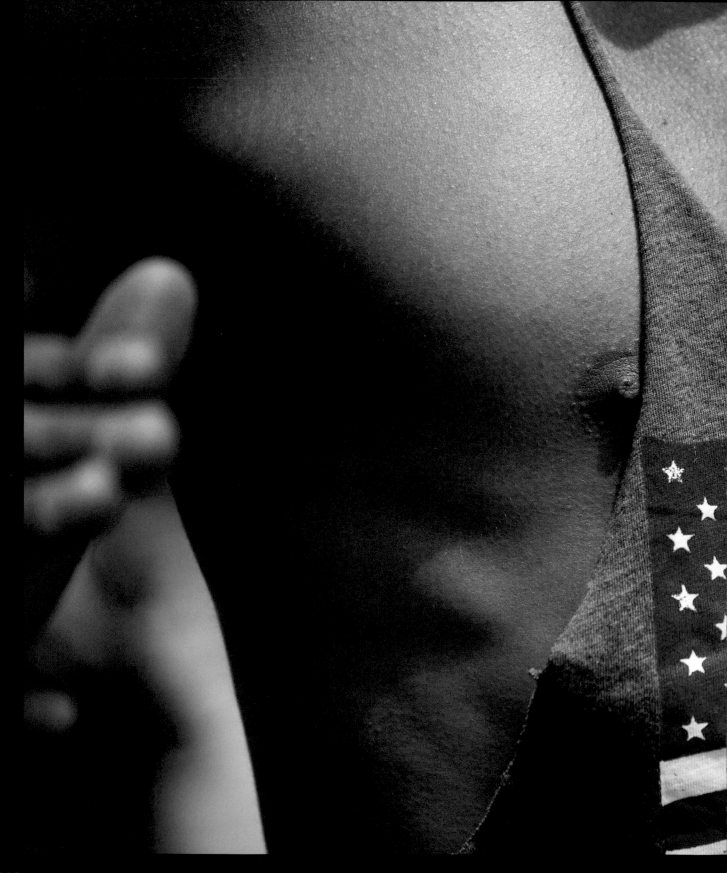

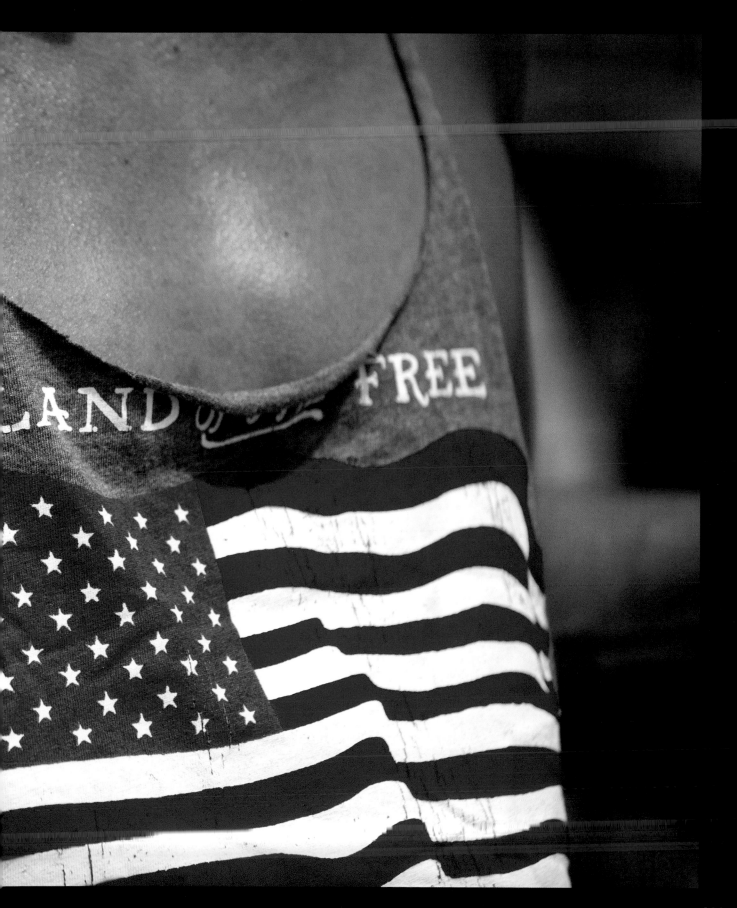

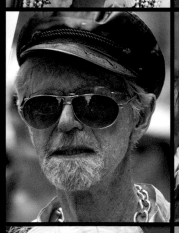

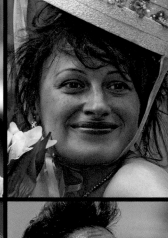

The New York City Pride March is an essential part of my gay DNA and I'm proud to have had a role in creating some of its hallmarks—the Lavender Line, the balloon arches, the moment of silence, and the fireworks. I have so many memories. In 1984, we were broke (because of embezzlement by our former male co-coordinator), and we could afford only one portable toilet. Somehow, that lonely portosan got pitched into the Hudson River. Through groveling and creative writing, the vendor didn't make us pay for it. The next year, we were able to get the city to agree to paint a lavender line down the march route and we raised the money to pay for the city to do it. But the paint truck didn't come and didn't come and we'd basically given up. Finally, just as dawn was breaking, it arrived at Columbus Circle to begin its three-mile trek to Greenwich Village. Overjoyed, Candida Scott Piel, my co-coordinator, put her right hand into the wet paint and then pressed it against my chest. That framed lavender palm print has been with me ever since. In 2001, when I was at the Pride Agenda, I thought confetti cannons would add some drama to our float. So, we rented four of them and launched hundreds of pounds of multicolored paper and Mylar confetti along the parade route. The morning after the march, I received a call from the NYC Sanitation Department telling me that the confetti had clogged up several of their street-cleaning machines and the bill would be around $20,000. I nearly collapsed. It was a prank call from "friends" at HOP (Heritage of Pride).

—MATT FOREMAN

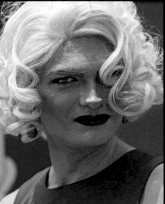
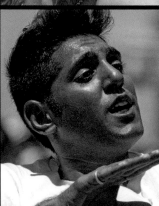

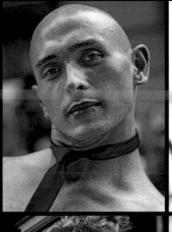

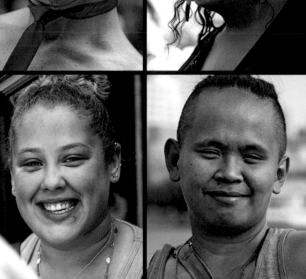

I can chart my lesbian career through parades I have known and loved. San Francisco was my first—sensuous and in-your-face—with more than a touch of hedonism. Washington was discreet and practical. Los Angeles had the glamour with a hint of power, but no edge. Now my home parade in Northampton is filled with kids and dogs in our family lesbitopia. Ah, but those New York parades of my lesbian youth in the early to mid-1990s! I remember sweaty, shouting women looking impossibly hip and worldly.

—LEE BADGETT

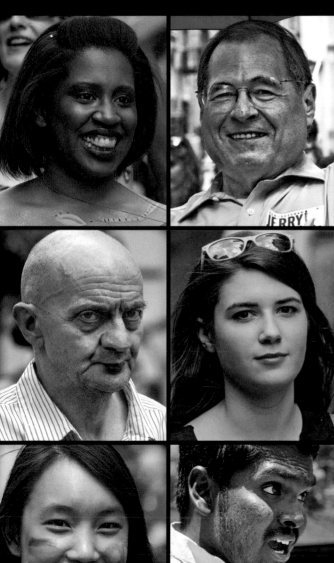

I began marching in Boston and New York City in 1976, the year I came out. Coming together, out in the streets, with so many amazing, talented, smart, and engaged people—this continues to be joyfully uplifting and still, at times, a personally validating experience.

I've always remained inclusive, fluid, and mindful of the human rights violations that have impacted us all so deeply. As we know too well, a cultural generation was devastated by AIDS. So many creative souls were lost. I come out to honor them, as well as our future creative voice—one that will hopefully continue to take the lead with alternative and innovative ideas.

There have been so many incredible moments, but a favorite was in 1996, when I was spotted in the crowd by one of the fabulous Dykes on Bikes, my dear friend Karen Perrine, and asked to hop aboard! What a thrill to be in and among the roar of engines driven by all those awesome women who led the march for five glorious blocks! **—DEBBIE NADOLNEY**

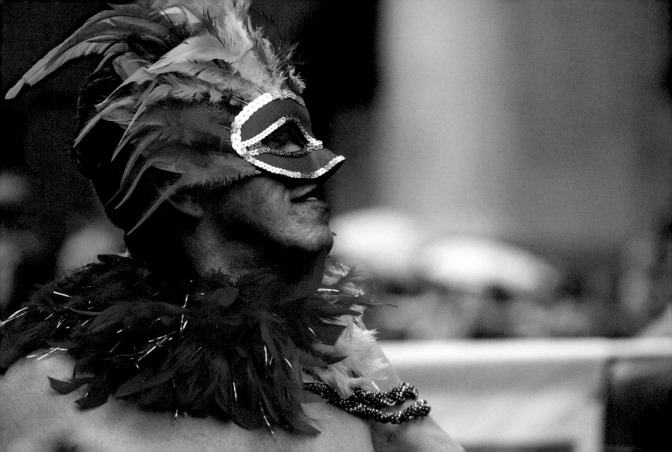

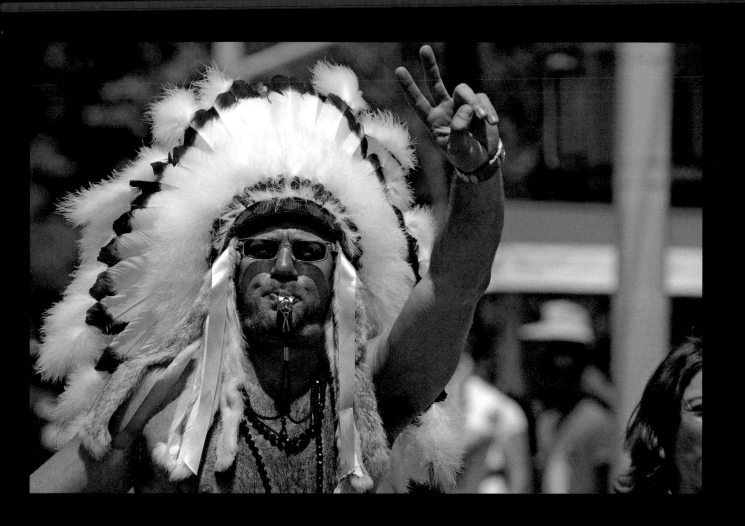

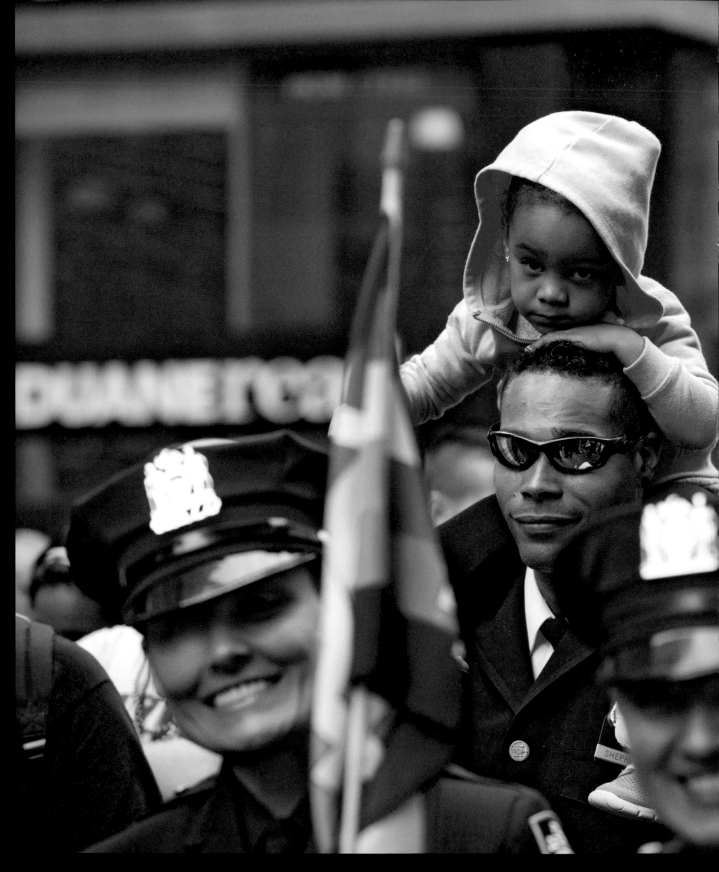

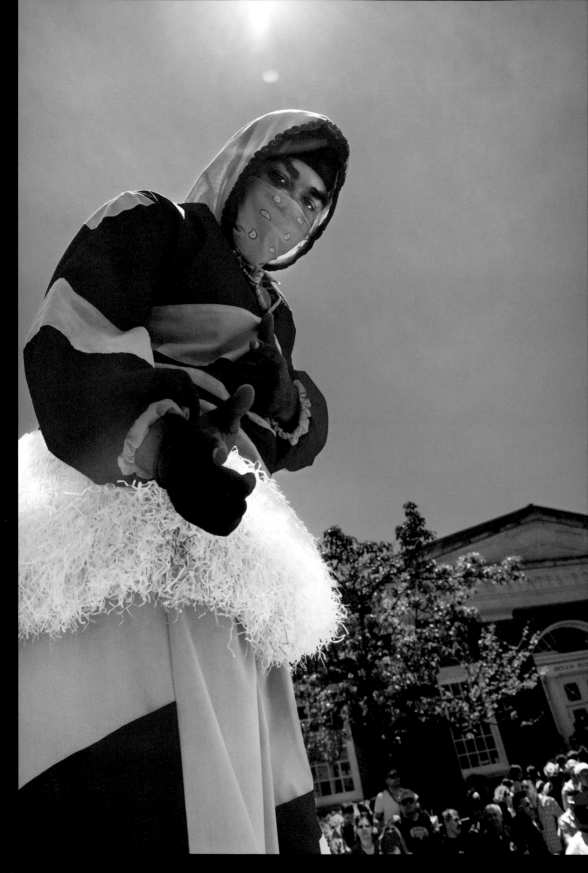

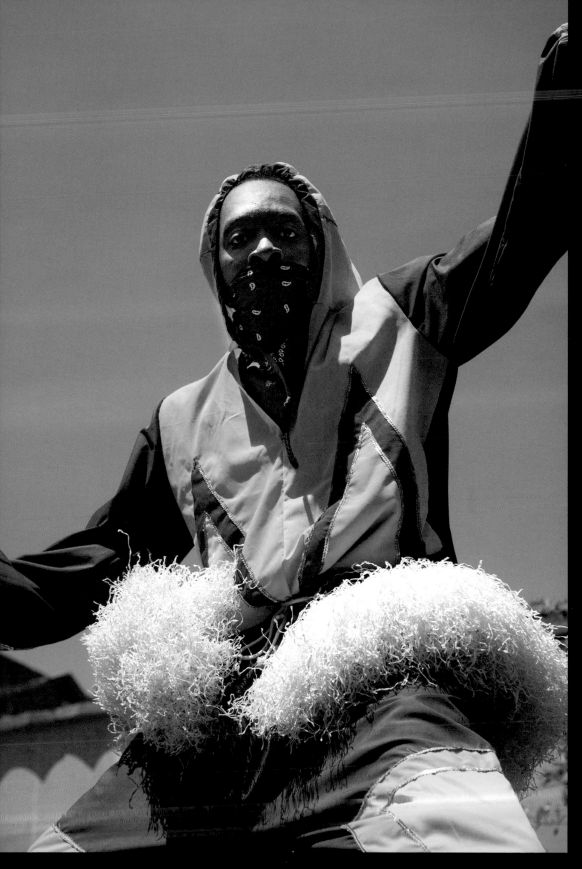

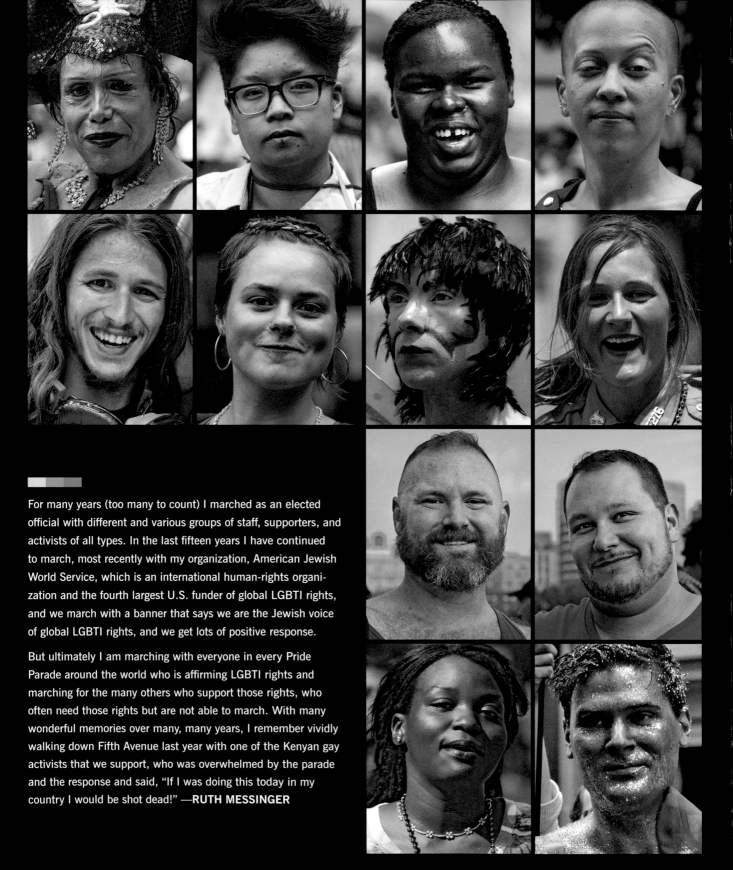

For many years (too many to count) I marched as an elected official with different and various groups of staff, supporters, and activists of all types. In the last fifteen years I have continued to march, most recently with my organization, American Jewish World Service, which is an international human-rights organization and the fourth largest U.S. funder of global LGBTI rights, and we march with a banner that says we are the Jewish voice of global LGBTI rights, and we get lots of positive response.

But ultimately I am marching with everyone in every Pride Parade around the world who is affirming LGBTI rights and marching for the many others who support those rights, who often need those rights but are not able to march. With many wonderful memories over many, many years, I remember vividly walking down Fifth Avenue last year with one of the Kenyan gay activists that we support, who was overwhelmed by the parade and the response and said, "If I was doing this today in my country I would be shot dead!" —**RUTH MESSINGER**

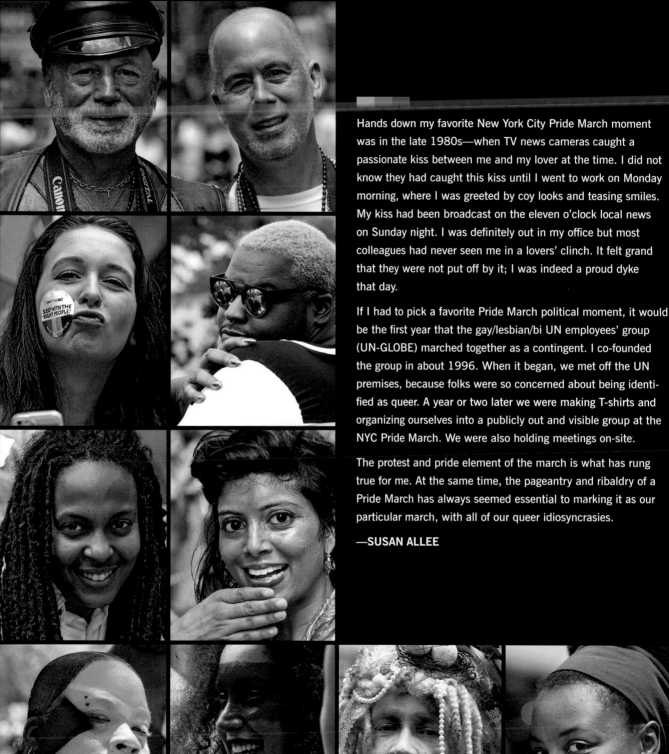

Hands down my favorite New York City Pride March moment was in the late 1980s—when TV news cameras caught a passionate kiss between me and my lover at the time. I did not know they had caught this kiss until I went to work on Monday morning, where I was greeted by coy looks and teasing smiles. My kiss had been broadcast on the eleven o'clock local news on Sunday night. I was definitely out in my office but most colleagues had never seen me in a lovers' clinch. It felt grand that they were not put off by it; I was indeed a proud dyke that day.

If I had to pick a favorite Pride March political moment, it would be the first year that the gay/lesbian/bi UN employees' group (UN-GLOBE) marched together as a contingent. I co-founded the group in about 1996. When it began, we met off the UN premises, because folks were so concerned about being identified as queer. A year or two later we were making T-shirts and organizing ourselves into a publicly out and visible group at the NYC Pride March. We were also holding meetings on-site.

The protest and pride element of the march is what has rung true for me. At the same time, the pageantry and ribaldry of a Pride March has always seemed essential to marking it as our particular march, with all of our queer idiosyncrasies.

—SUSAN ALLEE

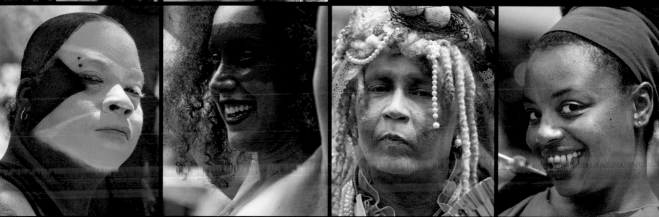

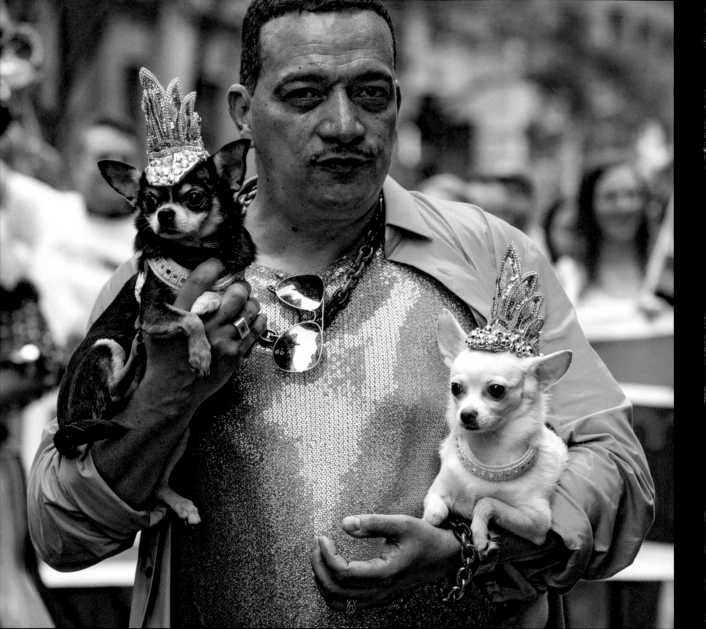

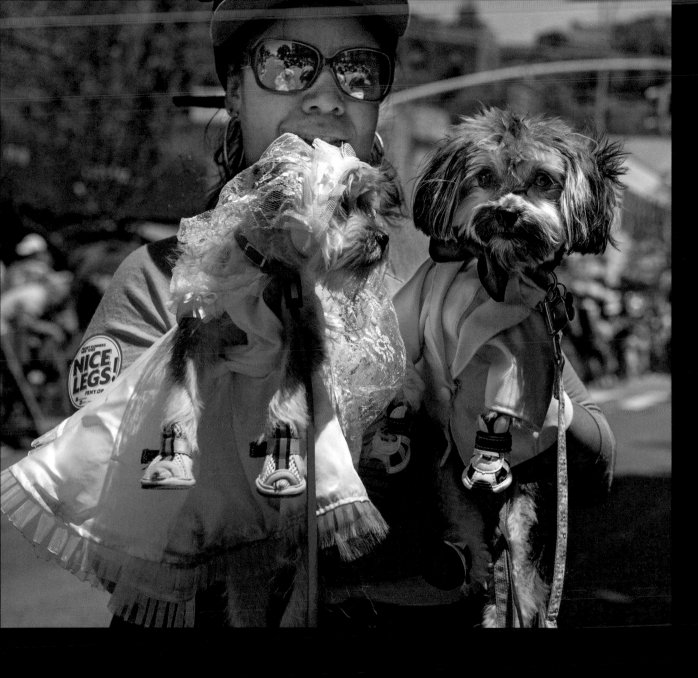

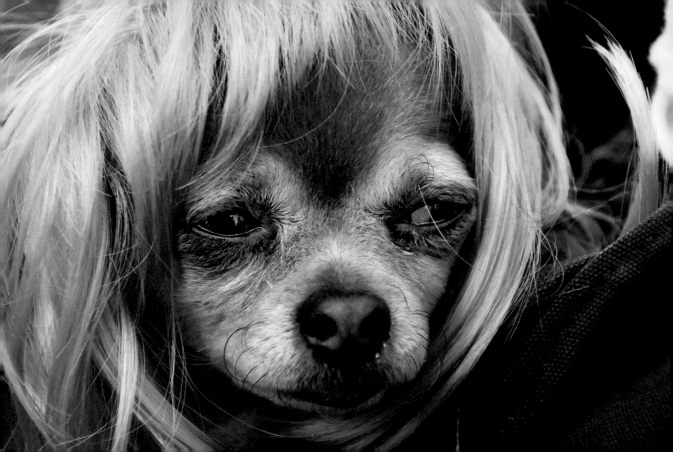

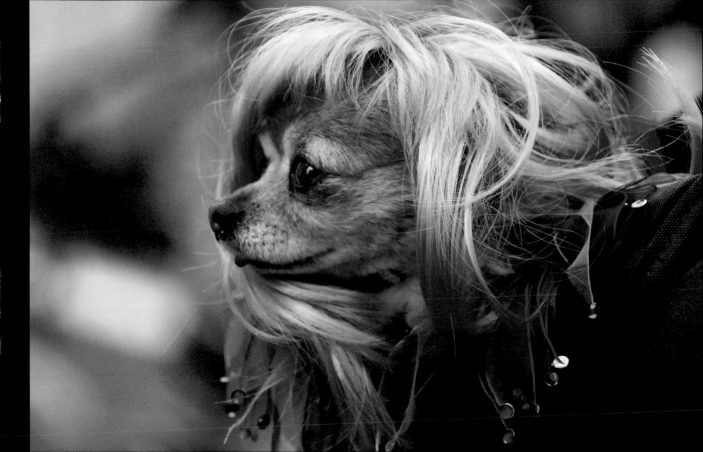

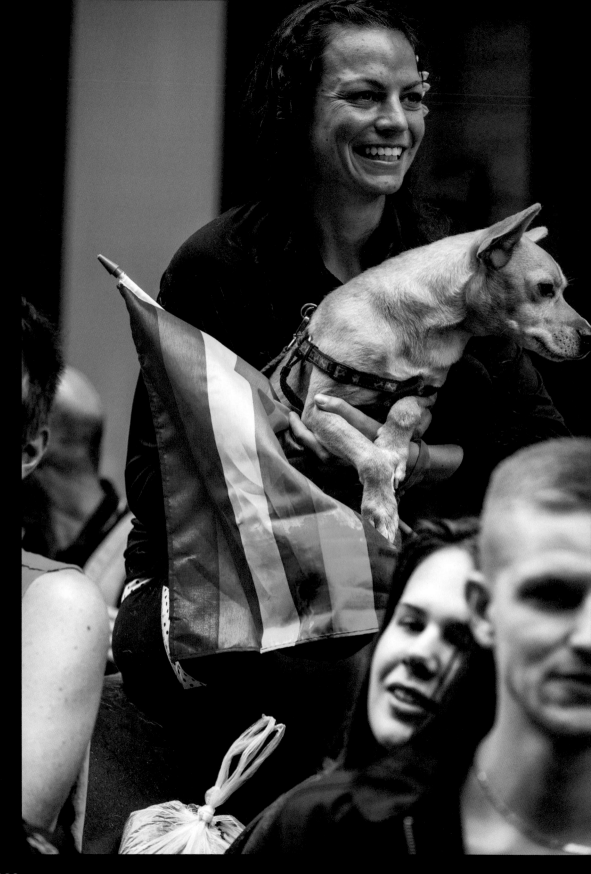

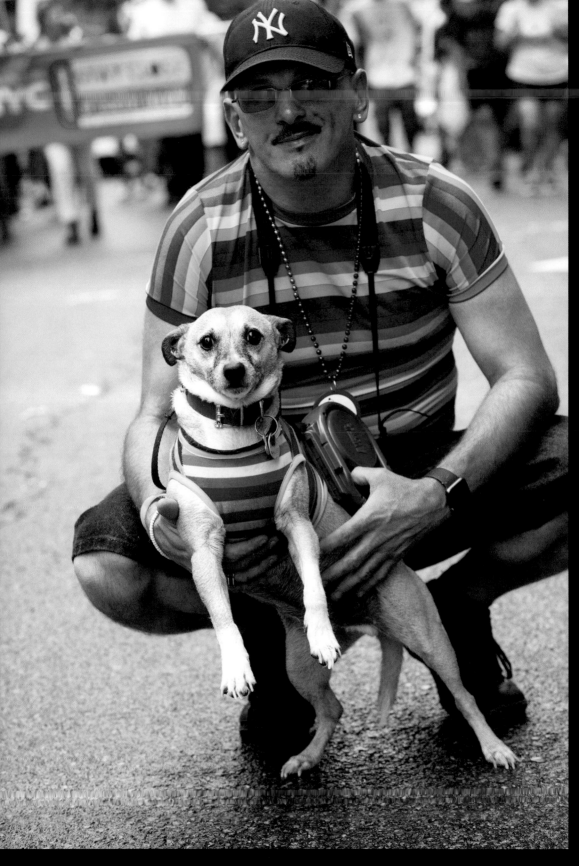

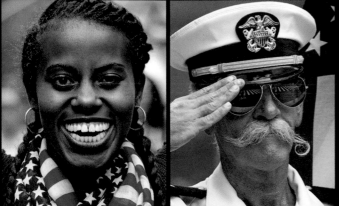

Here is my all-time favorite Pride chant from 1981 or 1982, when we lived in Hoboken:

We're not jokin' / We're outspoken
We're the Dykes / Of Hoboken

We had a great big sign we held up with the chant on it and everyone cracked up—we got a lot of attention and it was great fun as all eight or ten of us marched up Fifth Avenue.

—JUDITH TURKEL

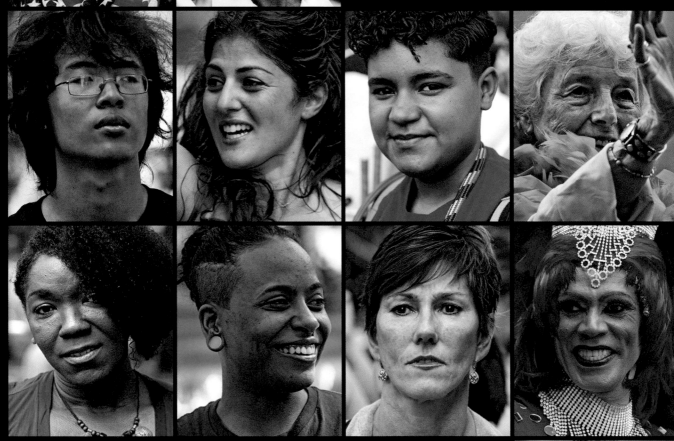

Over the course of my life, the reasons that drove me to march have changed. Initially, in the late '70s, it was to combat fear by finding community with others and nurturing my own growing political consciousness. Then it was—for a few glorious years—unadulterated fun and joy, a day of abandon and without care. Everything, yes, even me, was sexy, but it still felt deliciously transgressive. But by the late '80s, it was all about defiance, anger, and solidarity. Today it's mostly sentimental, like watching the veterans march on Memorial Day. I'm just as or more political, but the major city marches don't feel political. Next year we're having one in Milford, Pennsylvania (population 1,100), and that will feel more like the early days. We have to go farther into the heart of America to find our remaining frontiers. **—SEAN STRUB**

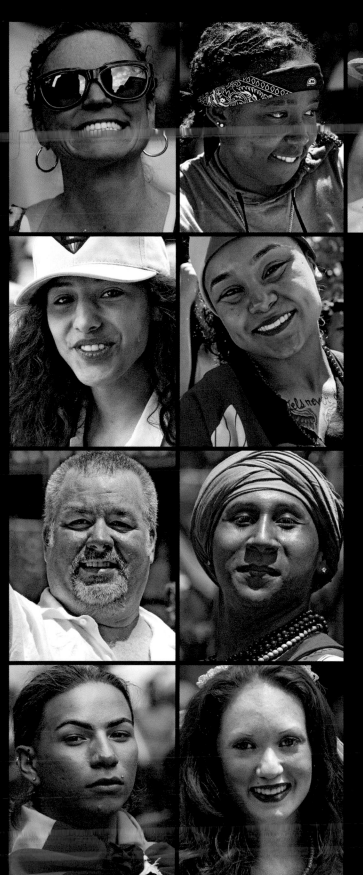

Harvey Milk encouraged generations of Americans to "come out" and demand our full dignity and equality. There is probably no event that is more in the spirit of Milk's exhortations than the Pride March: folks from all walks of life—gay and straight—expressing their fundamental belief that we each have a right to live with dignity regardless of whom we love.

As a little boy growing up, I remember hearing about the march from my father. He worked at a hotel that was near the Fifth Avenue parade route. And he would come home and talk about the parade and what he saw—not so nicely, I might add. But as a closeted little boy, it was my first signal that there were others out there who were like me. I'm fifty years old, and when I was a kid there were no gays on TV, there was no Internet, no Facebook. There were no openly gay persons in my family or neighborhood, so it was only the stories from my dad that told me there were other folks like me out there. I harbored closeted feelings then about someday joining them. Now I do.

I love the floats with the little old folks waving at the crowd. The change we have seen in our lifetimes has been amazing. Twenty, thirty, forty years ago, it was inconceivable that we would be at the cusp of securing our full equality. On the faces of the folks who lived through the hard times—the explicit and legally sanctioned discrimination, the AIDS crisis, the suffocating nature of the closet, the explicit violence against those who defied convention—you see the images of hope and redemption.

I went to the march this year to celebrate the historic win at the Supreme Court, granting all same-sex couples the right to marry anywhere in America. It is a rare moment when we get to watch history, and also be a part of history. It was exhilarating.

—ANTHONY ROMERO

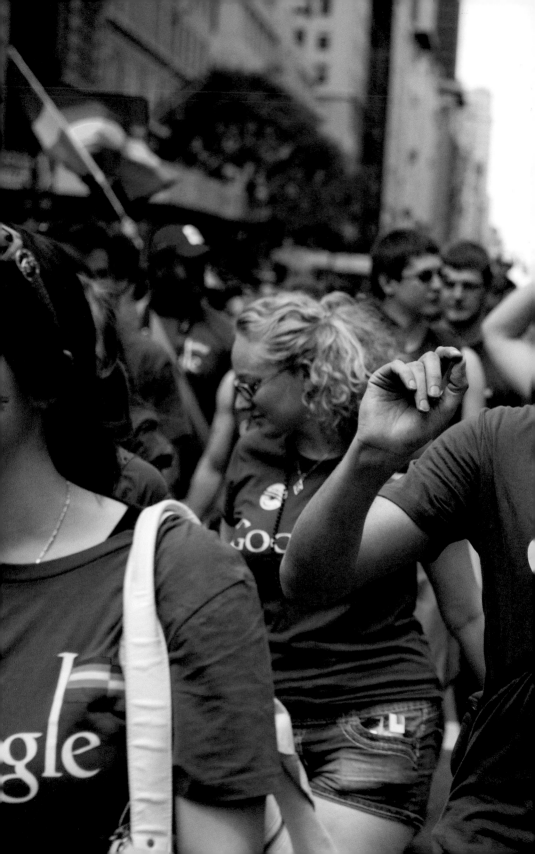

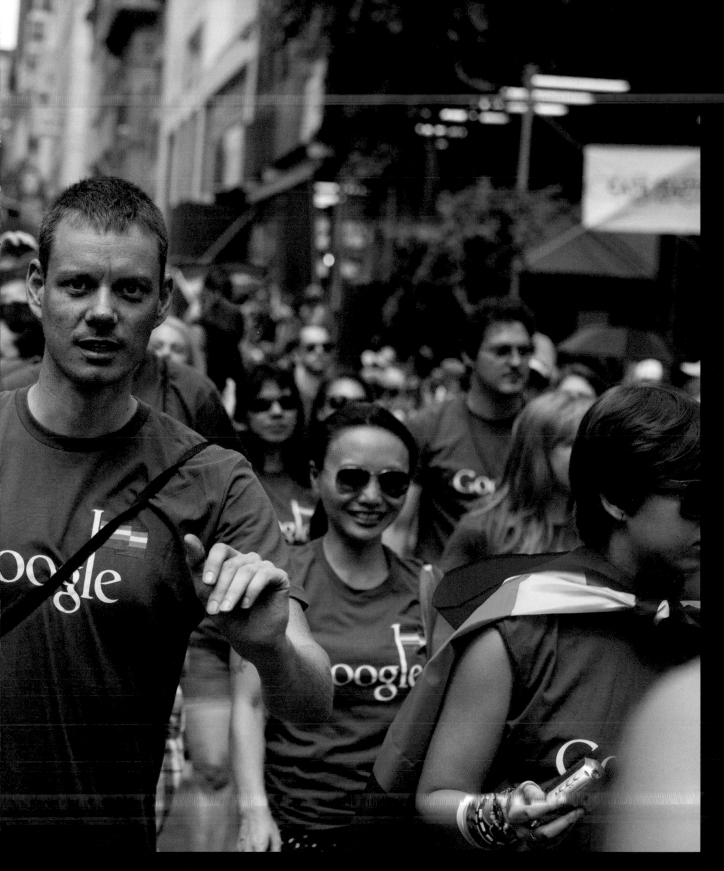

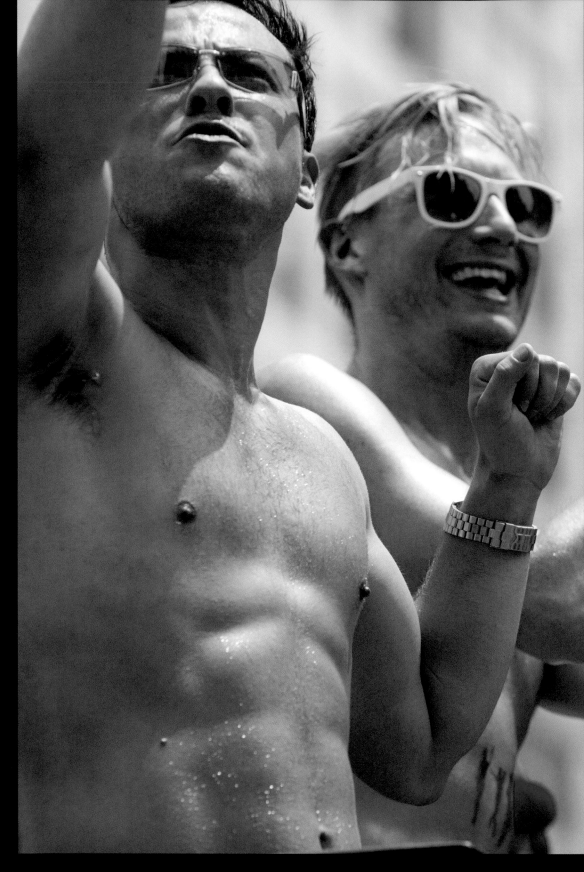

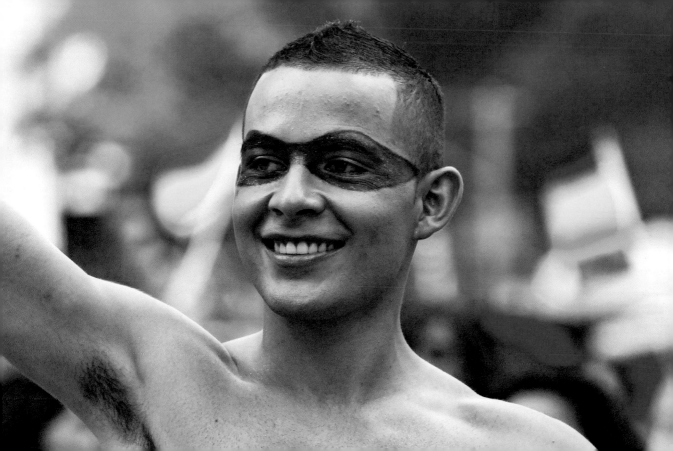

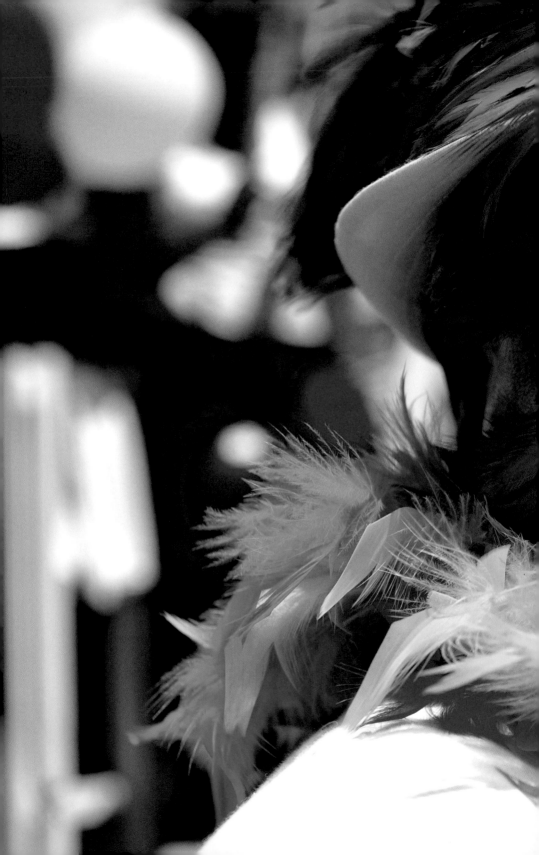

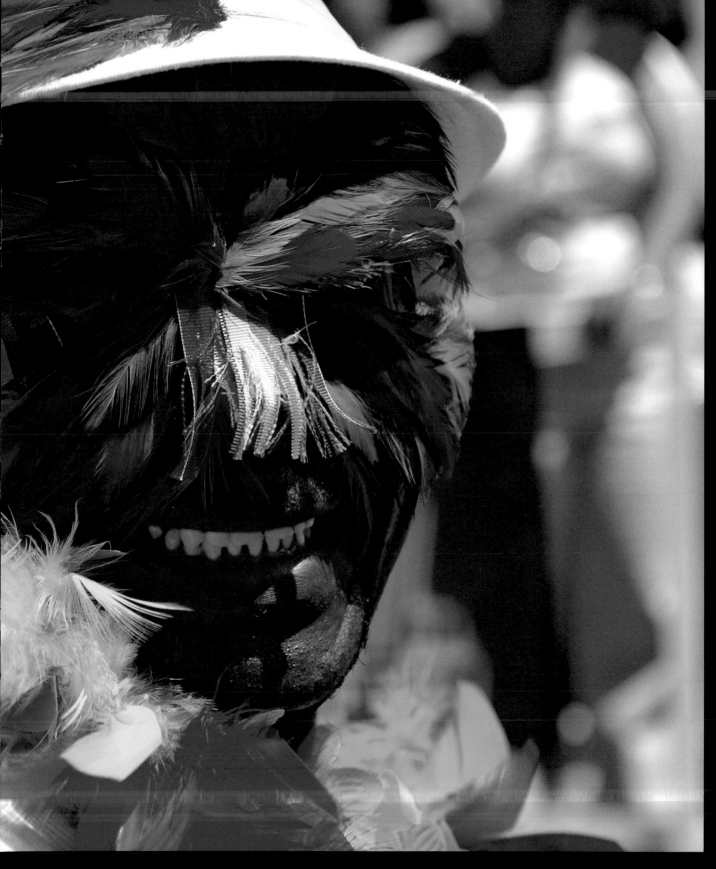

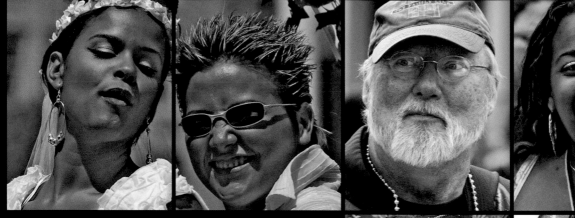

Having grown up in Washington, D.C., during the 1960s, marching to show solidarity against the Vietnam War, it seemed like a dream that one day our community would be able to do the same thing. So when Stonewall happened in June of '69 I knew that we would soon follow suit—and we did in November that year with the first march. I went and photographed it and every year after, for thirty-five years.

I always loved the celebratory aspect of the parade and would usually march with any group that had music and loved to dance along the parade route. Later on as I became more interested in the political aspect of the parade I would take turns marching with ACT UP and with the women's groups to show my support. I usually would march with one group for a while and then get out of the parade until another group came by and then I would join that group. It was a great way of familiarizing myself with different organizations and causes.

Without exception the most poignant memory I have of the parade would be the moment of silence that was initiated in 1986 in response to the AIDS crisis. Since I had buried over three hundred people during those early years and since, it reminded me of my many friends that had left us, and was a way of celebrating their struggles during their lives as gay men and women.

I loved when the parade reached and crossed Seventh Avenue onto Christopher Street because it would seem as though we had reached our neighborhood and that felt safe and amazing.

—BOBBY MILLER

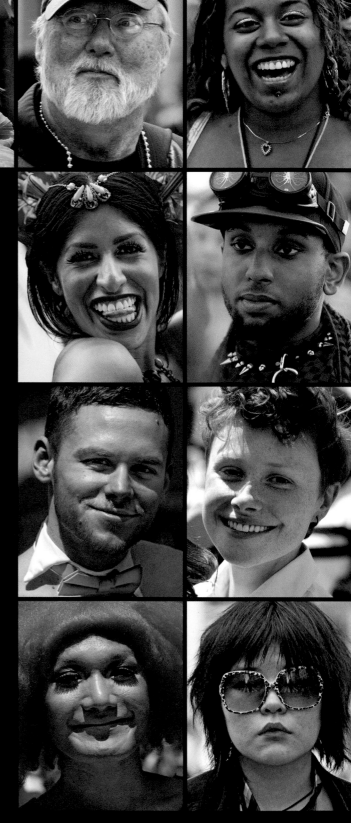

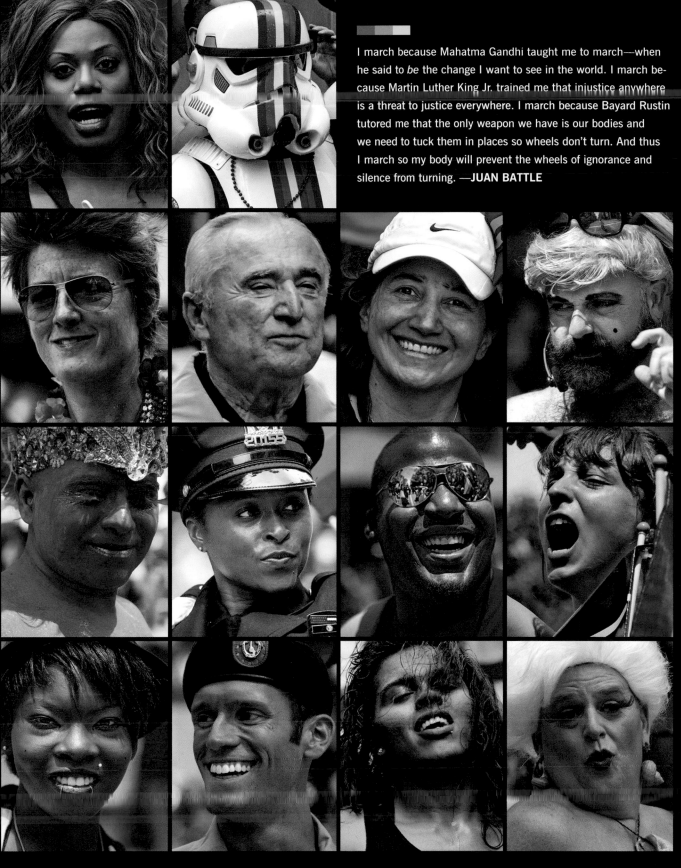

I march because Mahatma Gandhi taught me to march—when he said to *be* the change I want to see in the world. I march because Martin Luther King Jr. trained me that injustice anywhere is a threat to justice everywhere. I march because Bayard Rustin tutored me that the only weapon we have is our bodies and we need to tuck them in places so wheels don't turn. And thus I march so my body will prevent the wheels of ignorance and silence from turning. —**JUAN BATTLE**

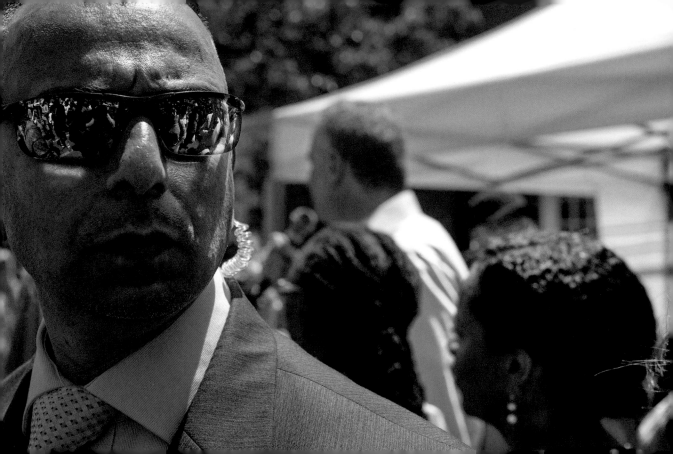

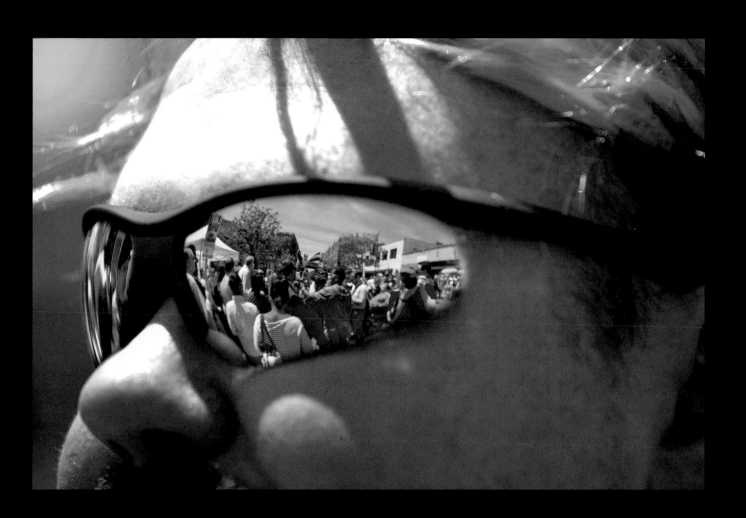

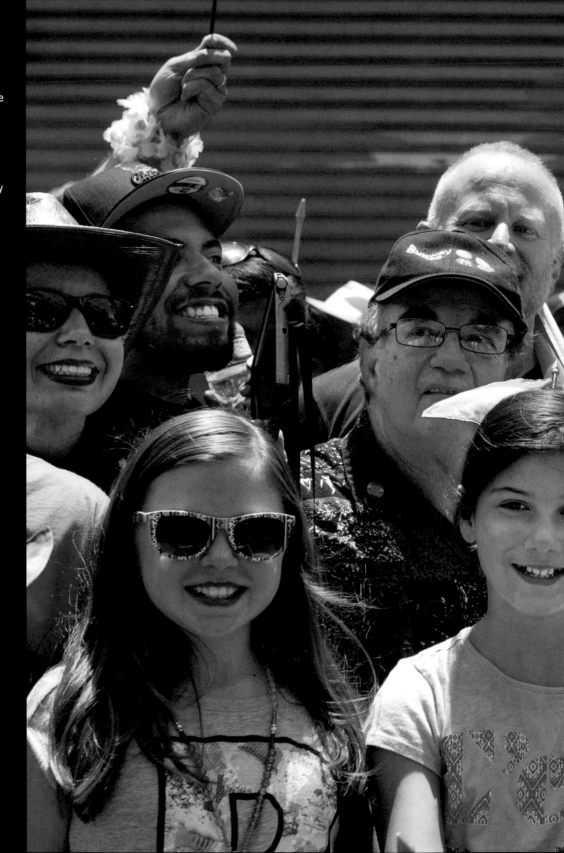

New York City has long been home to the country's largest and most diverse population, and we're proud our city's policies continue to reflect the equality that LGBT communities fought so tirelessly for. . . . The city will continue to work toward equality for all people who call this great city home, because we know the fight is far from over.

—**MAYOR BILL DE BLASIO**

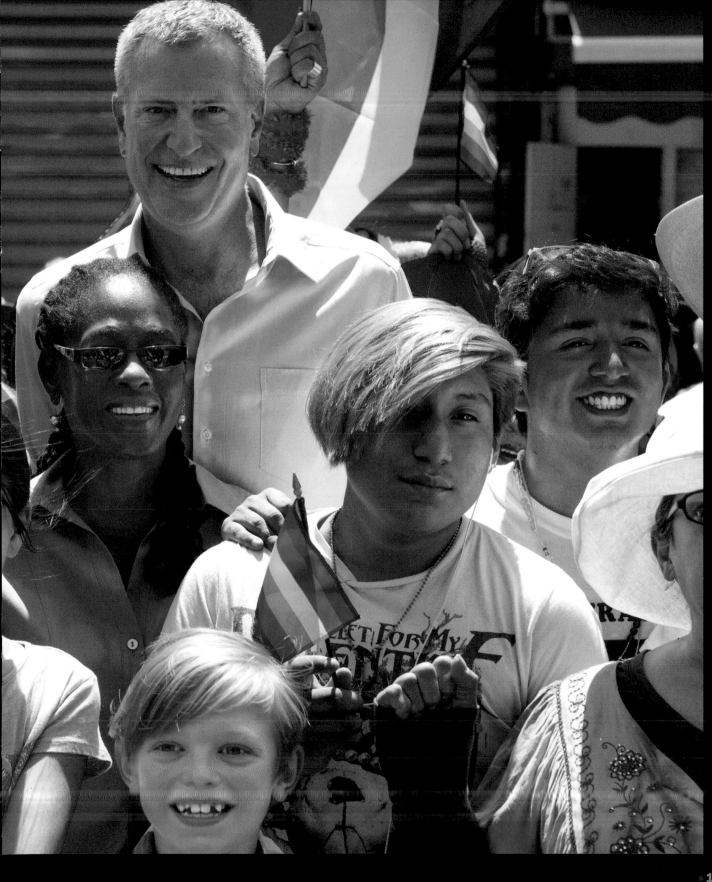

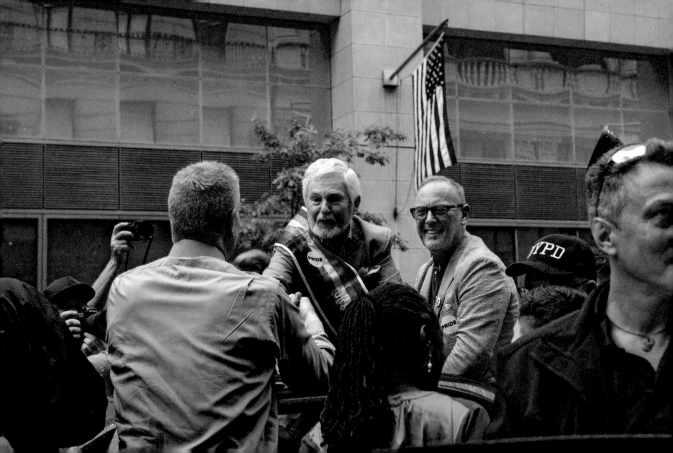

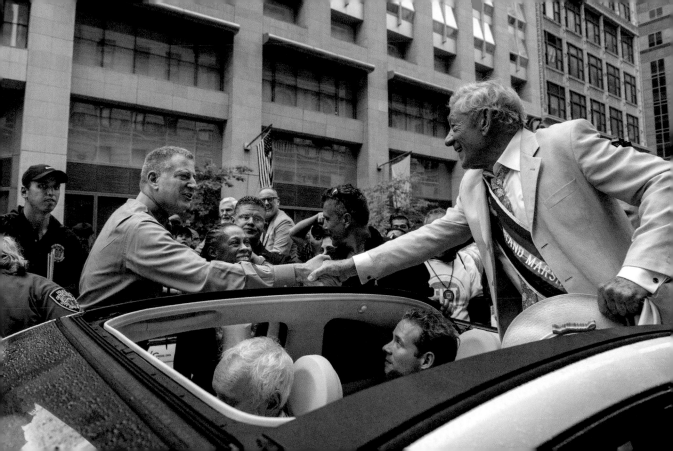

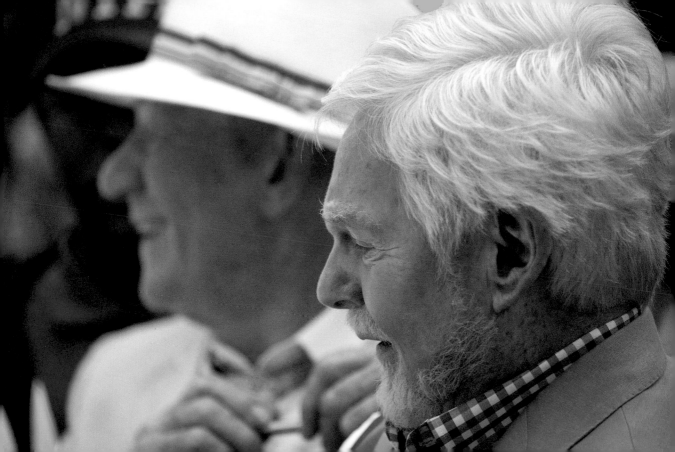

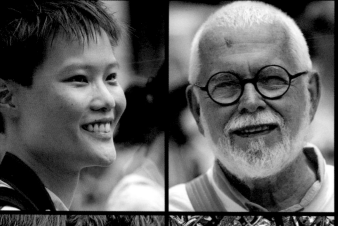

I've had so many experiences of the New York City Pride March—sideline lurker in the late 1970s, stalwart ACT UP contingent member in the 1980s, a grand marshal on a horse in the 1990s, a roving freelancer wandering up and down the route hanging out with friends in lots of different groups in the 2000s, and now an infrequent participant.

I love the joy and complexity of the march. I hate that its politics have diminished in favor of corporate frivolity. I yearn for a grass-roots message of a continuing demand for freedom for all.

—ANNE NORTHROP

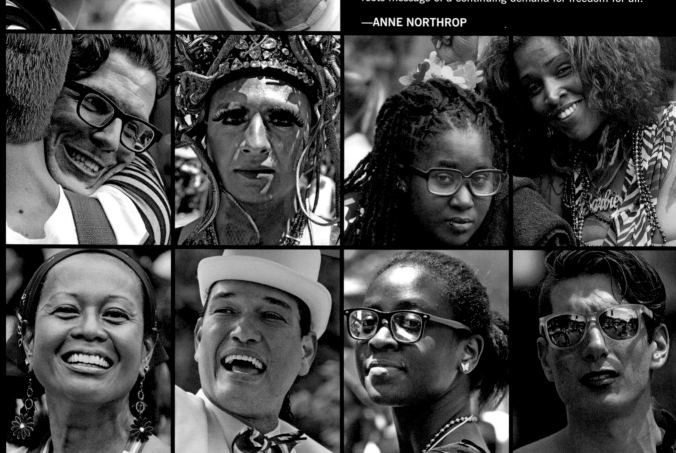

I remember my first march—my eyes wide open and my heart and head swimming at the vision of so many gay people, out and abounding with solidarity and fun.

I've marched with different groups over the years—Lambda Legal when I worked there, Immigration Equality when I helped start it in its early years, and for a few years, the best lesbian book group in the world (we even had our own T-shirts). Now I march with an assortment of groups but still am like a homing pigeon back to Lambda for my Pride roots.

Coming around the corner onto Christopher Street in the West Village, I feel as if I'm being carried along by the sustained blast of ecstatic and fierce energy that keeps me going all year.

—SUZANNE B. GOLDBERG

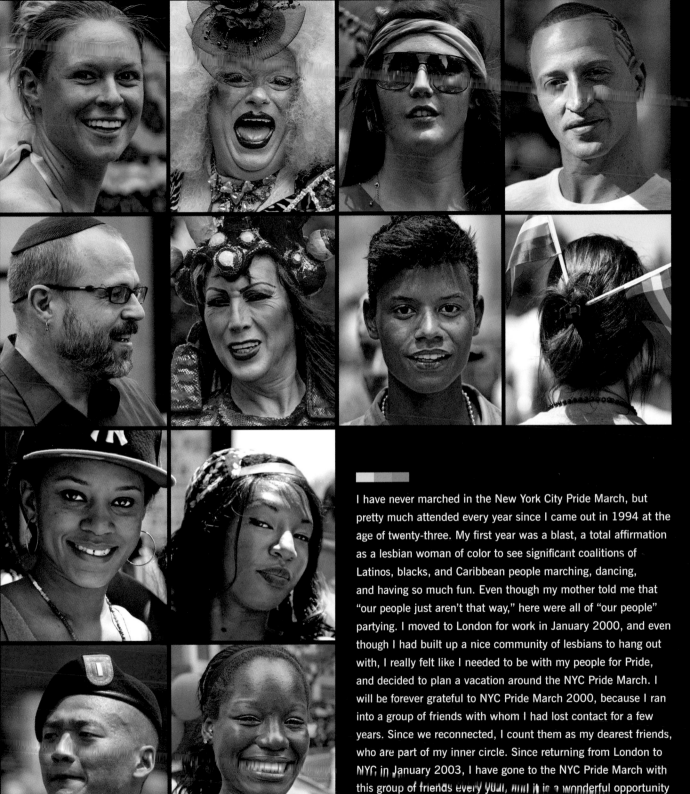

I have never marched in the New York City Pride March, but pretty much attended every year since I came out in 1994 at the age of twenty-three. My first year was a blast, a total affirmation as a lesbian woman of color to see significant coalitions of Latinos, blacks, and Caribbean people marching, dancing, and having so much fun. Even though my mother told me that "our people just aren't that way," here were all of "our people" partying. I moved to London for work in January 2000, and even though I had built up a nice community of lesbians to hang out with, I really felt like I needed to be with my people for Pride, and decided to plan a vacation around the NYC Pride March. I will be forever grateful to NYC Pride March 2000, because I ran into a group of friends with whom I had lost contact for a few years. Since we reconnected, I count them as my dearest friends, who are part of my inner circle. Since returning from London to NYC in January 2003, I have gone to the NYC Pride March with this group of friends every year, and it is a wonderful opportunity to run into people from our community. —**LISA BALTAZAR**

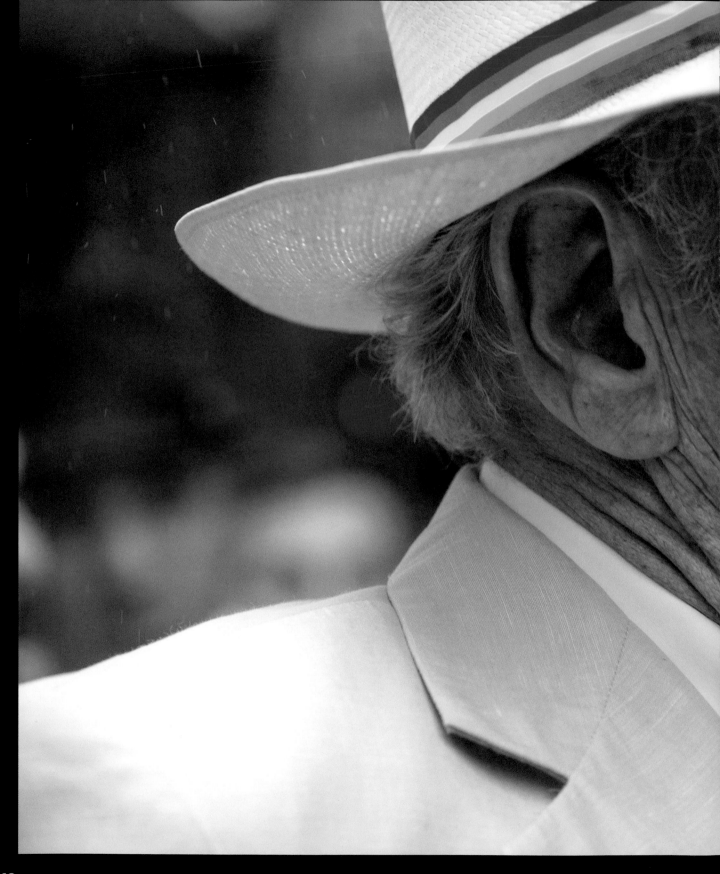

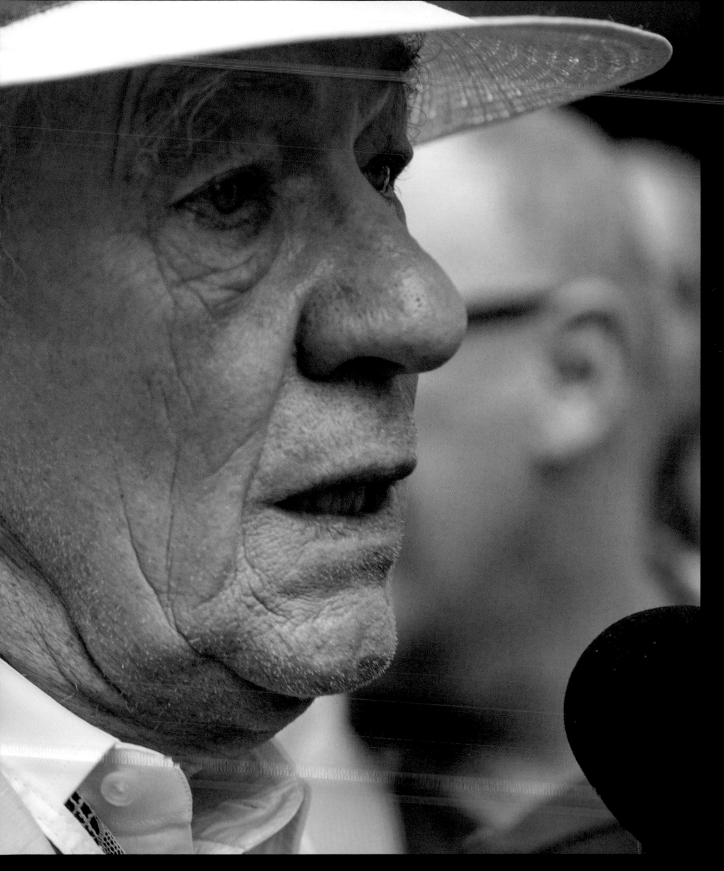

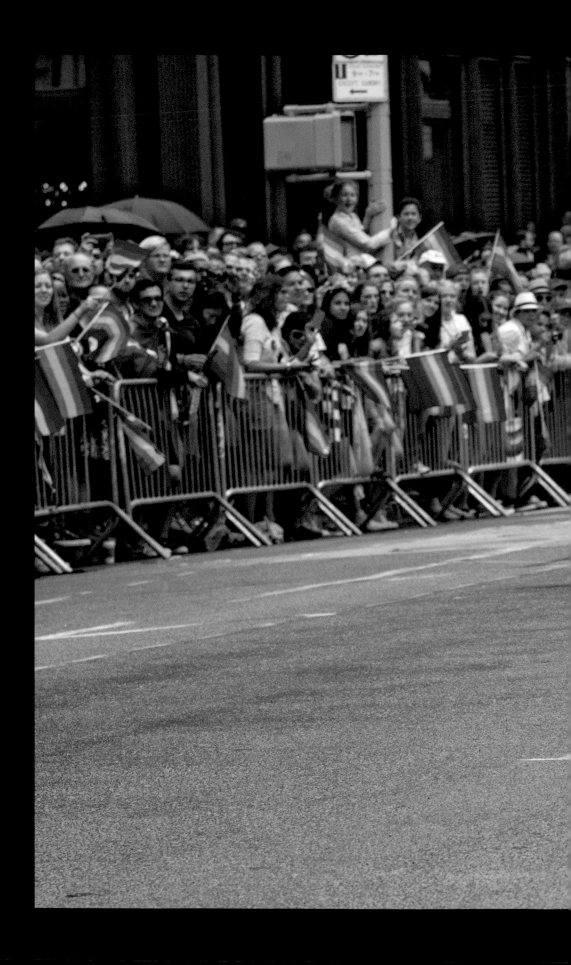

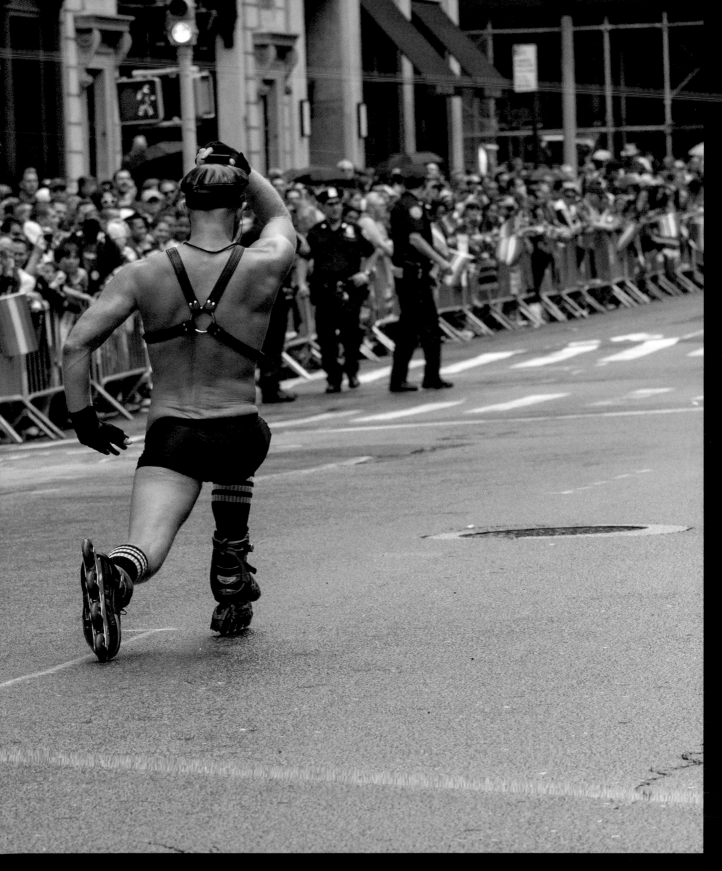

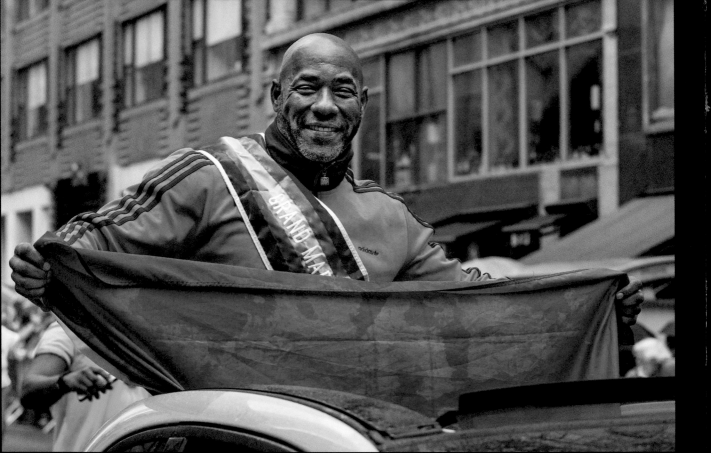

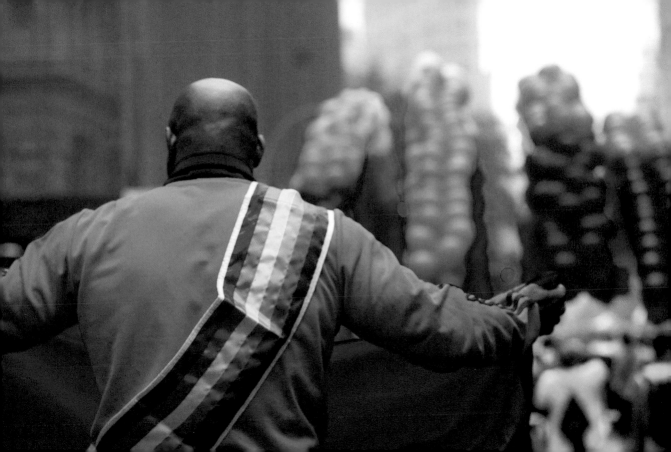

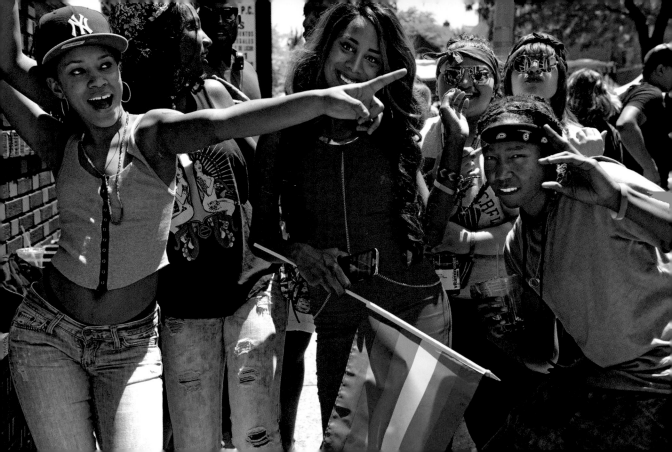

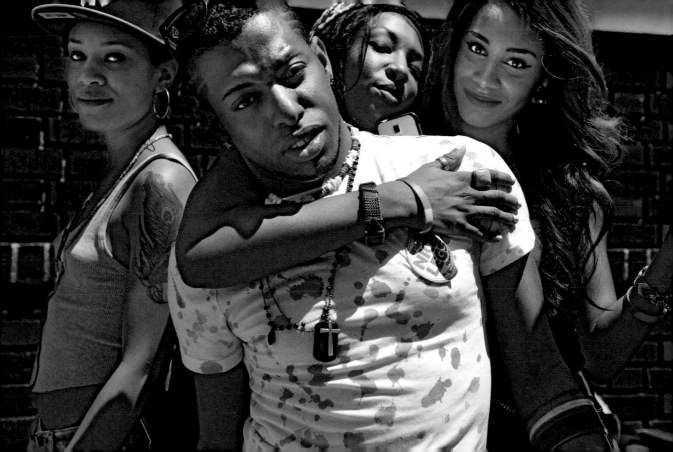

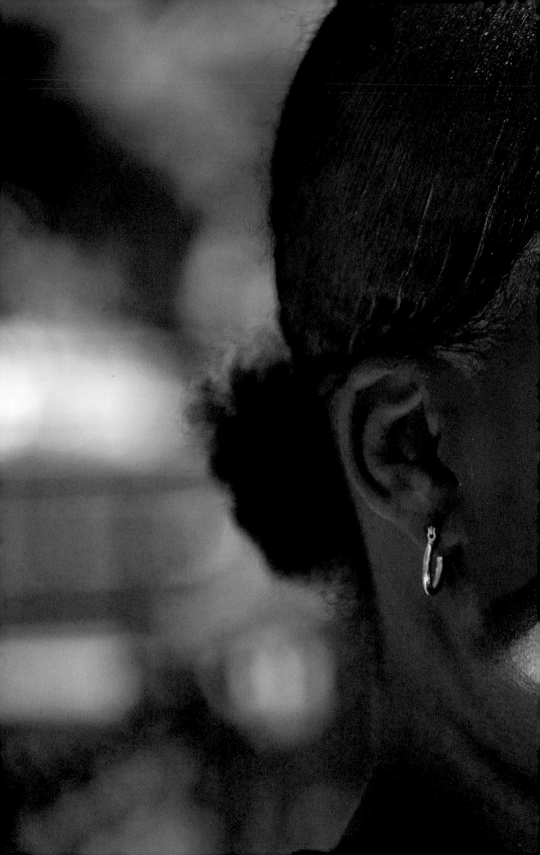

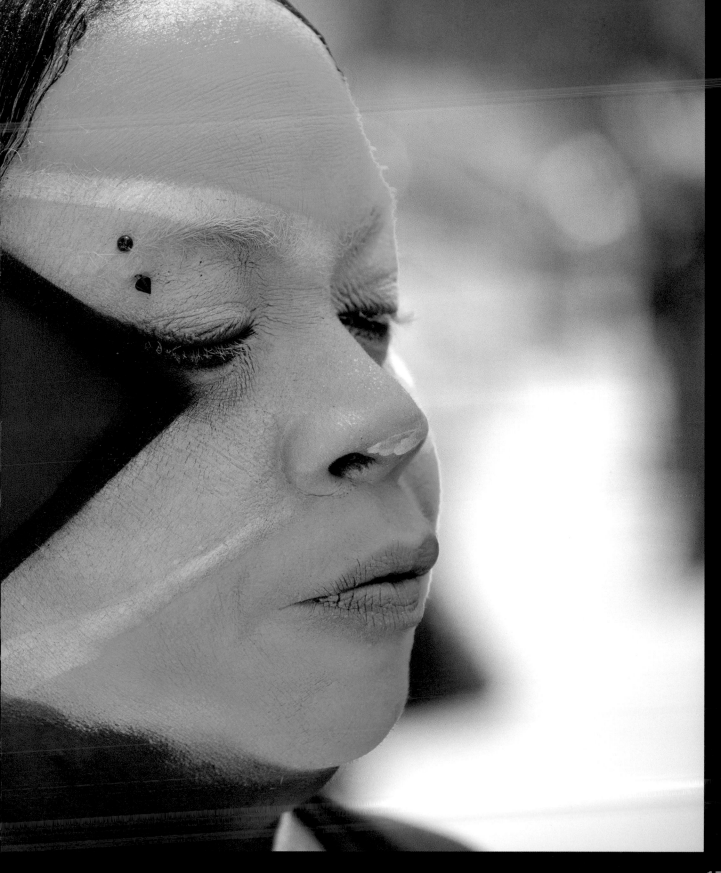

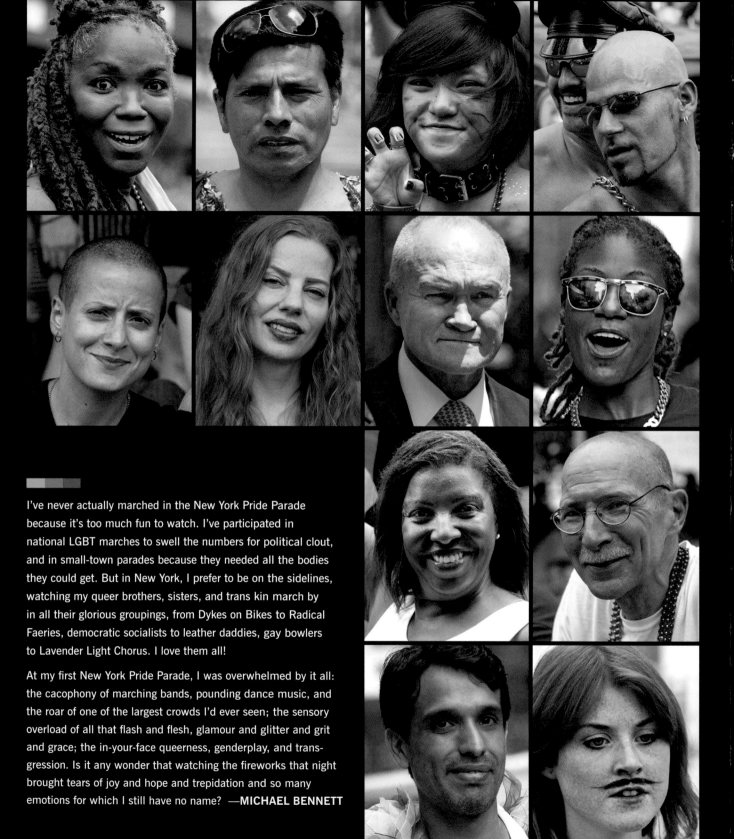

I've never actually marched in the New York Pride Parade because it's too much fun to watch. I've participated in national LGBT marches to swell the numbers for political clout, and in small-town parades because they needed all the bodies they could get. But in New York, I prefer to be on the sidelines, watching my queer brothers, sisters, and trans kin march by in all their glorious groupings, from Dykes on Bikes to Radical Faeries, democratic socialists to leather daddies, gay bowlers to Lavender Light Chorus. I love them all!

At my first New York Pride Parade, I was overwhelmed by it all: the cacophony of marching bands, pounding dance music, and the roar of one of the largest crowds I'd ever seen; the sensory overload of all that flash and flesh, glamour and glitter and grit and grace; the in-your-face queerness, genderplay, and transgression. Is it any wonder that watching the fireworks that night brought tears of joy and hope and trepidation and so many emotions for which I still have no name? —MICHAEL BENNETT

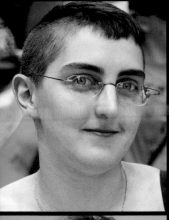
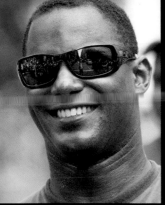

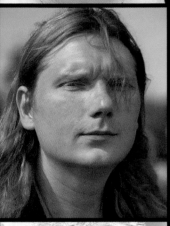
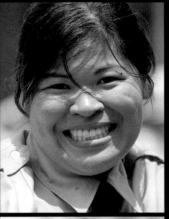

I attend the march with my wife and three friends—the same three friends every year. It's not that I only see them once a year at Pride, but that they are my regular crew of friends whom I see often. So the Pride March becomes part of what we do together.

There isn't a particular moment that I enjoy. Rather it's the entire vibe. I enjoy the music most of all. Since I don't go to clubs like I used to—being settled into a lovely domestic life—I enjoy hearing the kind of music that I associate with my former lifestyle, in which I would go out to such venerable places as the Garage here in New York or the Box in San Francisco.

It's hard to say what the Pride March really means to me. I'm very happy that it exists, but it has become too corporate over the years. While it's great, for example, that AT&T employees feel free to march, the corporate presence is off-putting. I would say the same thing about the degree of participation of politicians. It seems that supporting LGBT people is a rather safe —if not strategic—thing for corporations and politicians to do. Hence, there is less of an edge to the march.

Over the years, my favorite way of expressing pride and joy as a queer person has not been the NYC Pride March but rather the San Francisco Dyke March. I lived in the Bay Area for thirteen years, and back in the day (the 1990s) the Dyke March was over the top in terms of the expression of joy. I did march in the Dyke March. It was a real party; it was the highlight of my year.

—JACKIE BROWN

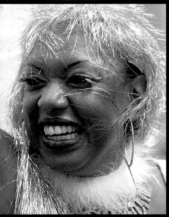

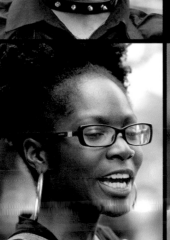
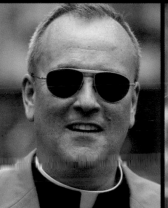

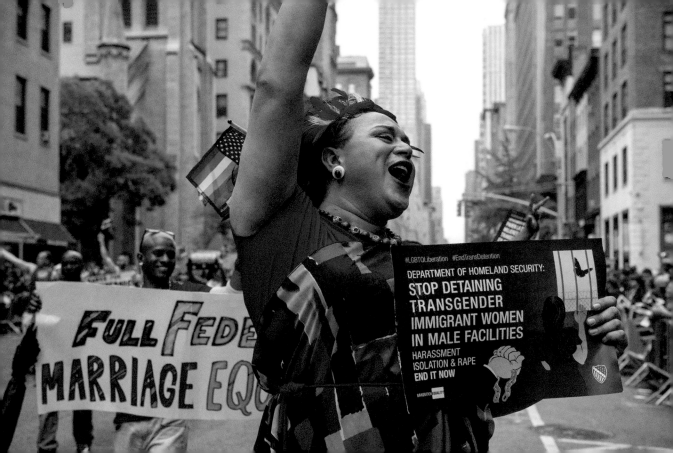

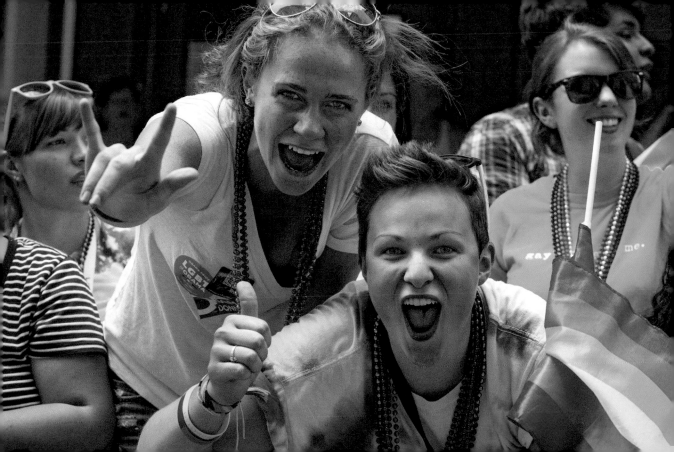

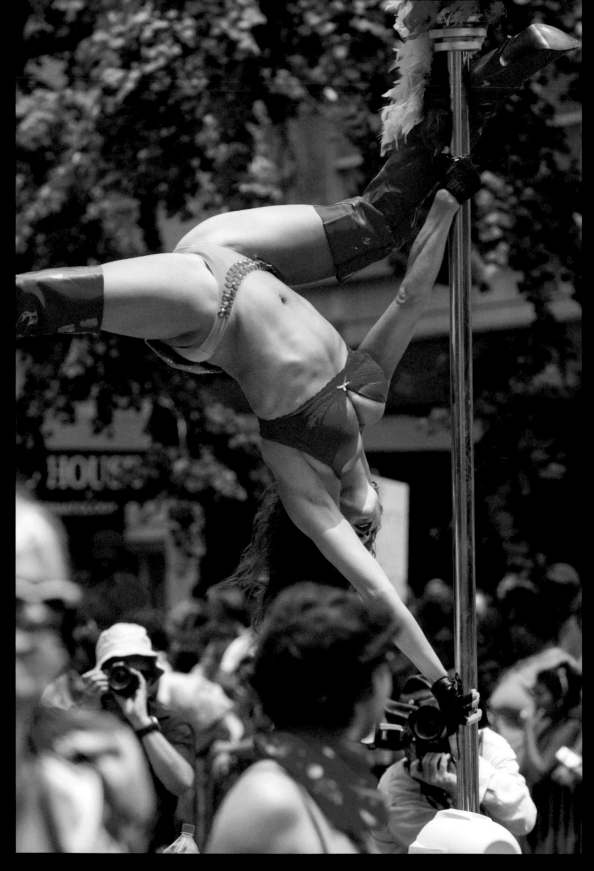

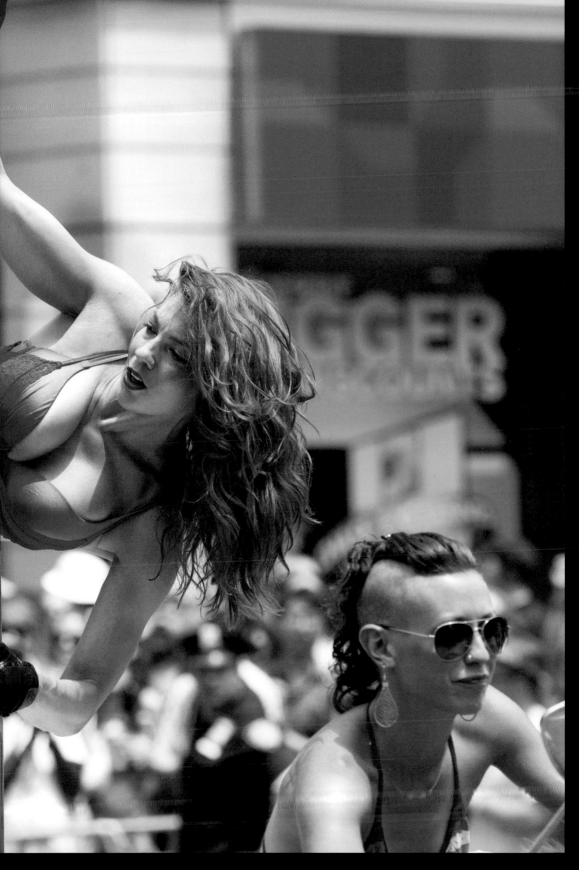

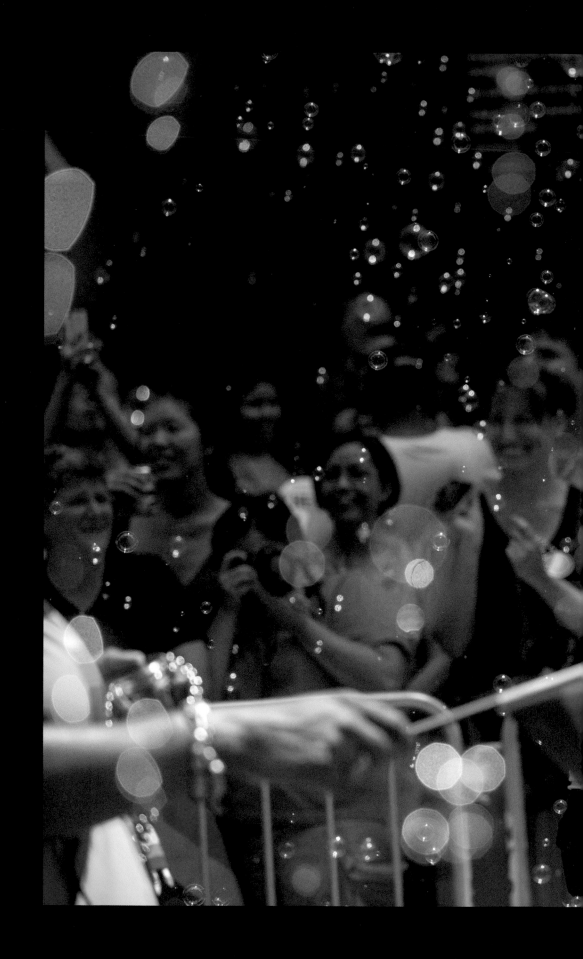

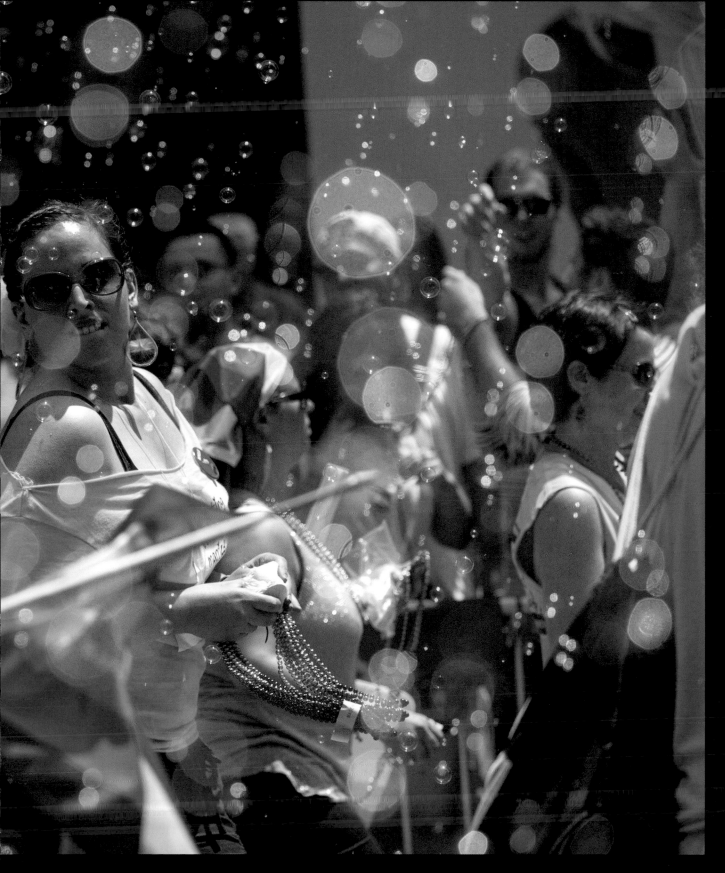

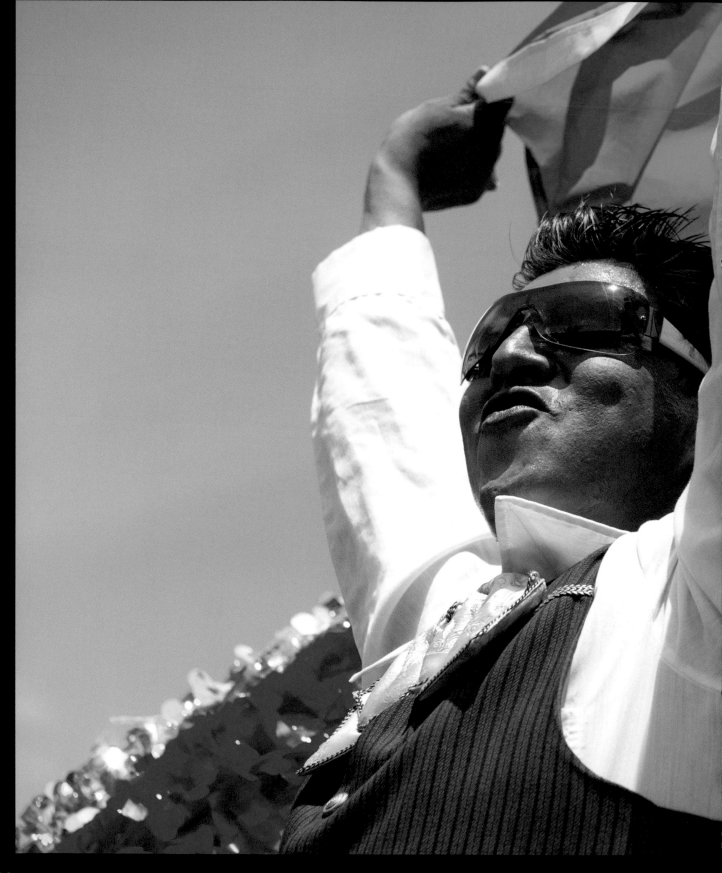

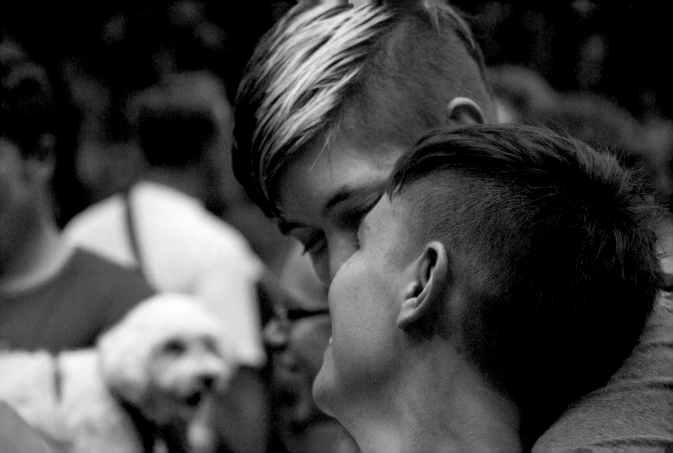

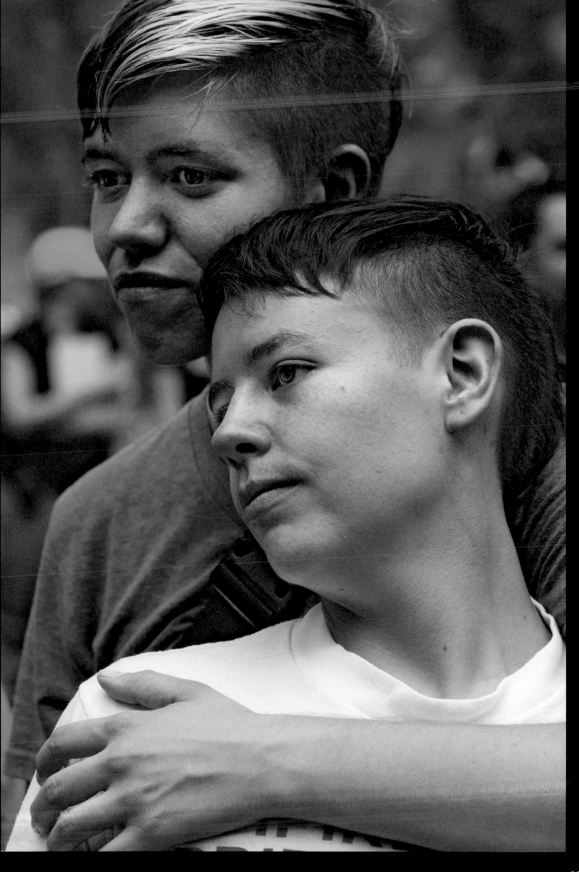

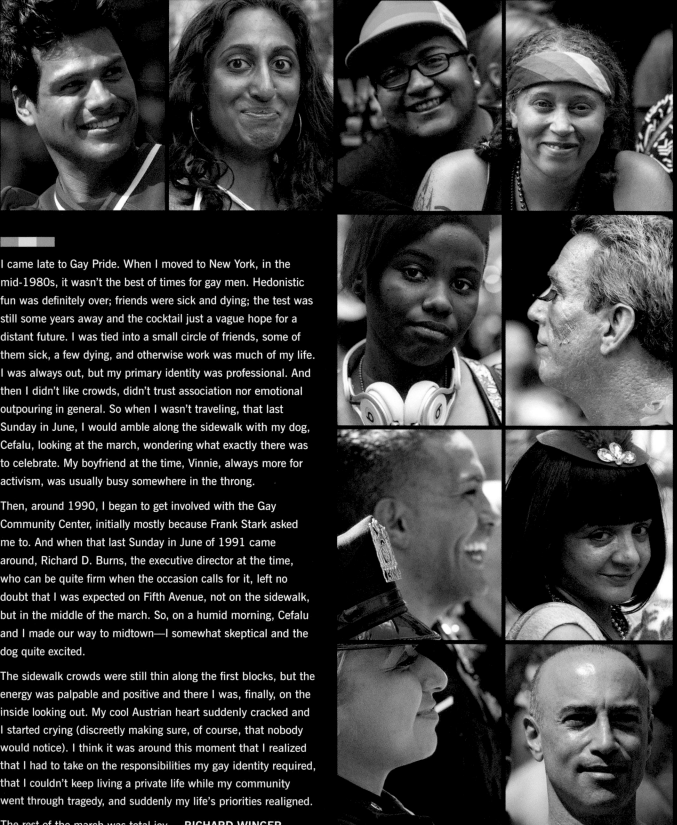

I came late to Gay Pride. When I moved to New York, in the mid-1980s, it wasn't the best of times for gay men. Hedonistic fun was definitely over; friends were sick and dying; the test was still some years away and the cocktail just a vague hope for a distant future. I was tied into a small circle of friends, some of them sick, a few dying, and otherwise work was much of my life. I was always out, but my primary identity was professional. And then I didn't like crowds, didn't trust association nor emotional outpouring in general. So when I wasn't traveling, that last Sunday in June, I would amble along the sidewalk with my dog, Cefalu, looking at the march, wondering what exactly there was to celebrate. My boyfriend at the time, Vinnie, always more for activism, was usually busy somewhere in the throng.

Then, around 1990, I began to get involved with the Gay Community Center, initially mostly because Frank Stark asked me to. And when that last Sunday in June of 1991 came around, Richard D. Burns, the executive director at the time, who can be quite firm when the occasion calls for it, left no doubt that I was expected on Fifth Avenue, not on the sidewalk, but in the middle of the march. So, on a humid morning, Cefalu and I made our way to midtown—I somewhat skeptical and the dog quite excited.

The sidewalk crowds were still thin along the first blocks, but the energy was palpable and positive and there I was, finally, on the inside looking out. My cool Austrian heart suddenly cracked and I started crying (discreetly making sure, of course, that nobody would notice). I think it was around this moment that I realized that I had to take on the responsibilities my gay identity required, that I couldn't keep living a private life while my community went through tragedy, and suddenly my life's priorities realigned.

The rest of the march was total joy. —**RICHARD WINGER**

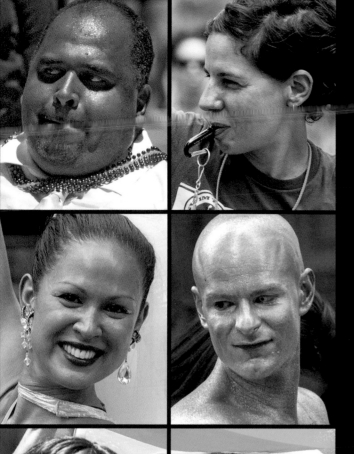

My world opened up in a big way when I met J.P. Singh and Shalini Vallabhan in D.C.—overachieving gaysis (gay desis*) who were out, but not so open with their parents and the extended community. They introduced me to the LGBT gaysis in D.C. and New York who organized the march delegations. They invited me to march with them.

I was transformed.

The South Asian Lesbian and Gay Association (SALGA) float was magical and beautiful. It included drag queens wearing their best saris singing Bollywood songs; and dholki (drum)-pounding sisters driving a bhangra beat—all to the cheers of thousands of our larger gay and straight allies.

At the start, part of me was scared that the "aunties would talk" and I would feel the wrath when I got back to the "real" world. But a larger part felt powerful beyond belief.

By the end, there was absolutely no shame in my game—and I vowed to share the strength that I found that day with other gaysis—and anyone else who has ever felt like an outsider.

—SHAMINA SINGH

*person of Indian, Pakistani, or Bangladeshi birth or descent who lives abroad

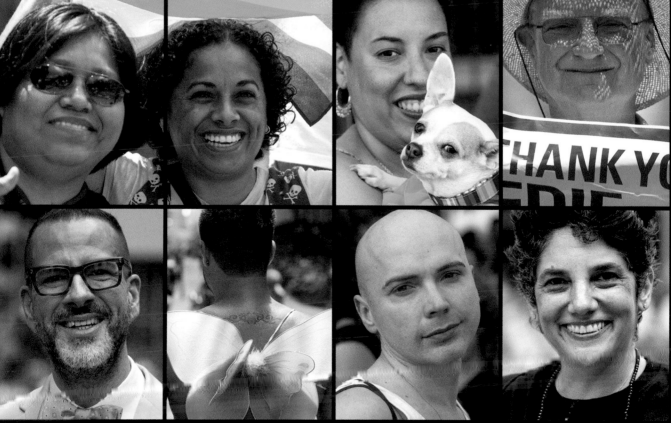

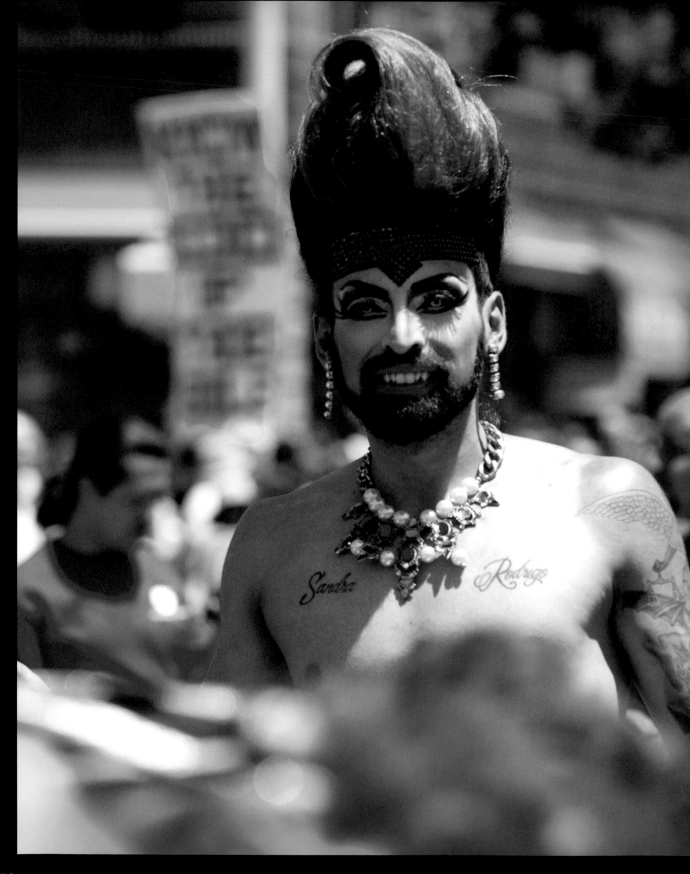

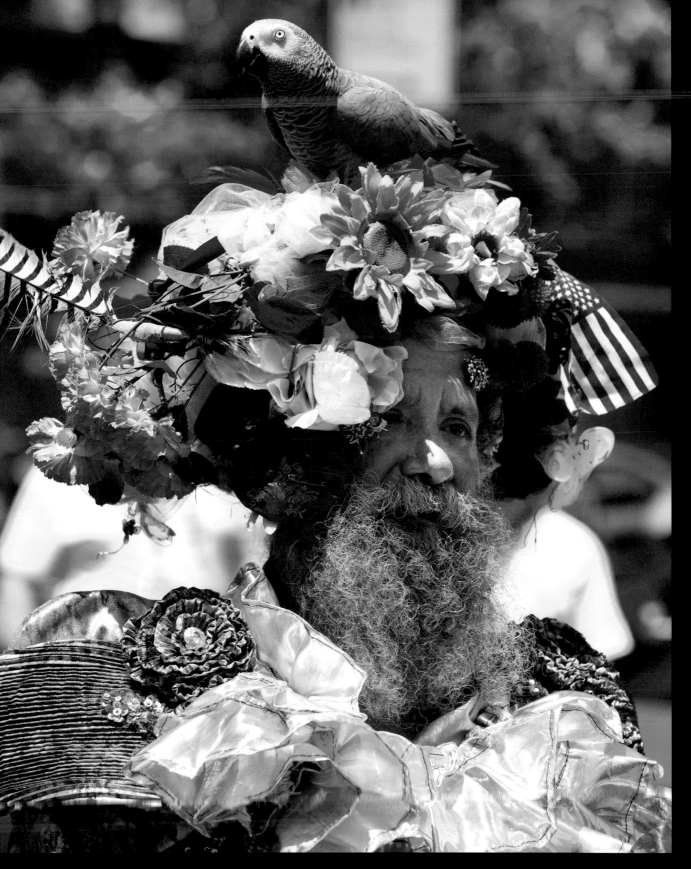

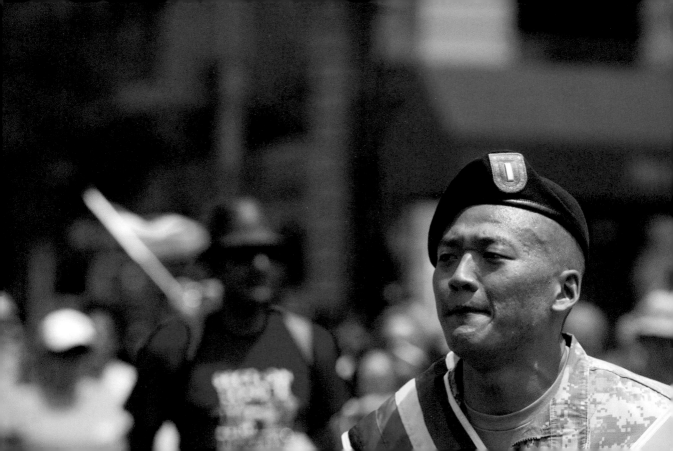

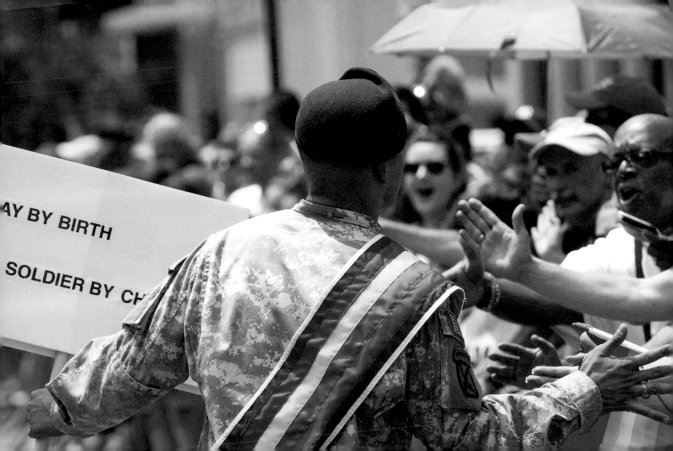

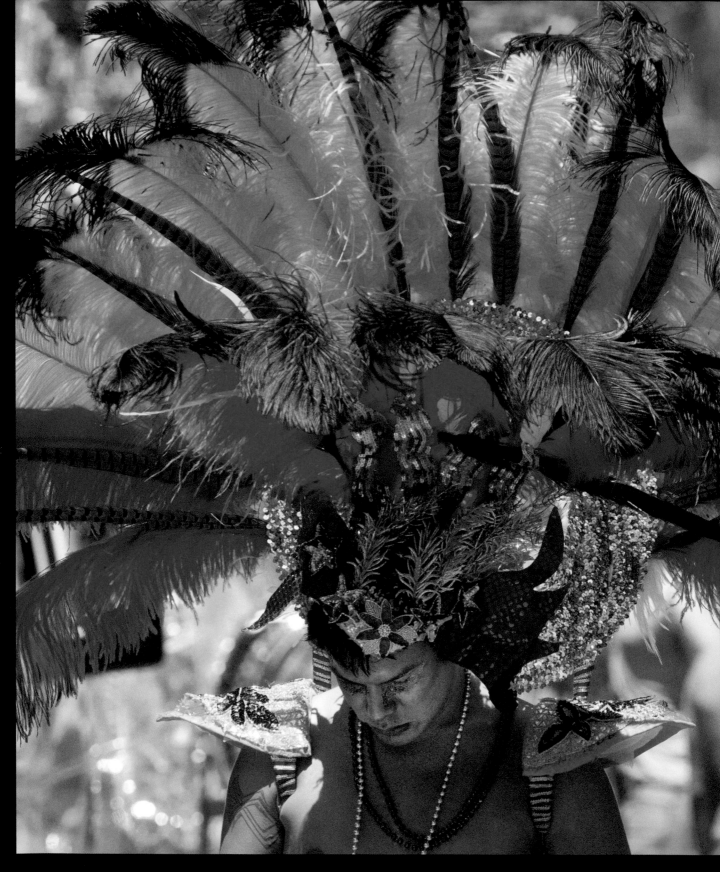

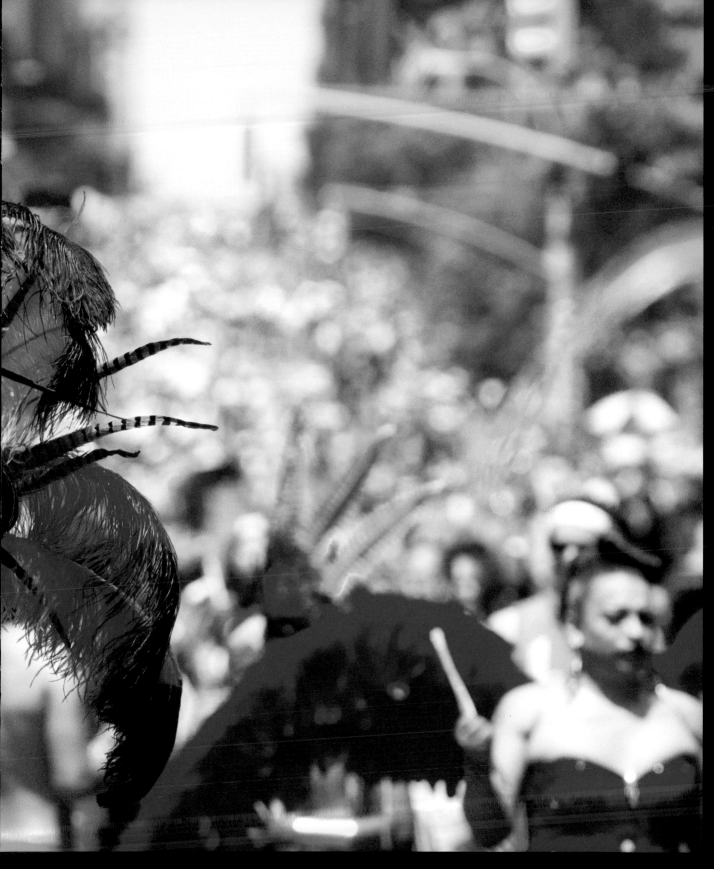

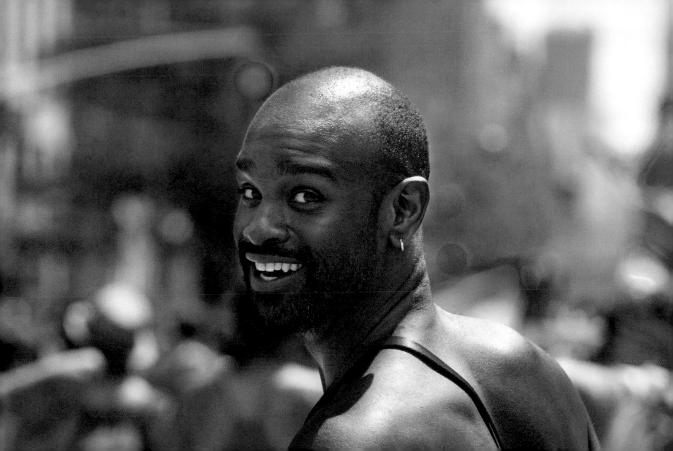

1969

The Stonewall riots transform the gay-rights movement from a small number of activists into a widespread protest for equal rights and acceptance. Patrons of a gay bar in New York's Greenwich Village, the Stonewall Inn, fight back during a police raid on June 28, sparking three days of riots.

1970

June
The first Christopher Street Liberation Day March, with 2,000 people, marches up Sixth Avenue to a Gay-In in Sheep Meadow, Central Park.

1971

October
The New York City Department of Consumer Affairs recommends the repeal of a city law banning homosexuals from working in or going to bars.

December
The U.S. gay-rights activist group Gay Activists Alliance protests in front of the Suffolk County, New York, police headquarters after two members were arrested for sodomy.

1972

July
The United States Supreme Court issues its ruling in *Baker v. Nelson,* in which the plaintiffs sought to have Minnesota's restriction of marriage to different-sex couples declared unconstitutional. The court dismisses the case "for want of a substantial federal question."

1973

The Christopher Street Liberation Day Festival (now Pride) is founded.

1974

The Lesbian Feminist Liberation (LFL) marches with the men but holds their separate rallies for women (through 1980).

January
New York City theater magazine *After Dark* bans the use of the word "gay" in advertisements.

February
Elaine Noble becomes the first openly gay or lesbian individual to be elected to a state legislature in the United States when she is elected to the Massachusetts House of Representatives.

1977

Dade County, Florida, passes an antidiscrimination ordinance. Anita Bryant, a born-again Christian singer and orange-juice spokeswoman, is affronted by this, and leads a successful repeal of the ordinance. In response, marches across the country swell. New York City's march swells from 15,000 to 75,000 and overtakes Fifth Avenue rather than be relegated to Sixth Avenue, and rallies in the Great Lawn of Central Park.

1987

WE THE PEOPLE —PROUD, STRONG, UNITED
Rev. John McNeill and Karen Thompson

The first Dance on the Pier is held on Pier 45 as a fundraiser for the march and the rally in New York.

1988

RIGHTFULLY PROUD AND FIGHTING ON
Jeanne Manford

October
In the United States, National Coming Out Day is founded.

1989

STONEWALL 20: A GENERATION OF PRIDE

June
The block of Christopher Street with the Stonewall, then vacant, is renamed "Stonewall Place" through the efforts of Heritage of Pride. The unveiling of new street signs and the flying of the rainbow flag in Christopher Park are highlights of that year's proclamation ceremony. This marks the first official recognition of the site of the Stonewall riots.

December
New York City sees approximately 4,500 protesters at St. Patrick's Cathedral during mass in a "Stop the Church" action organized by the AIDS Coalition to Unleash Power (ACT UP) and Women's Health Action and Mobilization to demonstrate dissatisfaction with the Roman Catholic Archdiocese's position against AIDS education, the distribution of condoms, and abortion. One hundred eleven protesters are arrested.

1990

FAMILY, FRIENDS AND LOVERS
Ove Carlsen and Ivan Larsen

February
The United States Court of Appeals for the Ninth Circuit in *High Tech Gays v. Defense Industrial Security Clearance Office* uses rational basis review and rules that the federal government can deny security clearances to homosexuals.

March
Queer Nation, a direct action group, is founded in New York City by activists from ACT UP.

June
The Empire State Building is lit up in lavender for the first time (it is now lit rainbow during Pride).

October
The U.S. Congress repeals a law prohibiting gays from being admitted into the country.

1991

OUT LOUD AND PROUD
Michael Callen
Deborah Glick

1980

- The Tenth Annual Commemoration of Lesbian and Gay Pride and commemoration of the Stonewall Rebellion assemble at Sheridan Square and march to Ninety-Seventh and Fifth Avenue, Central Park.

- At the 1980 Democratic National Convention held at New York City's Madison Square Garden, Democrats take a stance supporting gay rights, adding the following to their plank: "All groups must be protected from discrimination based on race, color, religion, national origin, language, age, sex or sexual orientation."

1982

A HERITAGE OF PRIDE
Anthony J. Gambino
Susan Horowitz

1983

DIVERSITY IS OUR STRENGTH. LIBERATION IS OUR FIGHT

- The Lesbian, Gay, Bisexual and Transgender Center is founded.

1984

- Scandal rocks Christopher Street Liberation Day Committee (CSLDC) and many members of executive board resign. The remaining organizers form Heritage of Pride (HOP). The first march permit is issued by the city.

1985

YOU AIN'T SEEN NOTHIN' YET!
Gean Harwood
Bruhs Mero
May and Marion

- March
The Supreme Court of the United States, being divided 4–4, affirms the ruling of the Tenth Circuit Court of Appeals, which struck down an Oklahoma state law allowing teachers to be fired for "advocating, soliciting, imposing, encouraging or promoting public or private homosexual activity in a manner that creates a substantial risk that such conduct will come to the attention of school children or school employees." The appellate court found that the law infringed on First Amendment guarantees of free speech.

- June
For the first time ever, the march goes down Fifth Avenue officially. The first Lavender Line is painted down Fifth Avenue along the entire march route.

- October
New York City mayor Ed Koch asks the American Legion's Veterans Day parade to allow gay veterans to march. He is ignored.

1986

FORWARD TOGETHER
New York City Council members who voted in favor of Intro 2*

- Another setback in the United States occurs in 1986, when the U.S. Supreme Court upholds a Georgia antisodomy law in the case of *Bowers v. Hardwick*. (This ruling would be overturned two decades later in *Lawrence v. Texas*.)

*Homosexual Rights BIll—discrimination in employment and public accommodations based on "sexual orientation" is illegal.

1992

PRIDE = POWER
Thomas K. Duane
Karen Thompson

- June
The Lesbian Avengers, a direct action group, is founded in New York City by activists from ACT UP.

1993

OUTLAW, OUTRAGE, OUTRIGHT, OUTSPOKEN, OUTRAGEOUS, OUTSTANDING
Miriam Ben-Shalom
Perry Watkins

- The "don't ask, don't tell" policy is instituted for the U.S. military, permitting gays to serve in the military but banning homosexual activity. President Clinton's original intention to revoke the prohibition against gays in the military is met with stiff opposition; this compromise, which led to the discharge of thousands of men and women in the armed forces, is the result.

1994

SEIZE THE SPIRIT, STONEWALL 25

- The Gay Games are held in New York.

- Twenty-fifth anniversary of the Stonewall riots—the world's first great international lesbian/gay march and rally.

- Two million in New York City, June 26, 1994.

1995

PRIDE: FROM SILENCE TO CELEBRATION
Karen S. Burstein
Elder Rev. Zachary G. Jones
Greg Louganis

- March
In *Abel v. United States of America,* the first challenge to "don't ask, don't tell," district judge Eugene Nickerson rules that the provision of the 1993 law barring LGBT military personnel from saying they are LGBT infringes on their First Amendment and Fifth Amendment rights.

- August
U.S. president Bill Clinton signs Executive Order 12968, which bans discrimination based on "sexual orientation" as it establishes uniform policies for allowing government employees access to classified information.

- October
The United States Supreme Court hears oral arguments in *Romer v. Evans*, the case that would eventually overturn Colorado's Amendment 2, which banned gay rights laws in the state.

1996

PRIDE WITHOUT BORDERS
Thomas B. Stoddard
Dr. Ramon Torres

- In *Romer v. Evans*, the Supreme Court strikes down Colorado's Amendment 2, which denied gays and lesbians protections against discrimination, calling them "special rights." According to Justice Anthony Kennedy, "We find nothing special in the protections Amendment 2 withholds. These protections . . . constitute ordinary civil life in a free society."

1997

LIBERATE EDUCATE DEMONSTRATE
Barney Frank
Barbara Gittings

- Obstacles, like the Defense of Marriage Act, continue to get in the way, but the community marches on. In 1997, Heritage of Pride hosts the sixteenth annual International Association of Lesbian and Gay Pride Coordinators conference, the first to have substantial participation from international committees.

1998

UNITY THROUGH DIVERSITY

**Margarita Lopez
Phil Reed**

- May
U.S. president Bill Clinton signs Executive Order 13087 to prohibit discrimination based on sexual orientation in the competitive service of the federal civilian workforce.

- September
The U.S. Court of Appeals for the Second Circuit in *Abel v. United States*

of America rules that the government's proffered reasons for passing "don't ask, don't tell" pass rational basis review, reversing the district court.

- October
The U.S. Supreme Court refuses an appeal in *Equality Foundation of Greater Cincinnati, et al. v. The City of Cincinnati*, in which the U.S. Court of Appeals for the Sixth Circuit had twice found the city's antigay Issue

3 constitutional despite the Supreme Court's ruling in *Romer v. Evans* that struck down a state constitutional amendment that used substantially the same language.

- November
Tammy Baldwin (D-WI) is elected to the U.S. House of Representatives. She is the first open lesbian and the first nonincumbent gay candidate to be elected to federal office.

1999

PROUD PAST/ POWERFUL FUTURE

**Jonathan Ned Katz
Joan Nestle**

- October
The *Washington Times* claims George W. Bush assured conservative supporters that he would not "knowingly" appoint any homosexuals as ambassadors or department heads in his administration if elected president.

2000

TAKE PRIDE, TAKE JOY, TAKE ACTION

**Virginia Apuzzo
James Dale**

2001

WHAT PART OF EQUAL DON'T YOU UNDERSTAND?

**Michelle M. Benecke
Matt Foreman
Hetrick Martin Institute**

- February
Jerrold Nadler, U.S. congressman from New York, reintroduces the Permanent Partners Immigration Act (H.R 690) in the U.S. Congress.

2002

AGAINST THE DARK SKY, A RAINBOW SHINES BRIGHTLY

Dr. Karla Jay

- U.S. state of New York bans sexual orientation discrimination in the private sector.

2010

LIBERTY AND JUSTICE FOR ALL

**Constance McMillen
Judy Shepard
Lt. Dan Choi**

- March
Congress approves a law signed in December 2009 that legalizes same-sex marriage in the District of Columbia.

- December
The U.S. Senate votes 65 to 31 in favor of repealing "don't ask, don't tell," the Clinton-era military policy that forbids openly gay men and

women from serving in the military. Eight Republicans side with the Democrats to strike down the ban. The ban will not be lifted officially until President Obama; Defense Secretary Robert Gates; and Admiral Mike Mullen, the chairman of the Joint Chiefs of Staff; agree that the military is ready to enact the change and that it won't affect military readiness.

- President Obama officially repeals the "don't ask, don't tell" military policy.

2011

PROUD AND POWERFUL

**Dan Savage and his husband Terry Miller
Rev. Pat Bumgardner**

- June
New York passes a law to allow same-sex marriage. New York is now the largest state that allows gay and lesbian couples to marry. The vote comes on the eve of the city's annual Gay

Pride Parade and gives new momentum to the national gay-rights movement. The marriage bill is approved with a 33 to 29 vote. Cheering supporters greet Governor Andrew Cuomo as he arrives on the Senate floor to sign the measure at 11:55 p.m., just moments after the vote. After making same-sex marriage one of his top priorities, Cuomo emerges as a true champion of gay rights.

2012

SHARE THE LOVE

**Cyndi Lauper
Chris Salgardo
Connie Kopelov
and Phyllis Siegel**

- May
President Barack Obama endorses same-sex marriage. "It is important for me to go ahead and affirm that I think same-sex couples should be able to get married," he says. He makes the statement days after Vice President Joe Biden and Secretary of Education Arne Duncan both come out in support of gay marriage.

2013

RAIN TO RAINBOWS

**Edith Windsor
Earl Fowlkes
Harry Belafonte**

- March
The Supreme Court begins two days of historical debate over gay marriage. During the debate, the Supreme Court considers overturning Proposition 8, the California initiative banning same-sex marriage, and the Defense of Marriage

Act, a federal law passed during Bill Clinton's presidency, which defines marriage as between a man and a woman. The Supreme Court's decision will be announced in June 2013.

- June
The Supreme Court rules that the 1996 Defense of Marriage Act (DOMA) is unconstitutional. In a 5 to 4 vote, the court rules that DOMA violates the rights of

2003
PEACE THROUGH PRIDE
Cherry Jones
Terrence McNally

● June
The U.S. Supreme Court rules in *Lawrence v. Texas* that sodomy laws in the United States are unconstitutional. Justice Anthony Kennedy writes, "liberty presumes an autonomy of self that includes freedom of thought, belief, expression, and certain intimate conduct."

2004
STAND UP! STAND OUT! STAND PROUD!
Candice Boyce
Harvey Fierstein

2005
EQUAL RIGHTS— NO MORE, NO LESS
Pauline Park
Andrew Tobias

2006
THE FIGHT FOR LOVE AND LIFE
Florent Morellet
Christine Quinn

2007
UNITED FOR EQUALITY
Rabbi Sharon Kleinbaum
Reverend Troy Perry

● November
The House of Representatives approves a bill granting broad protections against discrimination in the workplace, ensuring equal rights for gay men, lesbians, and bisexuals.

2008
LIVE—LOVE—BE
Gilbert Baker
Candice Cayne
NY Governor David A. Paterson

● February
New York State appeals court unanimously votes that valid, same-sex marriages performed in other states must be recognized by employers in New York.

2009
PAINT THE TOWN RUBY, STONEWALL 40
(Fortieth Anniversary of the Stonewall Riots in New York City)
Cleve Jones
Anne Kronenberg
Dustin Lance Black

● June 17
President Obama signs a referendum allowing the same-sex partners of federal employees to receive benefits. They will not be allowed full health coverage, however. This is Obama's first major initiative in his campaign promise to improve gay rights.

2014
WE HAVE ONE WHEN WE ARE ONE
Laverne Cox
Jonathan Groff
Rea Carey

gays and lesbians. The court also rules that the law interferes with the states' rights to define marriage. It is the first case ever on the issue of gay marriage for the Supreme Court. Chief Justice John G. Roberts Jr. votes against striking it down as do Antonin Scalia, Samuel Alito, and Clarence Thomas. However, conservative-leaning justice Anthony M. Kennedy votes with his liberal colleagues to overturn DOMA.

● January
The U.S. Supreme Court blocks any further same-sex marriages in Utah while state officials appeal the decision made by Judge Robert Shelby in late December 2013. The block creates legal limbo for the 1,300 same-sex couples who have received marriage licenses since Judge Shelby's ruling.

● October
The U.S. Supreme Court declines to hear appeals of rulings in Indiana, Oklahoma, Utah, Virginia, and Wisconsin that allowed same-sex marriage. The move paves the way for same-sex marriages in the five states. In fact, Virginia announces that unions would begin that day.

● November
The U.S. Supreme Court denies a request to block same-sex marriage in Kansas.

● A federal judge strikes down Montana's ban on same-sex marriage as unconstitutional.

● The U.S. Supreme Court denies a request to block same-sex marriage in South Carolina. The ruling means South Carolina becomes the thirty-fifth U.S. state where same-sex marriage is legal.

2015
COMPLETE THE DREAM
Ian McKellen
Derek Jacobi
Kasha Jacqueline Nabagesera
J. Christopher Neal

● June
The U.S. Supreme Court rules 5 to 4 in *Obergefell v. Hodges* that same-sex couples have the fundamental right to marry and that states cannot say that marriage is reserved for heterosexual couples. "Under the Constitution, same-sex couples seek in marriage the same legal treatment as opposite-sex couples, and it would disparage their choices and diminish their personhood to deny them this right," Justice Anthony Kennedy writes in the majority opinion.

2016
EQUALITY NEEDS YOU

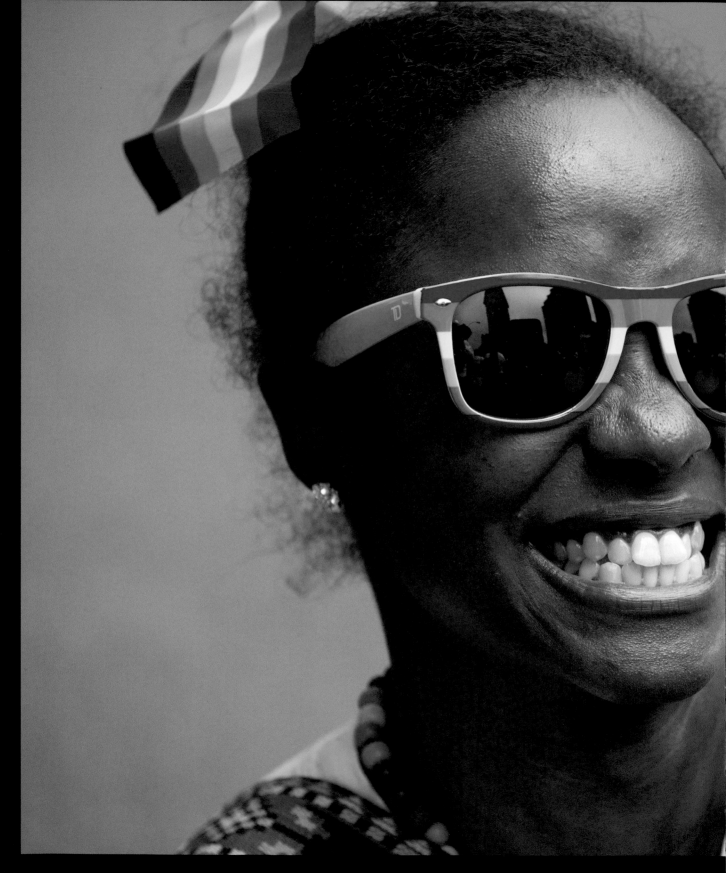

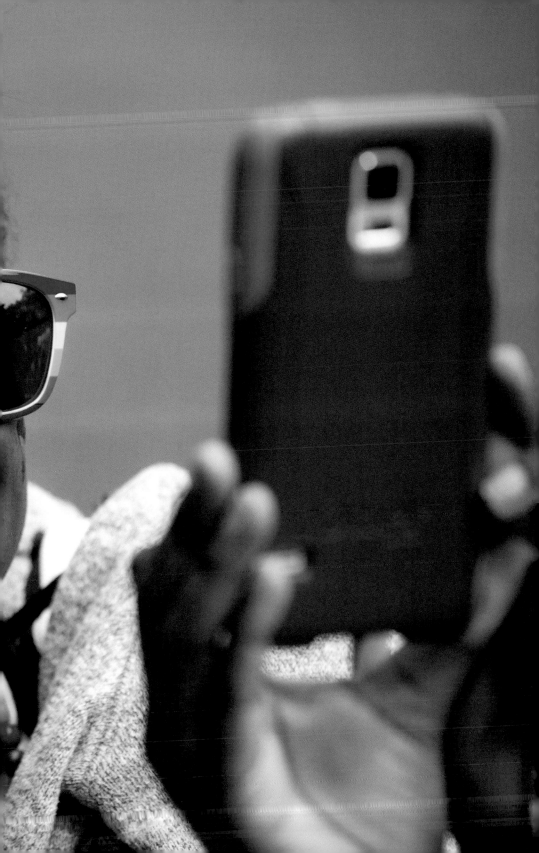

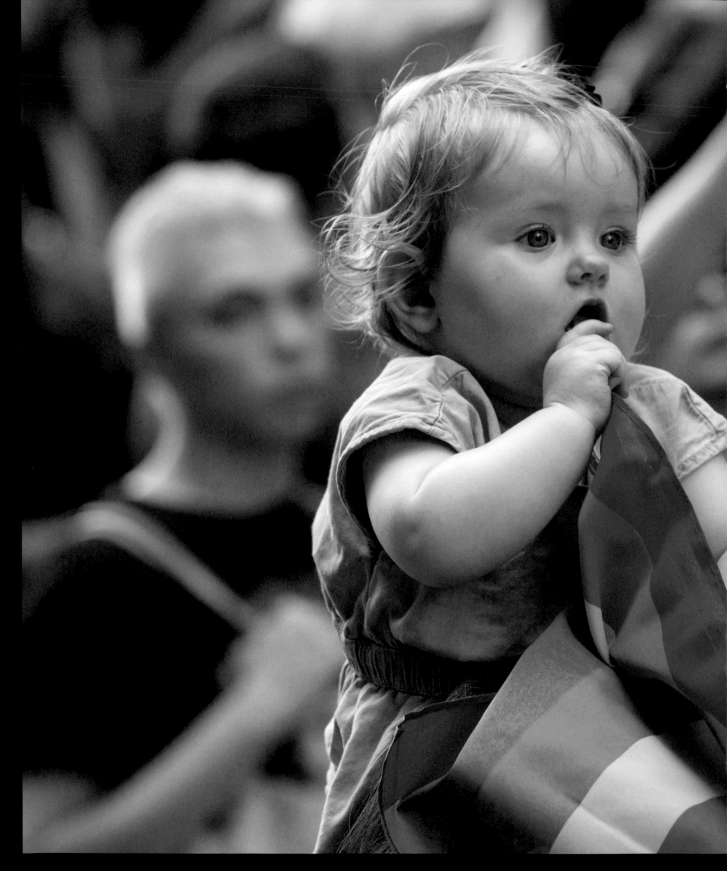

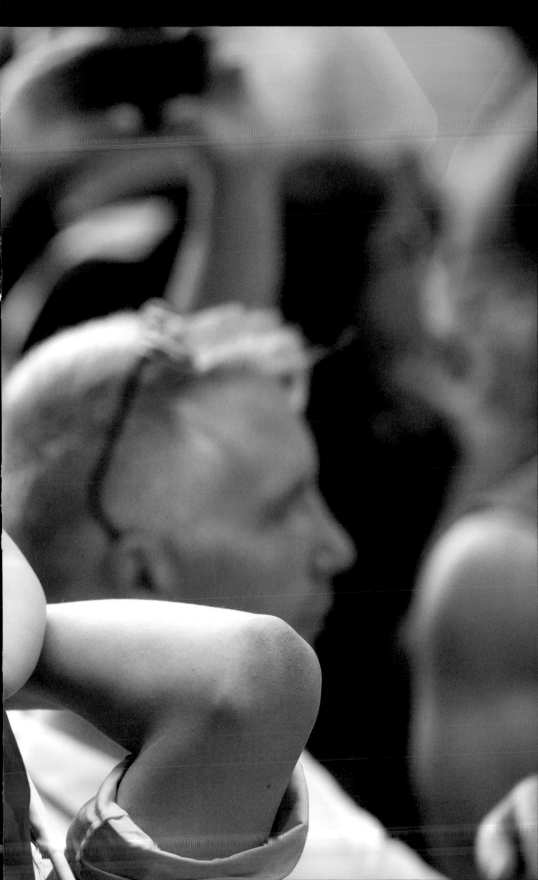

CONTRIBUTORS

Susan Allee *p.119*
Director of the Middle East desk at the Department of Peacekeeping at the United Nations, co-founder of UN Globe.

Byllye Avery *p.14*
Founder of the Black Women's Health Imperative and the Avery Institute for Social Change.

Lee Badgett *p.111*
Director of the Center for Public Research for Public Policy and Administration at the University of Massachusetts Amherst; professor of economics and Williams Distinguished Scholar at the Williams Institute.

Elizabeth Baltazar *p.147*
Senior assistant general counsel at Zurich Global Life.

Juan Battle *p.137*
Professor of sociology, public health and urban education at the Graduate Center of the City University of New York.

Alison Bechdel *p.15*
Cartoonist, writer, and author of graphic memoir *Fun Home.*

Michael Bennett *p.158*
Writer and professor of English, Long Island University, City University of New York.

Jacqueline Brown *p.159*
Professor of anthropology at Hunter College, City University of New York.

Richard D. Burns *p.67*
LGBTQ rights advocate. Interim executive director at Funders for LGBTQ Issues. Former interim executive director of the Stonewall Community Foundation and chief operating officer at the Arcus Foundation.

Leslie Cagan *p.86*
Activist, writer, and organizer involved with the peace and social justice movements.

Barbara Cohen *p.86*
Artist and LGBTQ rights activist.

John D'Emilio *p.66*
Professor of history and of women's and gender studies at the University of Illinois. Former professor at the University of North Carolina.

Wade Davis *p.99*
Activist, writer, and former NFL player turned LGBTQ rights advocate.

Lea DeLaria *p.51*
Comedian, actress, and jazz musician.

Laura Flanders *p.27*
English broadcast journalist and writer living in the United States. Host of the *Laura Flanders Show.*

Matt Foreman *p.110*
Senior program director at Evelyn and Walter Haas, Jr. Fund and LGBTQ rights lawyer.

Masha Gessen *p.72*
Russian journalist, author, and LGBTQ-rights activist presently living in the United States.

Suzanne B. Goldberg *p.146*
Executive vice president for university life; Herbert and Doris Wechsler Clinical Professor of Law; director, Center for Gender and Sexuality Law.

Catherine Gund *p.98*
Film director, writer, producer, community organizer, and founder of Aubin Pictures.

Holly Hughes *p.26*
Lesbian performance artist. Professor, University of Michigan School of Art & Design.

Kevin Jennings *p.87*
Educator, author, and administrator. Executive director of the Arcus Foundation. Former assistant deputy secretary for the Office of Safe and Drug-Free Schools and founder of GLSEN.

Rosamond S. King *p.39*
Writer and performance artist.

Rabbi Sharon Kleinbaum *p.67*
Spiritual leader of Congregation Beit Simchat Torah in New York City, advocate for human rights.

Cyndi Lauper *p.103*
Singer, songwriter, actress, and LGBTQ rights activist.

Ngina Lythcott *p.14*
Health care and higher education consultant.

Ruth Messinger *p.118*
Political activist. Former president and CEO of American Jewish World Service, and former political leader in New York City.

Bobby Miller *p.136*
Poet, actor, photographer, and author.

David Mixner *p.46*
Civil rights activist, author, LGBTQ-rights advocate, political strategist.

Debbie Nadolney *p.111*
Artist and musician. Co-founder of the Causeway Visual and Performing Artists.

Ann Northrop *p.146*
Journalist and activist. Co-host of TV news program *Gay USA.*

Cindy Rizzo *p.57*
LGBTQ-rights advocate, writer. Evaluation and strategy senior advisor of the Arcus Foundation.

Anthony Romero *p.129*
Attorney, civil rights activist. Executive director of the American Civil Liberties Union.

Dan Savage *p.56*
Author, journalist, and LGBTQ-rights activist.

Michelangelo Signorile *p.38*
Author, journalist, editor-at-large of *Huffington Post Gay Voices,* host of the *Michelangelo Signorile Show*.

Shamina Singh *p.173*
Executive director of the MasterCard Center for Inclusive Growth, and board member of the Corporation for National and Community Service.

Sean Strub *p.128*
Writer, activist, and director of The Sero Project. Founder of *POZ* magazine, *Mamm, Real Health,* and *Milford* magazine.

Glennda Testone *p.77*
Civil rights activist. Executive director of New York City's Lesbian, Gay, Bisexual and Transgender Community Center.

Judith Turkel *p.128*
Attorney in the area of nontraditional family law. Former board co-chair of SAGE.

Linda Villarosa *p.47*
Journalist, author, editor, LGBTQ activist, college professor.

Janet Weinberg *p.15*
Consultant and civil-rights activist. Former interim chief executive officer of the Gay Men's Health Crisis.

Randi Weingarten *p.56*
President of the American Federation of Teachers and a member of the AFL-CIO. Former president of the United Federation of Teachers.

Edith Windsor *p.38*
LGBTQ rights activist. Instrumental in the *United States v. Windsor* case resulting in the 2013 landmark ruling by the U.S. Supreme Court. Former technology manager at IBM.

Richard Winger *p.172*
Political activist and analyst. Publisher and editor of *Ballot Access News.*

Evan Wolfson *p.76*
Attorney, LGBTQ-rights advocate, author. Founder and president of Freedom to Marry.

Acknowledgments

The photographs presented in this book were made possible by a commission from Jon Stryker: philanthropist, architect, and photography devotee.

This book was made possible in part by a grant from the

My great appreciation to Kate Clinton for contributing a brilliant introduction to *Pride & Joy* and her essential editorial help on this book.

Special thanks to EWS in New York: Lisa LaRochelle Winton (my design partner), Manuel Mendez, Yoko Yoshida-Carrera, Lidia Momot, Abigail Watson, and Emma Zakarevicius. A more talented and dedicated team I've yet to find.

My gratitude to Fred Ritchin and Carole Naggar for their initial input on the concept of this series.

Thank you Anna and Leszek Hryniewieccy, Judi Rees, Byron Stinson, Kit Luce and Tina Liu, Edward Schneider and Jacqueline Mitchell, for your friendship and unconditional support.

My special gratitude to Bryan Simmons of the Arcus Foundation and to Marc Favreau of The New Press for their cooperation, patience, and advice. Thank you to Chris Fredrick, David Schneider, and the Heritage of Pride Inc.

Thank you to Maury Botton, Fran Forte, Gregory Lewis, Sebastian Naidoo, Anna Nowicka, Brian Pines, Slobodan Randjelović, Urvashi Vaid, and Cathy Davis and the team at Worzalla, for their contribution at various stages of this great project.

My deep gratitude goes to the *Pride & Joy* contributors: Susan Allee, Byllye Avery, Lee Badgett, Elizabeth Baltazar, Juan Battle, Alison Bechdel, Michael Bennett, Jackie Brown, Richard D. Burns, Leslie Cagan, Barbara Cohen, John D'Emilio, Wade Davis, Lea DeLaria, Laura Flanders, Matt Foreman, Masha Gessen, Suzanne B. Goldberg, Catherine Gund, Holly Hughes, Kevin Jennings, Rosamond S. King, Rabbi Sharon Kleinbaum, Cyndi Lauper, Ngina Lythcott, Ruth Messinger, Bobby Miller, David Mixner, Debbie Nadolney, Ann Northrop, Cindy Rizzo, Anthony Romero, Dan Savage, Michelangelo Signorile, Shamina Singh, Sean Strub, Glennda Testone, Judith Turkel, Linda Villarosa, Janet Weinberg, Randi Weingarten, Edith Windsor, Richard Winger, and Evan Wolfson. We extend our special thanks also to Governor Andrew Cuomo, former mayor Mike Bloomberg, and Mayor Bill de Blasio.

Thank you Lisa, Basil, Inka, Bela, Mama Zosia, and Tata Romek. Dziękuję.

Finally my deepest thanks go to Jon Stryker. I am honored to have him as my friend, project partner, and unwavering believer in the significance of this book series. Without Jon's enthusiasm, inspiration, and steady support of me —as well as of all other creators of these photo books—this unprecedented series would never be happening.

—Jurek Wajdowicz

* The Arcus Foundation is a global foundation dedicated to the idea that people can live in harmony with one another and the natural world. The Foundation works to advance respect for diversity among peoples and in nature (www.ArcusFoundation.org).

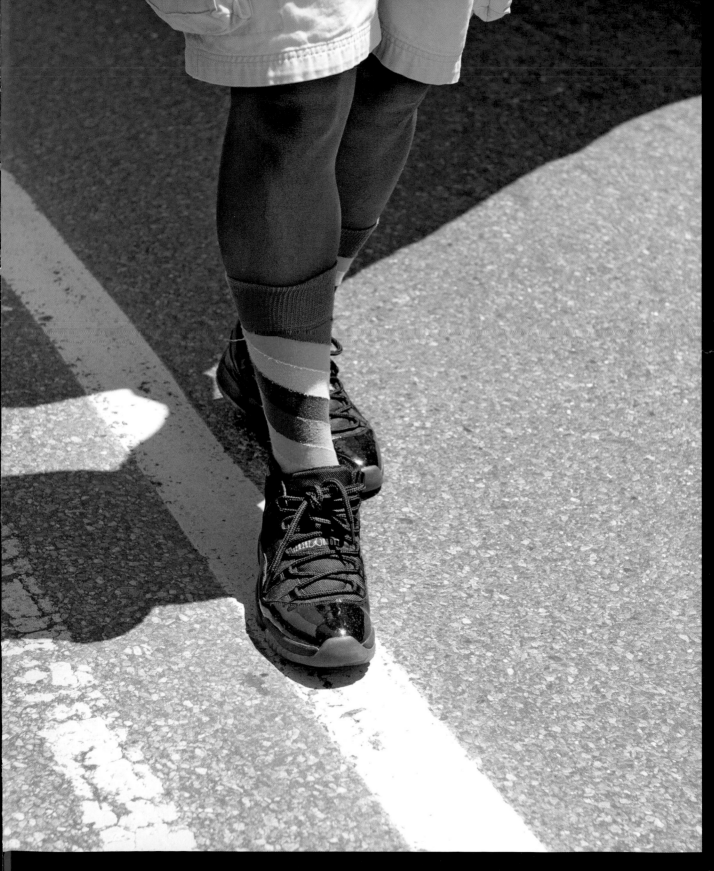